E A R T H + S P A C E

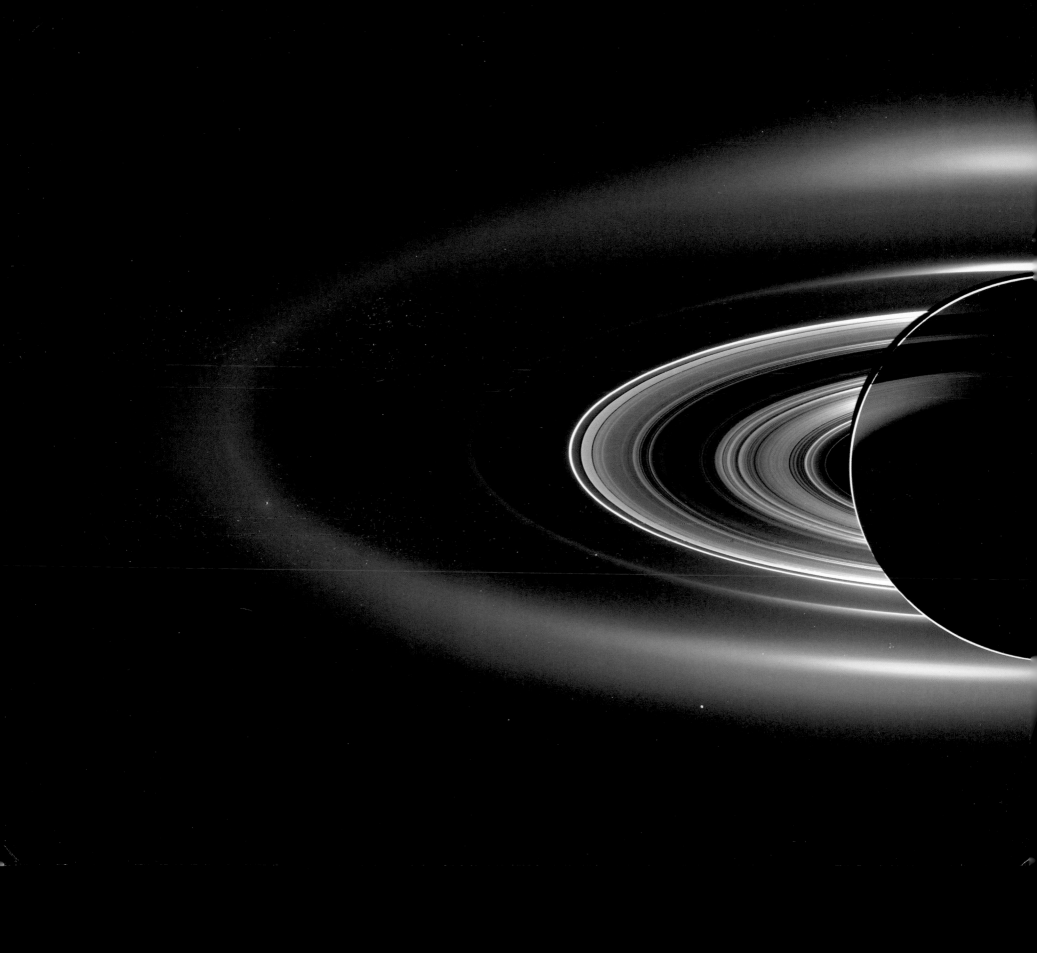

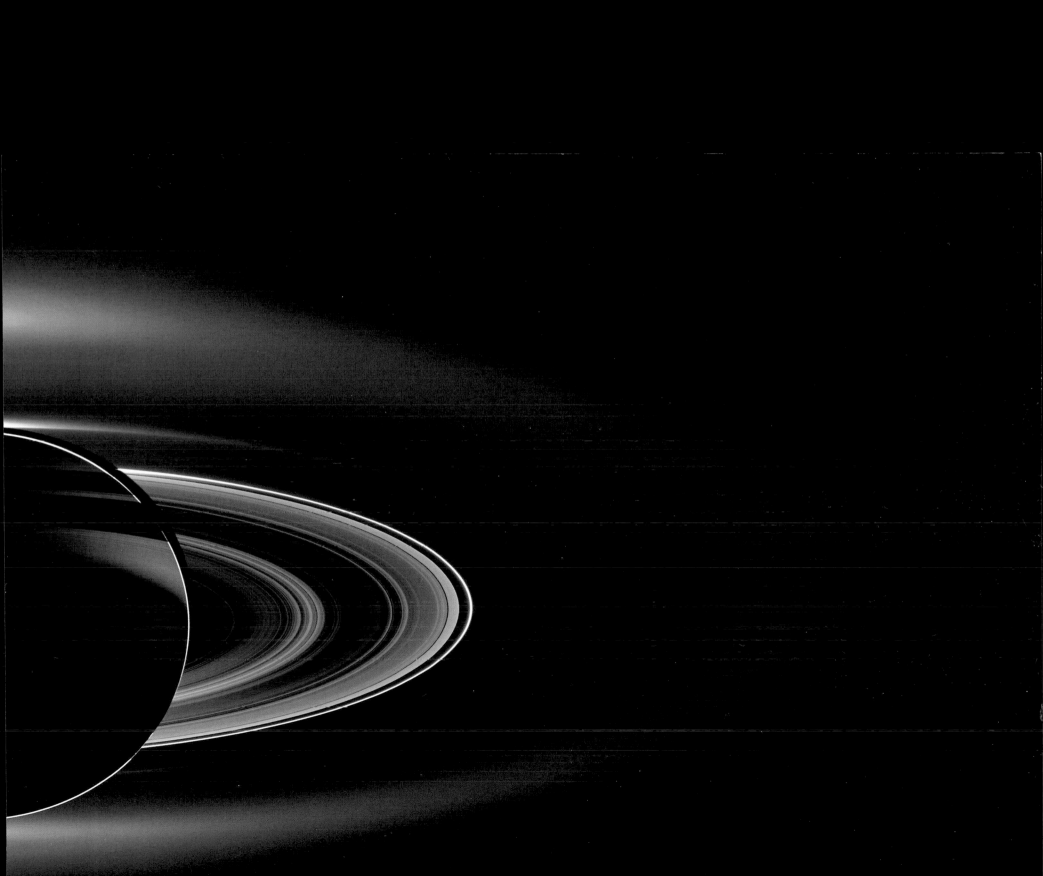

EARTH

SPACE

PHOTOGRAPHS FROM THE ARCHIVES OF NASA

PREFACE *by* BILL NYE

TEXT *by* NIRMALA NATARAJ

CHRONICLE BOOKS

SAN FRANCISCO

[*frontispiece*]

WIDE-FRAME MOSAIC OF SATURN

On July 19, 2013, NASA's *Cassini* spacecraft captured exquisite images of Saturn, resulting in this composite photo of 323 images taken in just over four hours. *Cassini* captured Saturn's seven moons, its rings, and the Earth, pictured as a barely visible dot in the background of space—all backlit by the Sun.

[*title page*]

BLOOMING PHYTOPLANKTON

This colorful image, taken in September 2014 by the Operational Land Imager on the Landsat 8 satellite, reveals phytoplankton blooming in the Bering Sea near Alaska's Pribilof Islands. The phytoplankton, microscopic organisms that provide a fertile habitat for fish and birds, can be seen in the milky light blue and green areas of the image. Phytoplankton blooms are delicate and can be easily impacted by an ecosystem's changing temperature, vitamins, minerals, and predators. The blooms in the Bering Sea increase in the springtime when ice retreats and nutrients are available near the water's surface, and they decrease in the summertime as the water warms and grazing marine life feed on the phytoplankton.

Library of Congress Cataloging-in-Publication Data

Nataraj, Nirmala.
 Earth and space : photos from the archives of NASA / Nirmala Nataraj.
 pages cm
 Preface by Bill Nye.
 Includes bibliographical references.
 ISBN 978-1-4521-3435-2
 1. Outer space–Pictorial works. 2. Earth (Planet)—Pictorial works. 3. Astronomical photography. I. United States. National Aeronautics and Space Administration. II. Title.

 QB68.N38 2015
 520—dc23

 2014043715

Manufactured in China.

Book design by Neil Egan
Additional typesetting and layout by Liam Flanagan

10 9 8 7 6 5 4 3 2

Chronicle Books LLC
680 Second Street
San Francisco, CA 94107

www.chroniclebooks.com

CONTENTS

PREFACE

by Bill Nye

EVERY ONE OF US HAS DREAMED OF IT—the ability to fly. With the freedom of flight, we imagine vistas: mountains, rivers, forests, deserts, and the trackless sea. But what if we could not only soar above the ground? What if we could fly high beyond the Earth to view our world and the deepest reaches of the cosmos? That is what the creators of the images in this book were able to do for real—not by flying like a comic book hero, but by conceiving and creating robotic spacecraft that carry cameras to vantage points our ancestors could only have imagined in their wildest dreams.

Pictures from space are remarkable, of course. The views amaze and astonish us; the images themselves are artwork. But unlike many portraits, landscapes, or still lifes, these photographs are not the product of one artist or visionary. Instead, these images were created by a national program and are the result of the work of thousands of highly skilled engineers, artisans, and scientists who share the human need to explore and feel the joy of discovery.

Our ancestors have been watching the sky for perhaps the last hundred thousand years. But it was only in the last hundred years that we came to understand why galaxies take on distinctive shapes. It was only in the last decade that we've had roving eyes on Mars, and it was only in the last few years that we've seen the true delicate shape of the rings of Saturn. None of this would be possible without the National Aeronautics and Space Administration. NASA's recognition and respect are unmatched, and the astonishing images NASA produces for books like this are a testament to the American program's continuing cultural relevance.

As you turn the following pages of *Earth and Space*, I hope you appreciate the inherent beauty of each image. But I further hope that each picture and caption whets your curiosity about the science behind the astronomical phenomena. Why do stars establish these elegant patterns? Why do reflected beams of light produce these apparent colors, which we cannot see with our unaided eyes? Why did all this material arrange itself into a planet at this particular point in all that is outer space? I also hope that you take a few moments to appreciate the remarkable collective work of the engineers, artisans, and scientists who created these beautiful images. Every bit of hardware—from the small rocket motors used for maneuvering to the large lenses used to detect photons in the icy blackness of space—was built by people, who thought up performance specifications, systems, and shapes to create remarkable spacecraft that can journey into the deep reaches of our galactic neighborhood and send stunning pictures back to us on Earth.

It's only from above that we can appreciate the fragile nature of the world below. *Earth and Space* allows us to fly, to soar high above our own planet and into deep space. How lucky we are that the images that NASA collects in space are available to us, the first generations of humans to build and fly these extraordinary spacecraft. Here's hoping that we continue to journey, explore, and discover from this day forward so that we may always be aware of the remarkable cosmos and our place within it.

[*right*]

NEW WINGS FOR THE HUBBLE SPACE TELESCOPE

This image, recorded by a digital camera on March 9, 2002, offers an impressive view of the Hubble Space Telescope floating above Earth and sporting four new flexible solar array "wings," which were installed by space shuttle *Columbia*'s STS-109 crew. The crew gave the Hubble a much-needed hardware upgrade over the course of its ten-day mission, which included five space walks. The former solar arrays were destroyed by radiation and space debris, and the Hubble's new wings offer it 30 percent more power and the ability to endure extreme temperatures. The mission also oversaw the installation of the Advanced Camera for Surveys (ACS), a sensitive tool with ten times the discovery power of the camera it replaced. With a wide field of view, crisp image quality, and the ability to pick up information from the visible to the far ultraviolet spectrum, the ACS can generate detailed images of galactic inner regions and the objects in neighboring star systems.

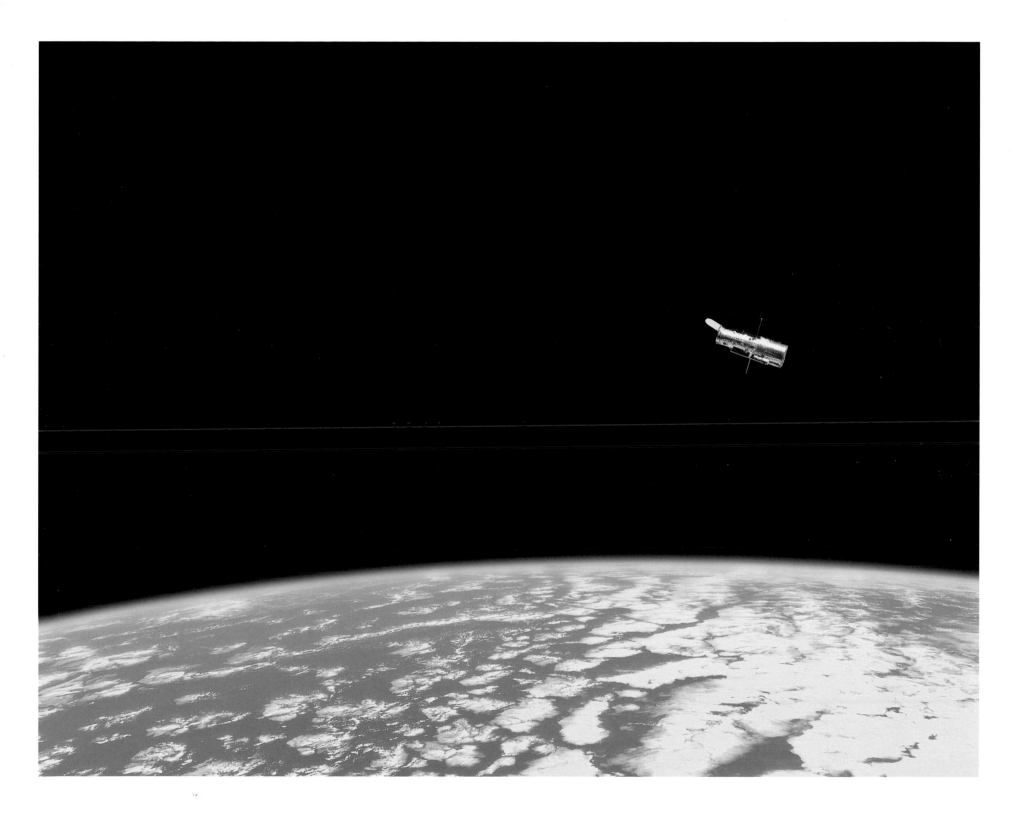

INTRODUCTION

by Nirmala Nataraj

FOURTEEN BILLION YEARS AGO, just seconds after the Big Bang, the universe was merely a sac of radiant plasma made up of hot ionized hydrogen and helium gas. As the universe gradually cooled and expanded outward over time, the hydrogen's electrons and protons recombined. This newly neutralized hydrogen began to absorb existing photons, and as a result, the light that had illuminated the dawn of the universe slowly faded. Four hundred thousand years after the Big Bang, the universe entered the Dark Ages, a period lasting hundreds of millions of years in which an opaque blackness reigned supreme. Had humans been around during this time, nothing in our cosmos would have been detectable to the naked eye.

Eventually, thick fogs of gas, barely lit by the infrared beams left over from the Big Bang, gathered to form galaxies. As early stars and quasars (masses of energy and light that are the brightest objects in the current universe) emerged from these gaseous galactic cradles, the energy they radiated re-ionized the hydrogen, allowing light to spread throughout the cosmos.

The Dark Ages were over. The universe was radiant, and visible, once again.

The celestial bodies in outer space have long held deep meaning for our species. Planets, constellations, and galaxies have inspired vast realms of art, literature, and metaphysical theory. Early in human history, the phenomena witnessed in the night skies dictated mythology as our ancestors attempted to satiate the desire to know our origins.

Our ability to capture the phenomena of space has come a long way since ancient astronomers first recorded their observations with quill and paper. These early methods of data recording were prone to error because of the imprecise mechanics of translating sight into a written record. Capturing the cosmos accurately came with the advent of photography. In 1822, the French inventor Joseph Nicéphore Niépce experimented with creating permanent photographic images by using polished tin covered in bitumen (a derivative of petroleum). In 1839, astronomer Johann Heinrich von Mädler coined the term "photography" to describe this process, and the word was eventually popularized by the British mathematician and astronomer John Herschel.

Stellar astrophotography, the practice of photographing space, began in earnest in the mid-nineteenth century, when the Moon, stars, and nebulae were first captured on black-and-white film via long exposure. French artist and photographer Louis Daguerre took the first astronomical photograph when he captured the Moon in 1839. (Unfortunately, the image was destroyed when Daguerre's laboratory went up in flames later that year.) Several years later, in 1844, French physicists Jean Bernard Léon Foucault and Armand Hippolyte Louis Fizeau took the first photograph of the Sun. For the first time, humans could hold an accurate picture of the cosmos in their own hands. The vast reaches of space were no longer an unknowable void.

Over the next hundred years, the technology of stellar astrophotography advanced dramatically. In 1887, the first sky-wide photographic astronomical project was conducted by twenty observatories, using photographic telescopes to map the sky. (Though the project was not completed at the time, astronomers continued to work toward building a comprehensive map of the sky.) By the mid-twentieth century, information recorded by the Hale Telescope and the Samuel Oschin Telescope at the Palomar Observatory in California revealed the imaging possibilities of large-scale telescopes. As earthbound astrophotography continued

[*right*]

THE SWIRLS OF JUPITER

This iconic image of Jupiter was assembled from three black-and-white photos captured in March 1979 by *Voyager 1*. The spacecraft's mission was to discover detailed information about Jupiter's complex system of rings and moons, as well as its turbulent atmosphere. The swirls are the tops of clouds that float high in the planet's atmosphere. Though they may look placid, the clouds are moving faster than 400 miles (644 kilometers) per hour, generating storms that are roughly 3.5 times bigger than our home planet.

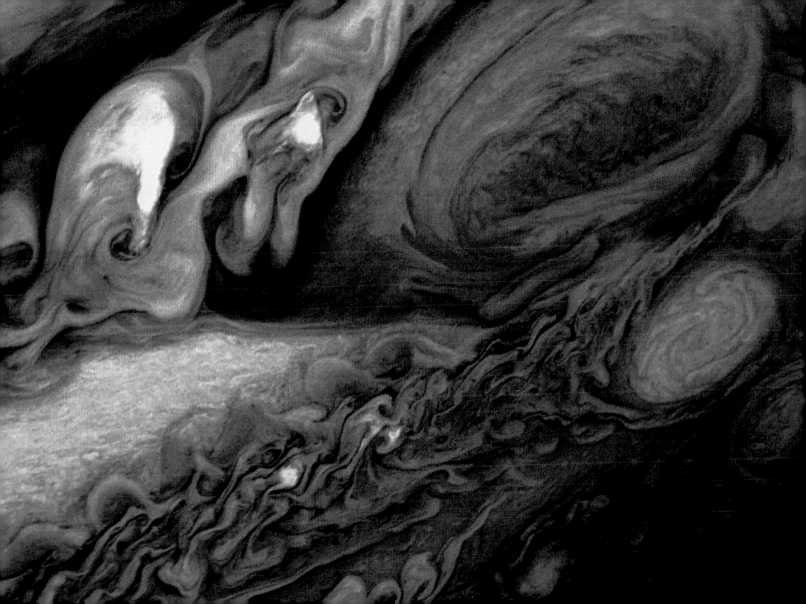

to improve, the images became increasingly useful to science, allowing scientists to predict storm patterns and leading to new discoveries in oceanography and environmental science. At long last, scientists were getting the bigger picture in all its startling dimensions.

The notion of a space-based observatory began with Lyman Spitzer, who first introduced the idea of taking space imaging beyond the Earth's limits in 1946 as a researcher at Yale University. At the time, ground-based telescopes were unable to capture X-rays, gamma rays, and other types of radiation, and Spitzer noted that an orbital telescope, unencumbered by the Earth's atmosphere, would significantly impact our understanding of cosmology and physics.

Spitzer's vision came to fruition the following decade, thanks to the National Aeronautics and Space Administration (NASA). NASA was founded in 1958, during the United States' space race with the USSR. At the time, intercontinental ballistic missiles were perhaps the most overt indication of global power for both nations. These missiles led the Soviet Union to launch the Sputnik satellite in 1957, making the USSR the first nation to place an object into orbit around the Earth. In 1958, the United States answered the USSR by launching the first American satellite, *Explorer 1*, into space. Later that year, President Dwight D. Eisenhower signed the National Aeronautics and Space Act, calling for research on the Earth's atmosphere and the far reaches of space.

NASA's earliest photographs were primarily industrial—images of bulky spaceships, pyrotechnic launches, and astronauts engaging in routine tasks. Photographs taken by astronauts with handheld cameras were considered purely recreational—impressive souvenirs to bring home to friends and family. When John Glenn was sent into orbit in 1962 (becoming the first American to orbit the Earth), he brought along a drugstore-purchased Ansco Autoset 35 mm camera for the ride. In 1965, during NASA's Project Gemini, astronaut Ed White took the first photograph of a spacecraft in orbit, using a Zeiss Contarex 35 mm camera as he "walked" through zero gravity. But as camera technology became more sophisticated, NASA increased their emphasis on space photography. In the 1960s, lunar probes took hundreds of thousands of photographs, resulting in precise and detailed mappings of the Moon, paving the way for the Apollo program. By the Apollo 11 mission in 1969, astronauts were taking a variety of camera equipment aboard, ranging from motion-picture film cameras to television cameras to a stereo close-up camera that was specially commissioned to snap detailed images of lunar soil. As NASA's photography expanded our knowledge of space, our species' burgeoning understanding of our place in the universe grew. Our visual imagination of the cosmos was no longer bound to the Earth.

Many of the images featured in the following pages were captured by the Hubble Space Telescope. Named after American astronomer Edwin P. Hubble, whose early research proved that the universe is expanding by the second, the Hubble launched in 1990. Unfortunately, the telescope's early journey was marked by a series of failures. The initial images it sent back to Earth were blurry and difficult to decipher. Eventually, scientists discovered that the edges of the telescope's primary mirror were too flat, which distorted the images. A new set of optics was installed in 1993, and a number of subsequent servicing missions over the years have dramatically improved the Hubble's technology.

The Hubble's powerful telescopes, outfitted with large mirrors, capture light that the human eye cannot detect. At 7.9 feet (2.4 meters) in diameter, the Hubble's main mirror is actually fairly small compared to some Earth-based telescope mirrors, which can be over 32 feet (or 10 meters). But because the Hubble sits 353 miles (or 568 kilometers) above the Earth's surface, its telescopes have a clearer, sharper purview than earthbound telescopes, since the particles in the Earth's atmosphere distort what we can see of the cosmos (this is why the stars in the night sky appear to "twinkle").

Every ninety-seven minutes, the Hubble makes a complete orbit around the Earth, speeding along at five miles per second (fast enough to take us from one coast of North America to the other in ten minutes). As the telescope moves through space, its six specially designed instruments are constantly capturing images, including images of phenomena that occur beyond the visible light spectrum. The Wide Field Camera 3 is capable of picking up near-ultraviolet, visible, and near-infrared light. (This camera is used to detect dark energy and matter, as well as galaxies that exist millions of light years away from Earth.) The Cosmic Origins Spectrograph carries back images in ultraviolet light and provides information about the temperature, chemical composition, density, and motion of celestial objects. The Space Telescope Imaging Spectrograph surfaces the existence of black holes, the Advanced Camera for Surveys marks changes in galaxy clusters, and the Near Infrared Camera and Multi-Object Spectrometer shows us celestial objects that would otherwise be concealed by stellar dust clouds. The Fine Guidance Sensors offer measurements of star positions, which work to keep the Hubble on track and in the right direction at all times. These instruments translate "invisible" spectacles into stunning images. (The Hubble Space Telescope also once utilized two other instruments—the Wide Field and Planetary Camera 2, which had been the telescope's main camera, and the Faint Object Camera, which was Hubble's old telephoto lens. Both were supplanted by the Advanced Camera for Surveys, which was installed in 2002.)

The Hubble offers us glimpses of the most elusive parts of the universe as

it transmits detailed images back to Earth. In revealing the deepest reaches of our cosmos—including the remnants of supernovae, dark energy, black holes, and the birth of new galaxies—the Hubble's images have provided a basis for groundbreaking discoveries, putting an end to hundreds of years of scientific conjecture. Thanks to the Hubble, billions of years of astronomical phenomena can now be deciphered.

The Hubble won't always be sitting pretty above the Earth's atmosphere. Eventually, the telescope will slow down and degenerate. Plans for the Hubble's successor, the James Webb Space Telescope, are in the works at NASA. Unlike the Hubble, which orbits just several hundred miles from the Earth, the Webb will drift a million miles outside our solar system. Its penetrating infrared vision and 21.3-foot (6.5-meter) primary mirror will offer us insight into the most hidden phenomena of the universe. The Webb's powerful telescope will also be able to record the size and atmospheric composition of planets outside our own solar system, which will allow us to explore the possibility of life on other planets. If all goes as planned, the Webb will launch in 2018 and become the largest space telescope ever put into orbit.

In addition to the images taken by the Hubble, *Earth and Space* includes images captured by other space telescopes, including the Herschel Space Observatory (built by the European Space Agency), the Spitzer Space Telescope, the Chandra X-ray Observatory, and the Wide-field Infrared Survey Explorer (WISE). WISE scans the sky in infrared light and captures millions of objects that would otherwise be undetectable on the visible light spectrum. This includes cool stars, extremely bright galaxies, and dark moving objects such as comets and asteroids. The Hubble Space Telescope, the Spitzer Space Telescope, and the Chandra X-ray Observatory are three of the four original satellites in NASA's Great Observatories Program (the fourth was the Compton Gamma Ray Observatory, which is no longer operating). The Spitzer is a cryogenically cooled infrared space observatory that spent close to six years (from 2003 to 2009) studying objects in infrared light (most of which gets absorbed by Earth's atmosphere). The impressive Chandra X-ray Observatory, NASA's flagship X-ray telescope, detects X-ray emissions from some of the hottest and highest-energy reaches of the universe, including supernovae, galaxy clusters, and all the matter that encircles black holes.

NASA's powerful imaging and observation tools are some of the most acute viewing instruments in the world. As you'll discover in the following pages, the information recorded by these observatories is often synthesized to create stunning composite images that offer us information on astronomical phenomena in a range of wavelengths. Viewing the universe at different wavelengths gives us an intimate window into cosmic occurrences that would otherwise remain unseen and shrouded in mystery.

For more than half a century, NASA has been at the forefront of space exploration and discovery. Photographs from the agency's extensive archives chronicle the evolution of NASA's imaging capabilities—from early images that capture the excitement of space flight (including candid photos chronicling the Apollo Moon program) to iconic shots of Earth as a "blue marble" rolling through space; from sophisticated satellite imaging that changed our understanding of weather patterns and climate change to composite images of regions billions of light years from Earth.

In the following pages, you'll explore astronomical phenomena that best even the most extravagant works of science fiction. The images are organized in order of distance—we move from intimate renditions of our planet and solar system to intergalactic images that offer us extraordinary views of our universe's natural wonders. This collection of photographs catapults us through the cosmos on a breathtaking journey from our own Milky Way solar system, past solar flares and star-making nebulae, and to the dramatic scenes of star deaths and the mysterious rings of dark matter billions of light years from Earth.

Photographs of our planet as seen from space shape our understanding of the Earth and its resources. Early images of the Earth from space led astronaut William Anders, a pilot on the Apollo 8 mission, to proclaim: "We came all this way to explore the Moon, and the most important thing is that we discovered the Earth." In the 1960s, while working on a project with NASA, scientist James Lovelock developed the Gaia hypothesis, which suggests that our Earth is not an inanimate bundle of matter floating aimlessly through space; rather, it is a vast, self-regulating, and wise organism, one upon which life prevails and continues despite new and ever-changing circumstances.

Photographs of deep space offer us a vision of a universe that is constantly evolving. From the birth of protoplanetary discs to the dramatic deaths of stars, these stunning images from the archives of NASA provide answers to scientific questions that have puzzled astronomers since the days of Galileo. These spectacular images of the cosmos play to our insatiable curiosity and collective yearning for a sense of connectedness and for a deeper knowledge of our universe's origins and our Earth's fate. Many of the images you'll find in the coming pages contributed to scientific discoveries that forever altered long-standing theories about the universe, and as we keep transforming invisible spectacles into breathtaking images, we will continue to change the way we view our Earth, our universe, and our reality.

PHOTOGRAPHS

FROM THE ARCHIVES

OF NASA

A BACKWARD GLANCE AT EARTH

Dramatic images of the Earth from space were first captured by the Apollo program, NASA's human spaceflight program. These images allowed us to conceptualize our planet as a self-contained entity moving through oceans of black space. As spacecraft explored more distant regions of the solar system, they routinely took departing views of the Earth and the Moon, offering us poignant backward glimpses of our planet. This image of the Earth was taken by the crew of the space shuttle *Columbia* on the fifth Spacelab mission in 1991; the official flight number, STS-40, stands for "space transportation system," the shuttle program's original name. Scientists on board were conducting experiments primarily concerned with the effects of microgravity on the heart, kidneys, and hormone-secreting glands, but they also took time to snap some stunning photographs of the Earth.

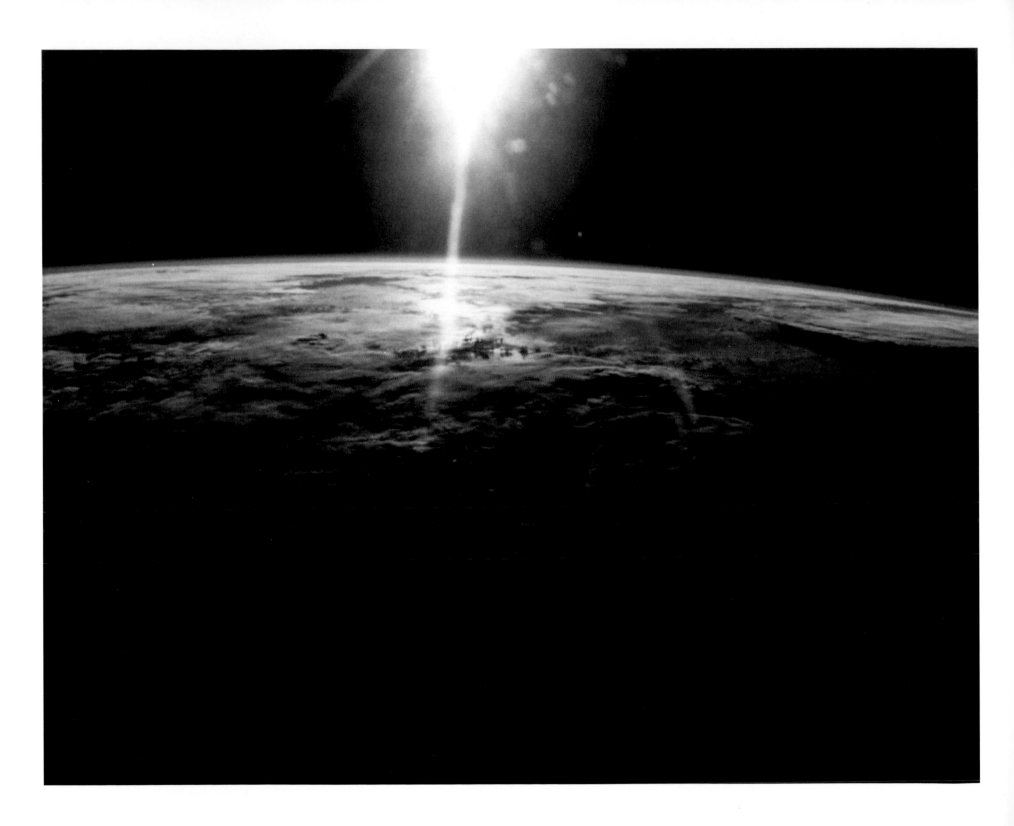

SUNLIGHT OVER EARTH

This photograph was taken with a simple 35 mm
point-and-shoot camera in 1989 by the STS-29 crew
aboard the space shuttle *Discovery*. The sun beams
down over the Earth, which is blanketed by an
ethereal bank of mushroom-like clouds. The highest
clouds in our atmosphere can be found up to thirty-
one miles (fifty kilometers) above the Earth's surface
and tend to be a deep twilight blue color. These
clouds form at extremely cold temperatures from a
combination of dust and water vapor whose sources
are not absolutely known. A 2012 NASA study
revealed that global cloud height has lowered over
the course of the past decade.

[*right*]

EARTH OBSERVATIONS

In 1992, NASA launched STS-52, another orbital
mission of the space shuttle *Columbia*, which
gathered a great deal of valuable information about
the Earth. STS-52 took this snapshot of the Earth,
one of many shots that enabled scientists to better
understand the subtle movements of the Earth's
crust. STS-52's observations included measuring
the wobble in the Earth's axis, as well as using the
size and shape of the Earth to determine exactly how
long a day really is (23 hours, 56 minutes, and 4.1
seconds, to be exact).

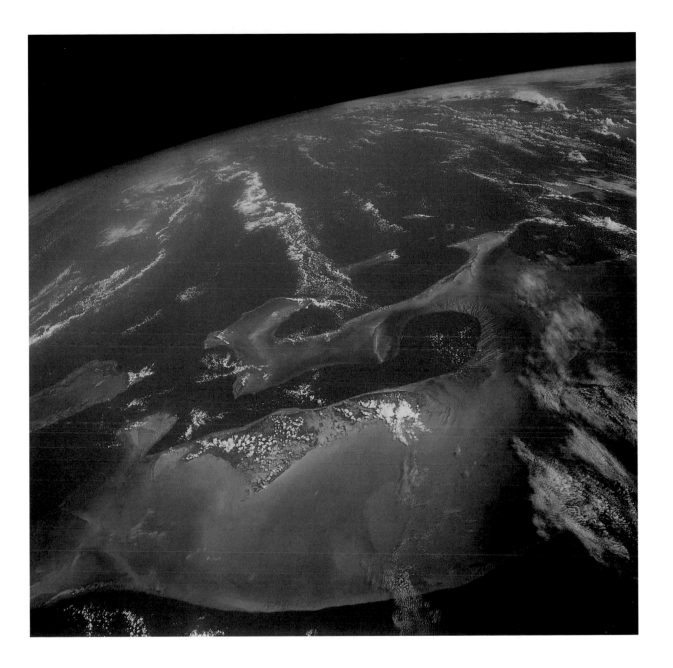

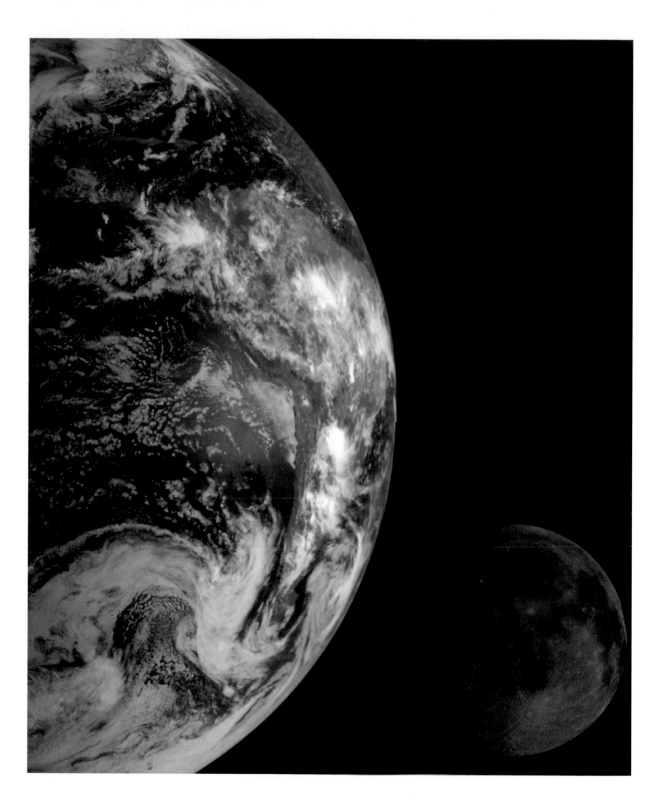

[*left*]

EARTH AND MOON

This composite image was assembled from separate photographs taken of the Earth and the Moon by the *Galileo* spacecraft in 1992 while it was en route to Jupiter. The spacecraft's transit around the Earth and the Moon created a slingshot effect that helped it to reach the speed necessary to get closer to the giant planet. On the Earth you can see the swirling pattern of storm clouds hovering over the Pacific Ocean, southwest of South America. The darker areas of the Moon, including the giant Tycho impact basin, are packed with lava rock that formed following the impact of an asteroid.

[*right*]

THE BLUE MARBLE

This iconic photograph, known as "The Blue Marble," was captured by the crew of *Apollo* 17 in December 1972. It is famous for being the first photograph taken of the Earth in its entirety. Here we have a clear view of our planet's geography, from the Mediterranean Sea to the south polar ice cap. Eventually, NASA created composite satellite-generated images of our planet entitled "Blue Marble: Next Generation," which offer us the most accurately colored images of the Earth to date. These images stemmed from months of satellite observations covering every square kilometer of the planet, from land formations to oceans, clouds, and sea ice.

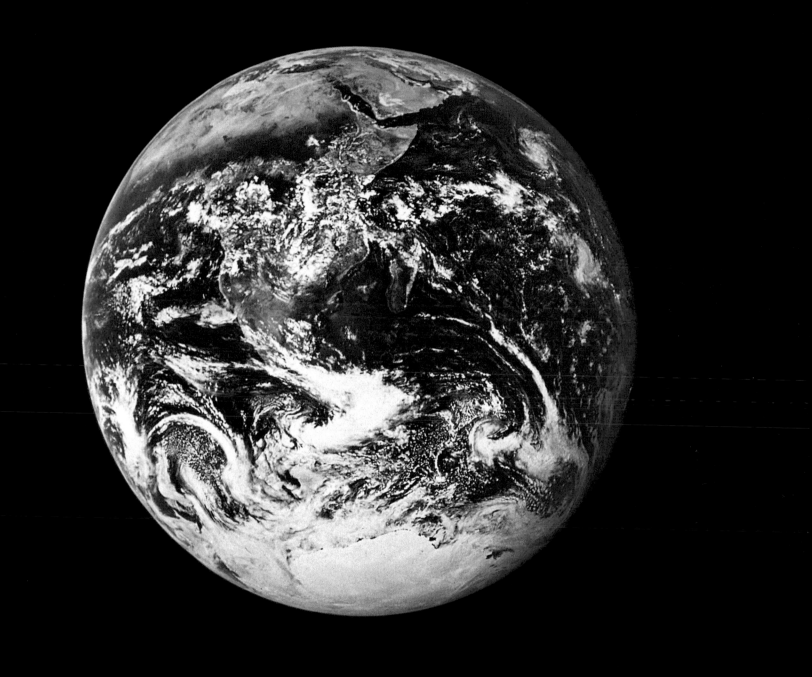

CLOUDS AND SUNLIGHT OVER THE INDIAN OCEAN

This bucolic scene of clouds billowing over the Indian Ocean was taken in 1999 by the space shuttle *Discovery*. Although it captures the eerie beauty of Earth from space, fifteen years after the photo was taken, scientists at NASA discovered that something more ominous lurked amid those clouds. Subsequent observations from space revealed that a large swath of the atmosphere over South Asia and the Indian Ocean contains something known as brown cloud pollution, an oppressive layer created by aerosol gases in the lower and upper atmospheres. This smoggy region is now known as the Asian brown cloud.

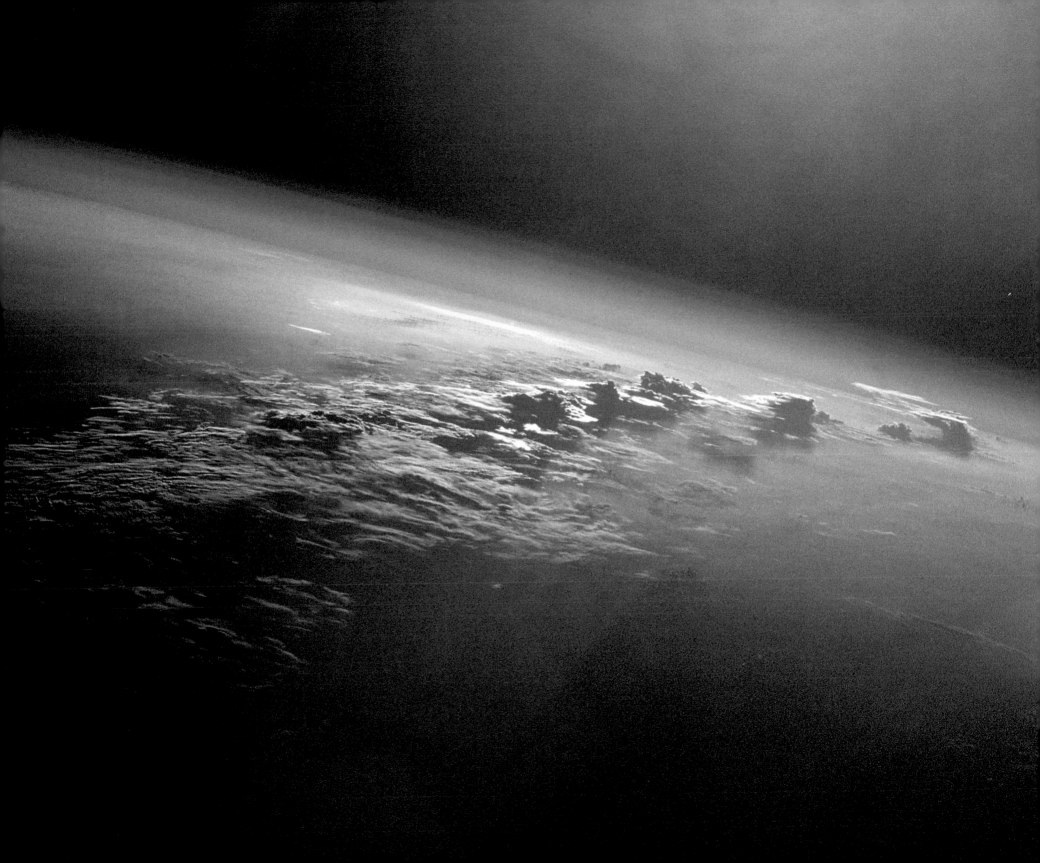

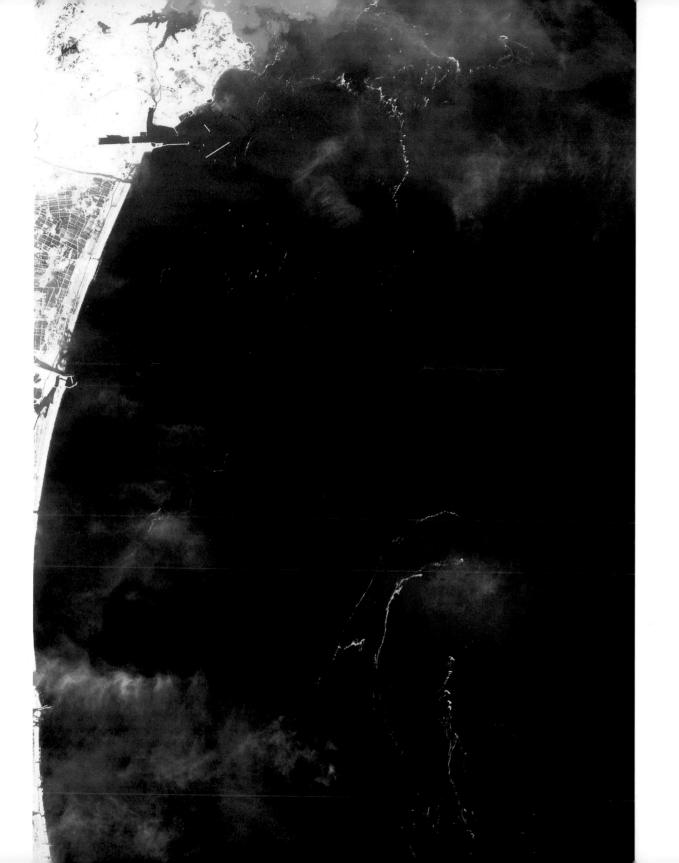

[*left*]

TSUNAMI DEBRIS

This dramatic image gives us a snapshot of the effects of the earthquake-triggered tsunami that devastated the northeastern coast of Japan on March 11, 2011, wiping out a number of cities and villages. The photograph, taken three days after the tsunami, captures an area covering 18.5 by 26.5 miles (29.8 by 42.6 kilometers) and reveals a monumental amount of debris (the black material visible beyond the coastline) from uprooted land, homes, and other objects. The image was taken by the Advanced Spaceborne Thermal Emission and Reflection Radiometer (ASTER), one of five NASA instruments observing the Earth. Built in partnership with Japan, ASTER offers imagery that picks up everything from visible light to thermal infrared wavelengths, offering us information that is vital for monitoring glacial advances, active volcanoes, and other physical changes on the Earth's surface.

[*right*]

A LIT-UP EARTH

This composite image of the Earth, captured by the Suomi National Polar-orbiting Partnership (NPP) satellite, was compiled over twenty-two days and 312 orbits in 2012. The satellite's Visible Infrared Imaging Radiometer Suite (VIIRS) lets us note light at visible and infrared wavelengths. While the image highlights urban areas, it also captures fainter light signals—from gas flares to auroras to wildfires. The data captured by the NPP satellite was mapped over NASA's "Blue Marble" imagery to offer an accurate depiction of the planet.

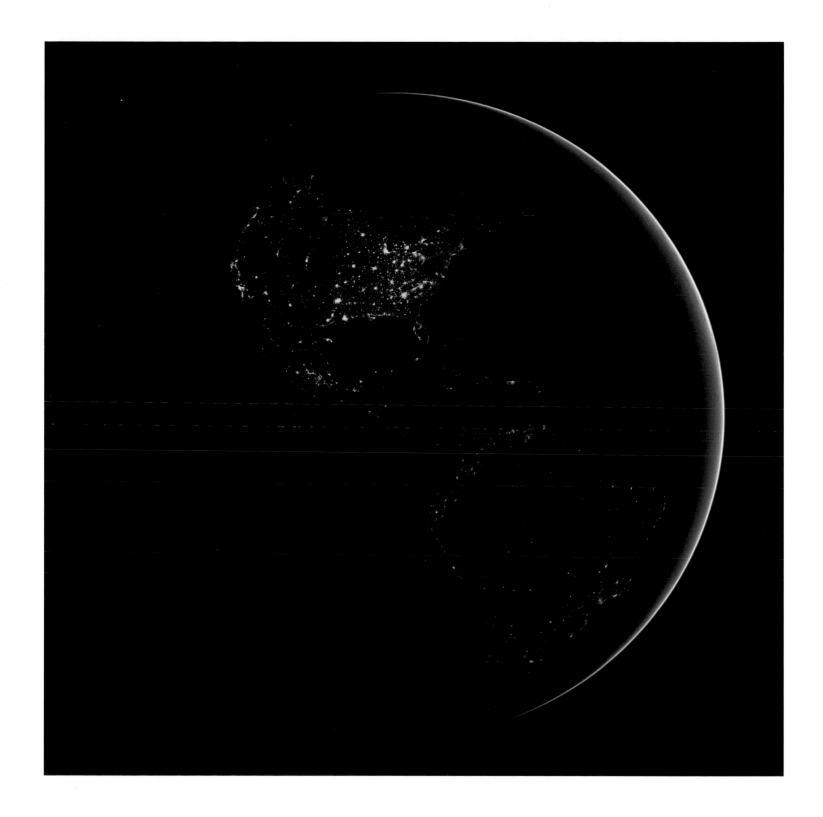

CRESCENT MOON

This now-famous photograph of a crescent moon beaming through a rich pano-
rama of the Earth's atmosphere was taken by the Japan Aerospace Exploration
Agency's astronaut Koichi Wakata in February 2014 during Expedition 38 to the
International Space Station. Wakata transmitted the photo to Earth via Twitter—it
was one of his daily tweets from space, which included photos of glaciers and the
aurora borealis. The red layers mark the areas where the longest wavelengths of
visible light gather in the Earth's atmosphere, while the shorter wavelengths are
scattered by the density of the molecules in the air. The primary gases in each layer
of the atmosphere are prismatic and act to screen out different wavelengths of light.

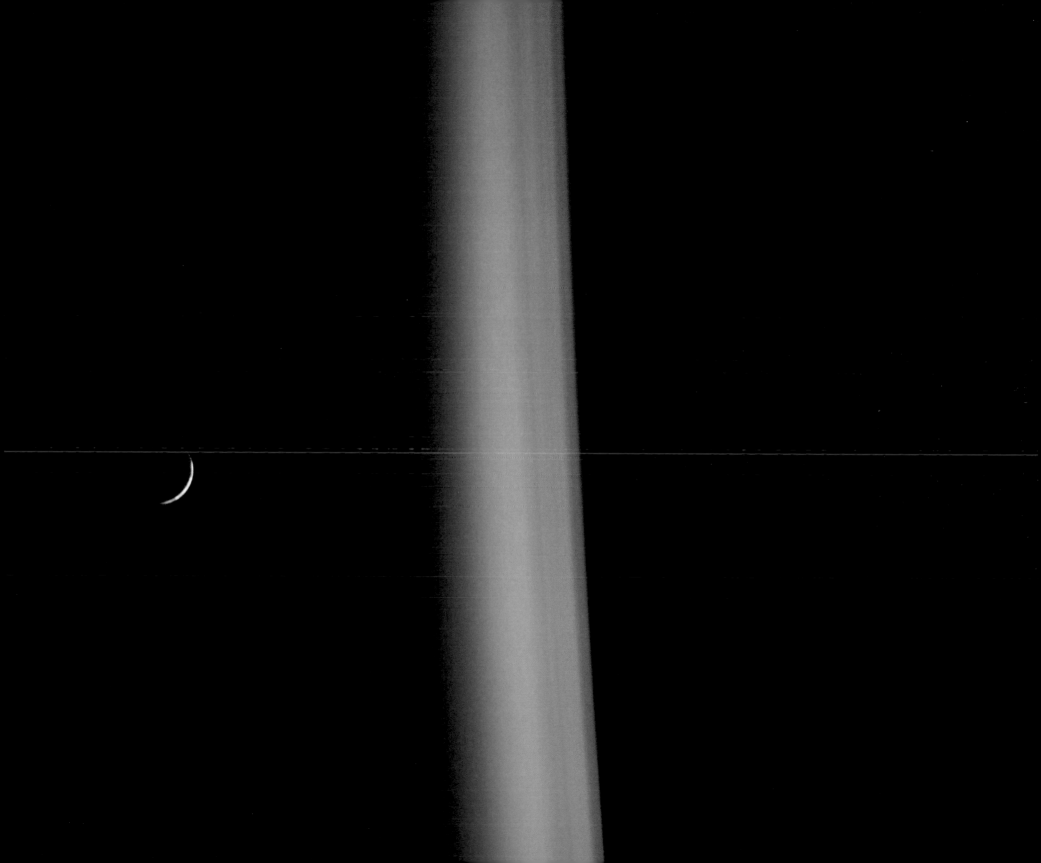

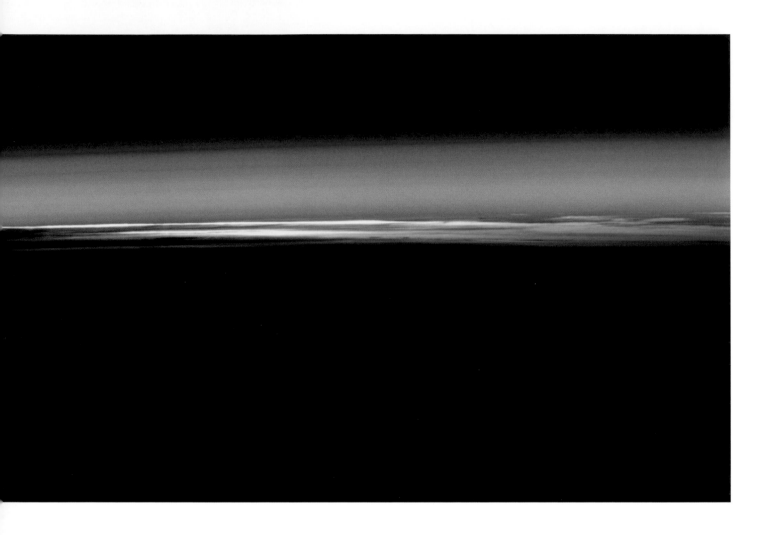

[*above*]

EARTH'S LIMB

The limb of the Earth is the atmospheric boundary that appears as a halo around the flattened disc of the planet when viewed from space. It is also where the curvature of the Earth meets the inky darkness beyond its atmosphere, acting as a beautiful shield against the hazardous climate of outer space. The thin mantle of gases has been photographed from satellites, shuttles, and the Moon. In this photograph, the luminous aerosol blanket draped over the Earth is shown glowing in the wake of the setting Sun. The bands of brilliant colors appear when temperature inversions cause smoke, dust, and gas to congregate in narrow layers.

[*right*]

EARTH'S LIMB AND LUNAR OCEAN OF STORMS

Here, the Moon rises above the Earth's limb. The Moon's largest lunar sea, a dark spot that resulted when a volcanic lava stream carved out the Moon's surface, faces us head-on. Known as the Ocean of Storms, it is the largest lunar sea on the Moon. In the foreground, vast clouds can be seen in the Earth's troposphere, the lowest layer of our planet's atmosphere (which hosts over 80 percent of our atmospheric mass, including water vapor and clouds). The upper atmosphere, where blue sunlight is scattered, abruptly gives way to the blackness of space. Like many photographs of the Earth's limb, this image highlights our planet's elegant combination of fragility and fortitude; the atmosphere that protects and sustains us is miniscule in comparison to the vastness and the potential ravages of space.

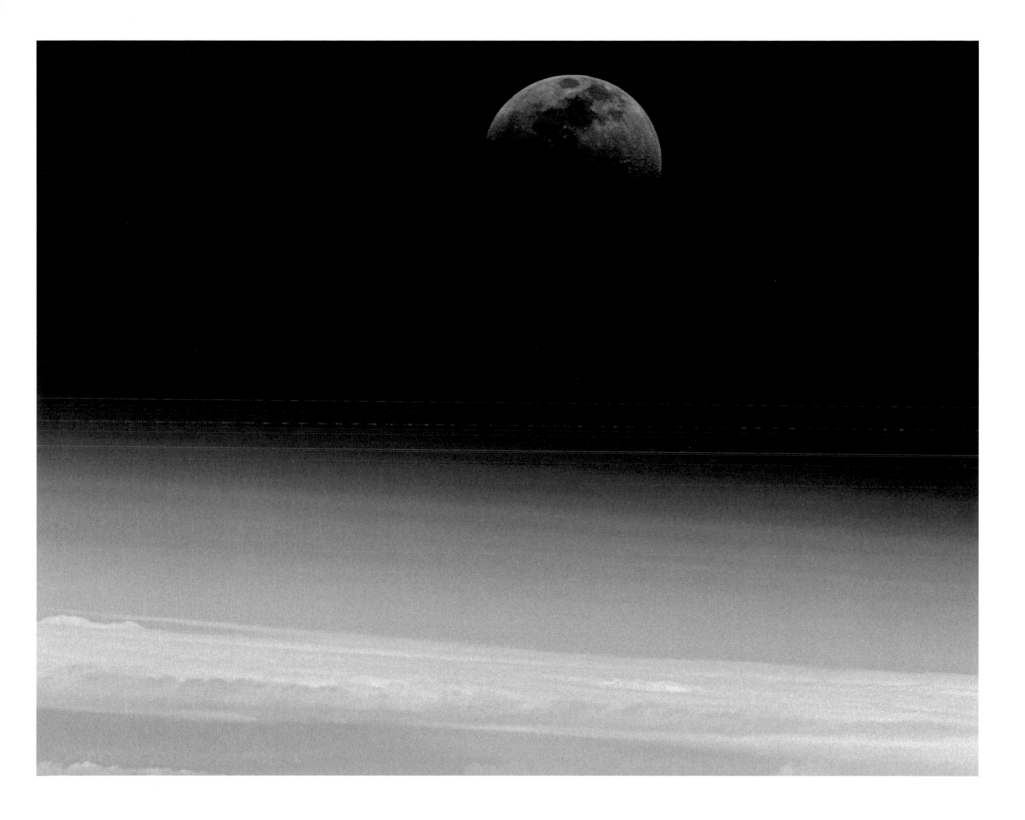

SUN SETTING OVER EARTH'S LIMB

This photograph of the Sun setting over the Earth's limb was taken in orbit aboard the International Space Station by the Expedition 5 crew, a 2002 mission that boasted one of the longest durations in space (184 days). The colors along the horizon line reveal a sequence of atmospheric layers. The troposphere, the lowest layer, is where we find the brilliant orange hues of the sunset. The stratosphere above contains almost no clouds and begins about thirty-one miles (fifty kilometers) above the surface of the Earth. The upper stratosphere is a darker blue, the final frontier before the darkness of space.

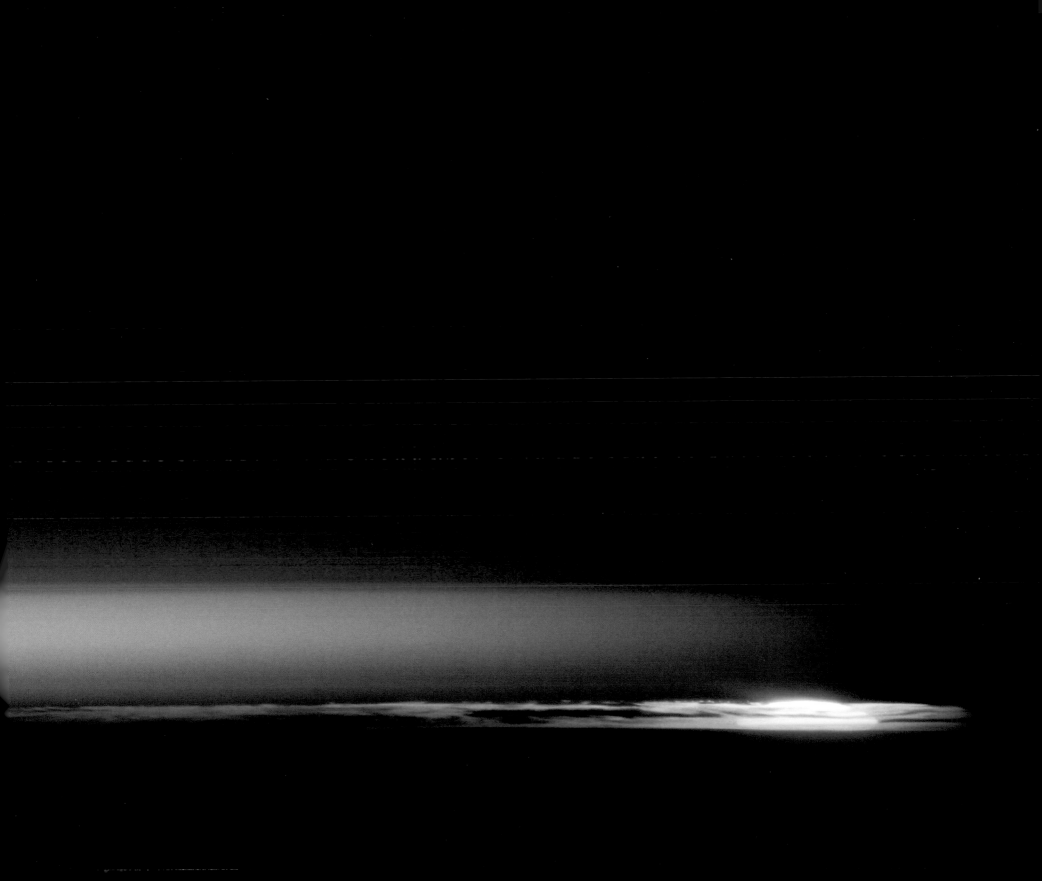

[*left*]

THE CRESCENT EFFECT

This image of a last-quarter crescent Moon suspended above a luminous pale Earth was taken by the Expedition 24 crew on the International Space Station in 2010. A last-quarter Moon occurs about three weeks after a new Moon, when the Moon is three-quarters of its orbit around the Earth. Its lighted portion typically faces the horizon of the Earth, as shown in this photograph. A last-quarter Moon gives us a clearer picture of the Earth's orbit around the Sun. To view a last-quarter Moon in the sky right before dawn actually provides us a view of the path of our planet's orbit as it moves forward. If the Moon weren't also in constant motion, Earth's eighteen mile (or twenty-nine kilometer) per second speed could carry us to the Moon within just a few hours.

[*right*]

EARTHRISE

This iconic image known as "Earthrise" was shot on December 24, 1968, by astronaut William Anders during the Apollo 8 mission. The famed nature photographer Galen Rowell believed this to be the most influential environmental photograph ever taken—and it certainly stands out as one of the most extraordinary observations of Earth from space. The impromptu shot was taken as the spacecraft was being rotated and Anders caught sight of the impressive view. In recordings of the moment, you can hear him marvel, "Wow, is that pretty!" as if he were seeing our planet for the first time. In the image, the Earth is rising 5 degrees above the horizon, just as the astronauts are rising up from behind the eastern (as viewed from Earth) part of the Moon. Although the Moon looks close enough to touch, it's actually about 484 miles (779 kilometers) from the spacecraft.

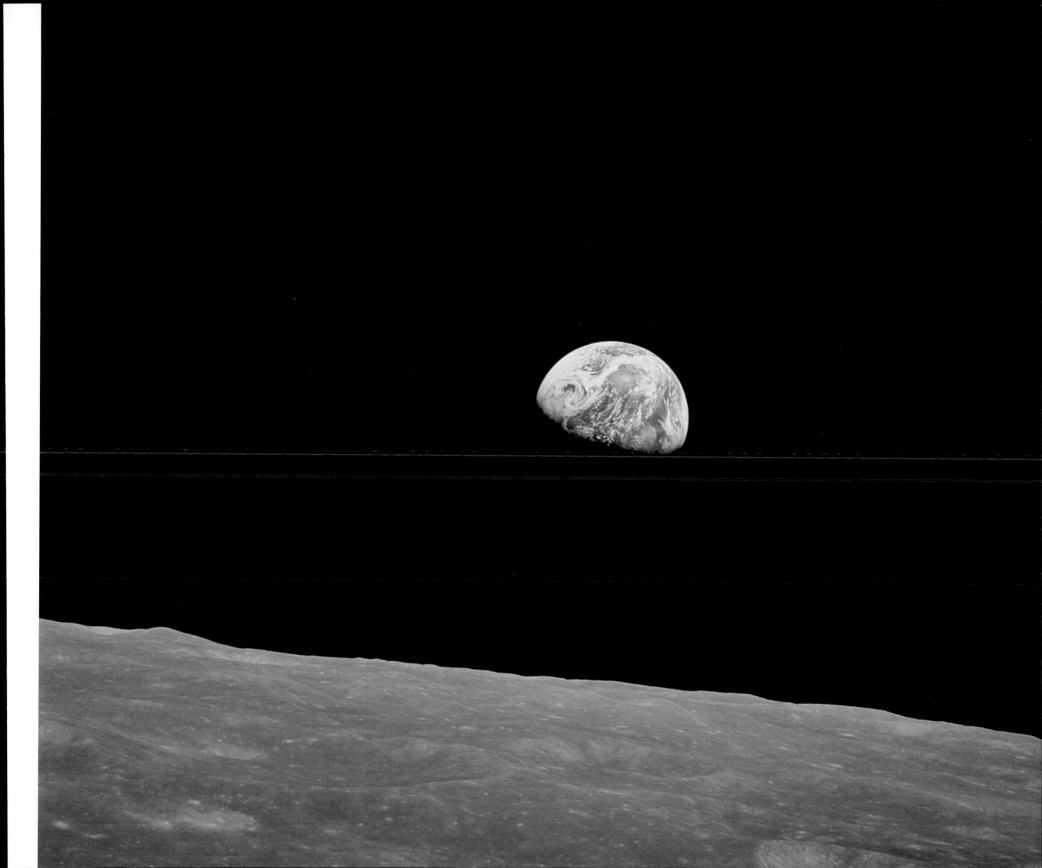

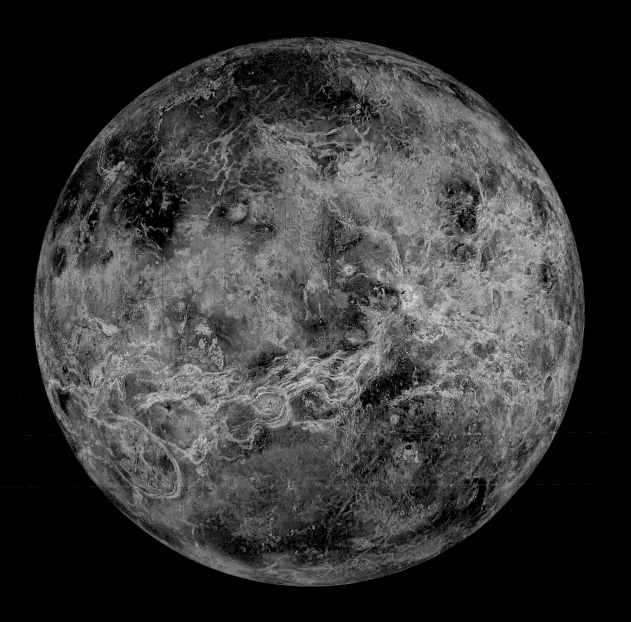

HEMISPHERIC VIEW OF VENUS

This colorful hemispheric view of Venus is the result of over a decade of radar investigations by the *Magellan* spacecraft, which was sent to the planet in 1990. *Magellan*'s photos eventually captured over 98 percent of the planet, and this mosaic of images (which includes imagery from the Earth-based Arecibo radar) is color-coded to mark elevations. *Magellan*'s images revealed that the surface of Venus is relatively youthful, somewhere between three hundred and six hundred million years old. Because Venus has no plate tectonics, it rarely experiences topographical shifts, and the planet is believed to completely resurface its crust once every few hundred million years.

A CLOSE LOOK AT MERCURY

Taken on October 6, 2008, during the second flyby of Mercury by the spacecraft MESSENGER (an acronym for MErcury Surface, Space ENvironment, GEochemistry, and Ranging), this image offers us one of the closest glimpses of the planet nearest to the Sun. Below the center of the image, we can see the crater Kuiper. In addition to capturing new information about the planet's magnetic field, MESSENGER's flybys detected charged particles in Mercury's exosphere, an area of the atmosphere where molecules are so far apart that they are more likely to make contact with the planet's surface than with each other. Mercury's exosphere consists mostly of material from the planet's surface, which is kicked up by solar radiation, solar winds, and vaporized meteoroids. There are no Hubble images of Mercury because the planet is too close to the Sun; light from the Sun would destroy the telescope's sensitive optics and electronics.

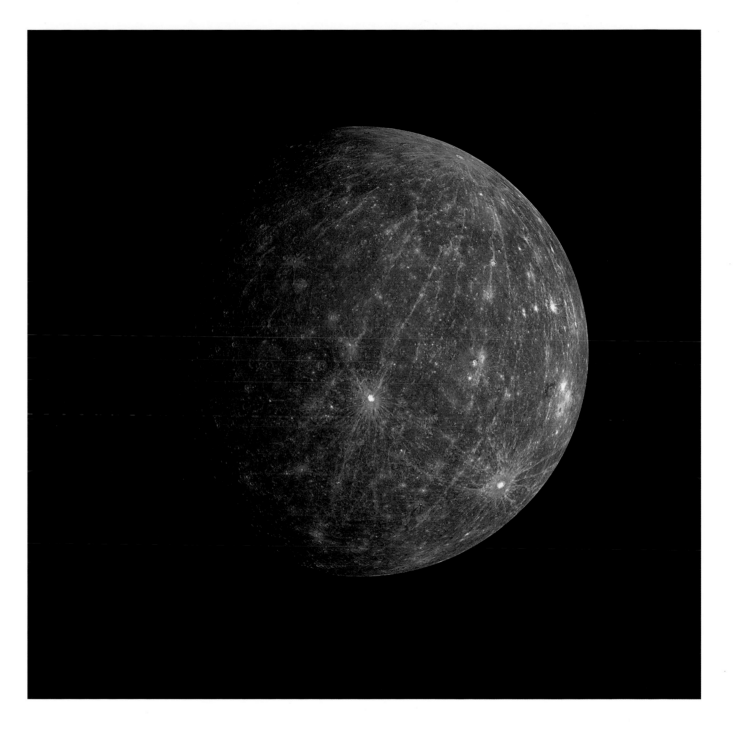

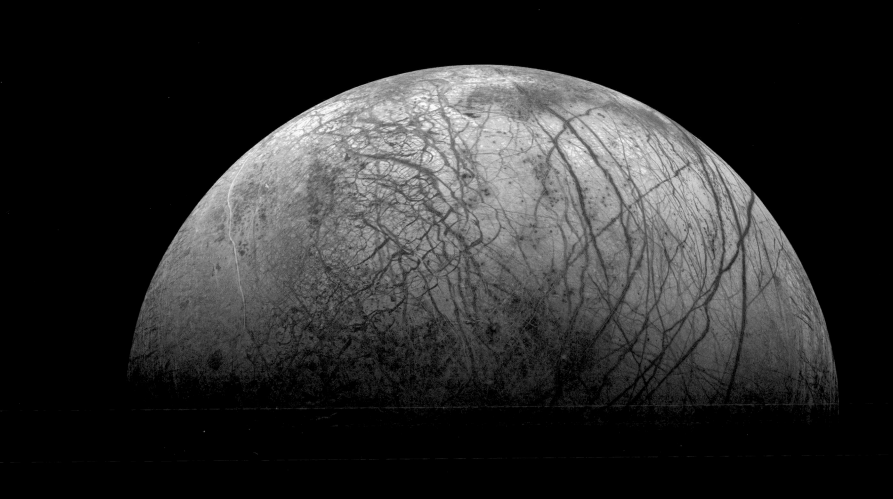

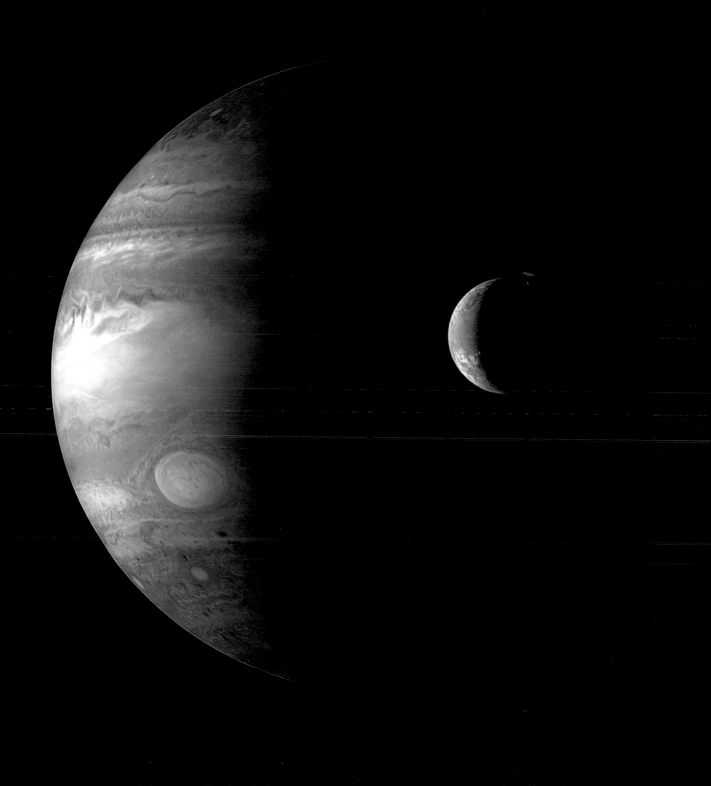

[*left*]

EUROPA

This gorgeous reprocessed color image, created from a combination of images taken through near-infrared, green, and violet filters, was captured by NASA's *Galileo* spacecraft in the late 1990s. Here, a large area of Europa, Jupiter's fourth-largest moon, is visible at a high resolution, with a color profile that approximates how Europa would appear to the human eye. The bluish-white areas show us where there is pure water ice, while reddish-brown indicates non-ice regions. Although Europa is mostly smooth, with few to no changes in altitude, crater impacts have caused cracks and ridges in the moon's ice crust. Jupiter's powerful gravitational force has warmed up Europa's interior considerably, melting the moon's subsurface ice and creating a salty ocean that may be close to sixty-two miles (one hundred kilometers) deep, making it twice as voluminous as Earth's liquid water. Scientists believe that it's possible that there is life on Europa, but most likely only in the form of microorganisms that subsist near thermal vents on the ocean floor.

[*previous page*]

JUPITER AND IO

This elegant montage of Jupiter and its moon Io was created from images taken by the *New Horizons* spacecraft in February and March 2007. The image of Jupiter is an infrared composite (blue reveals high clouds, while red shows clouds deeper in the planet's atmosphere). The bluish-white oval in the image is the Great Red Spot—a high-pressure storm raging far above most of Jupiter's clouds. The image of Io is a true-color composite that reveals an enormous eruption on Io's right side in the volcano known as Tvashtar. The intense tidal forces on Io (the result of the gravitational pull of Jupiter's moons Europa and Ganymede) make it the most volcanically active entity in our solar system, with volcanic plumes reaching as high as 190 miles (300 kilometers) above the moon's surface.

[*right*]

RINGED SATURN

On October 10, 2013, the *Cassini* spacecraft took this image of Saturn, which gives us an intimate view of the planet's sunlit northern hemisphere. While *Cassini* images taken in 2004 offered bluish renderings of the northern hemisphere, the 2013 images show us the region with a more golden color, even as the northern pole remains bluish due to wintry weather patterns. Saturn's current orbit offers *Cassini* a detailed view of its poles, rings, and magnetic environment. The rings of the planet comprise billions of particles, from tiny dust motes to mountainous boulders. These rings are thought to be chunks of comets, asteroids, and shattered moons.

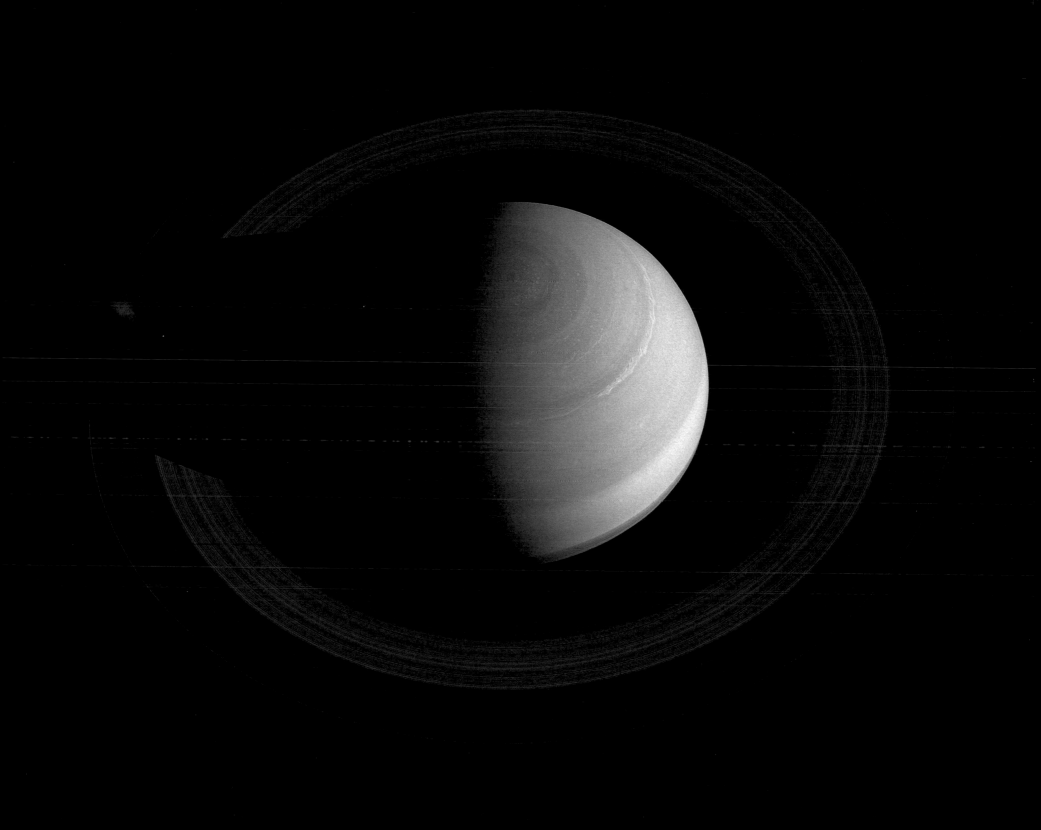

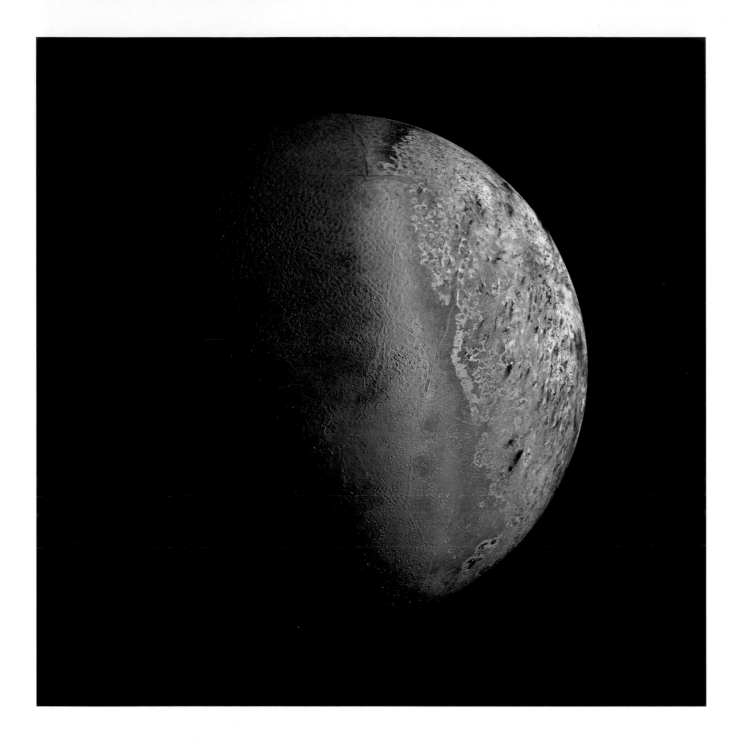

[*left*]

NEPTUNE'S MOON

This detailed image shows Triton, Neptune's only moon. Both moon and planet are roughly 4.5 billion years old, and Triton has a retrograde rotation, meaning it orbits in the direction opposite Neptune's rotation. The surface of Triton is mainly flat, with a few rocky canyons and geyser-like eruptions. Scientists believe that Triton was originally an object in the Kuiper belt, a region beyond the planets comprising stray vestiges of the solar system's formation.

[*right*]

BLUE NEPTUNE

This composite image of the eighth planet from the
sun was taken in August 1989 by *Voyager 2*. Captured
4.4 million miles from the planet, the center of
the image reveals Neptune's Great Dark Spot—a
storm that was first recorded in 1989 and lasted for
roughly five years—and a series of fast-moving clouds.
Scientists believe that the giant gaseous planet was
initially formed at close proximity to the Sun before
gradually drifting to its present position.

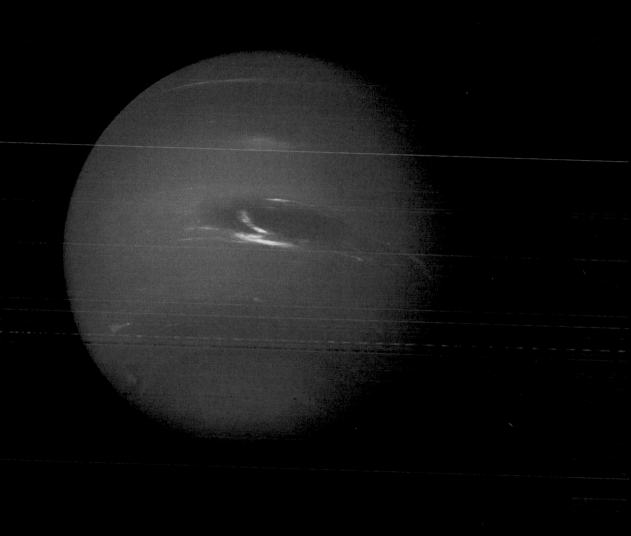

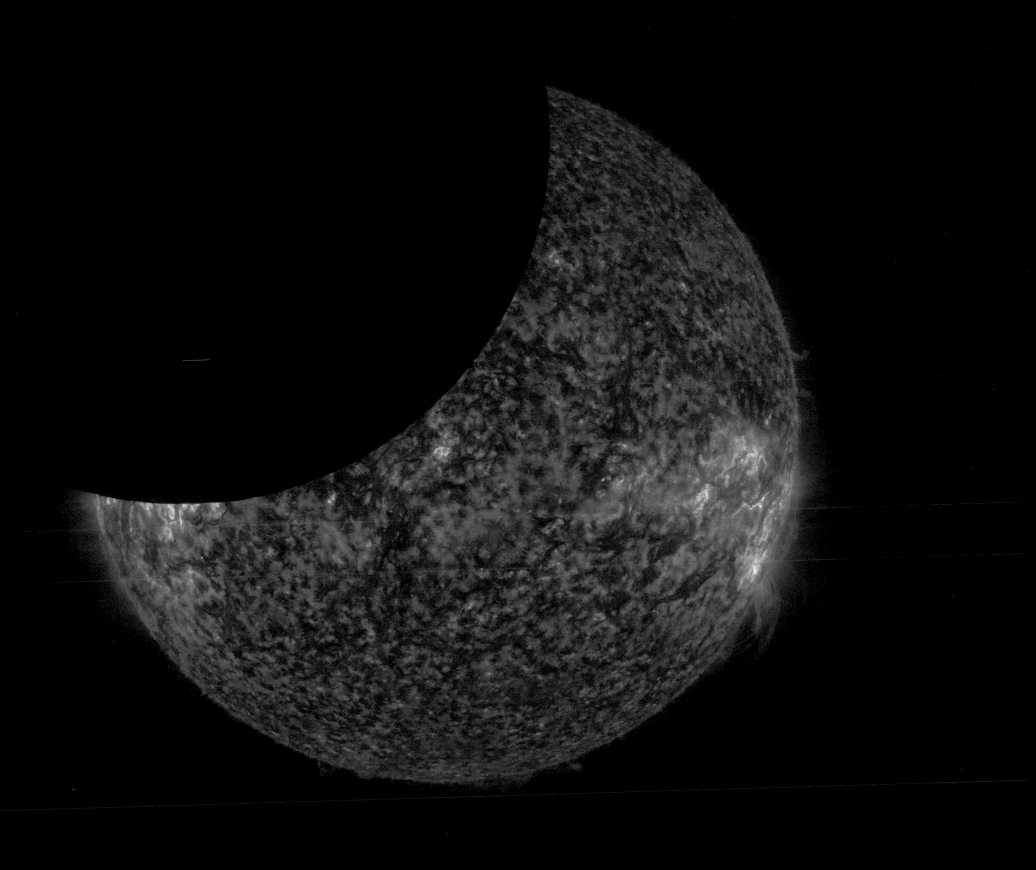

SOLAR ECLIPSE

On January 30, 2014, NASA's Solar Dynamics
Observatory (SDO) took this photograph of a partial
solar eclipse, as the Moon transited between SDO and
the Sun. Solar eclipses occur two to three times per
year, and this was the lengthiest one on record, lasting
for two-and-a-half hours. The Moon's horizon appears
clear; this is because it has no atmosphere to distort
the Sun's blazing light. It's particularly valuable for
SDO to witness the Moon's passages during an eclipse.
When scientists observe the degree of blackness of the
lunar disc, they can measure and compensate for stray
light that inhibits a telescope's capacity to detect space
dynamics more clearly. Ideally, the lunar disc should
be observed as entirely black, but indirect light makes
its way into the telescope.

CONVECTIVE ZONE
OF THE SUN

The convective zone, the outermost third of the Sun,
contains a swirl of heat-carrying plasma (gas that is so
hot its electrons are stripped off) that surges out from
our home star. This image was taken over the course
of October 27 and 28, 2010, and it captures the
dancing, rotating mass of super-hot plasma in a forty-
eight-hour entanglement with the Sun's magnetic
fields. The scene is imaged using ultraviolet filters,
and it features constant dynamic activity that would
normally be invisible to us. While most of the plasma
flows into space, the cooler and denser plasma sinks
back into the Sun and forms the fluid loops seen in
this photograph. Observing the rotating plasma can
help scientists better understand and predict solar
storms and their overall effect on the solar system.

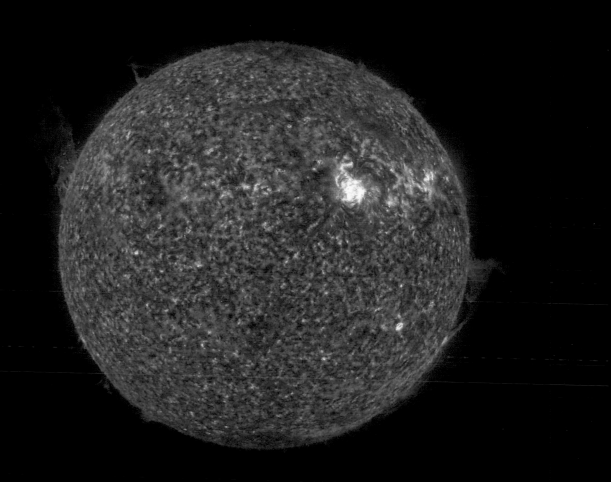

[*right*]

THE CORONA AND UPPER
TRANSITION REGION OF THE SUN

This image, captured by the Solar Dynamics Observatory (SDO) on December 31, 2013, features the corona and the upper transition region of the Sun. The corona is the Sun's outer atmosphere, and it exists thousands of miles above the visible surface of the Sun. The transition region is the area that separates the corona from the Sun's cooler lower atmosphere. In the transition region, temperatures rise dramatically away from the Sun, from thousands of degrees to millions. The corona is over a million degrees and much hotter than the Sun's surface, and it flows into the solar wind, a plasma stream that emanates from the Sun and circulates through the solar system. The corona isn't normally visible, as the Sun's surface is too bright to allow us a glimpse of the fainter solar atmosphere. SDO uses two imaging instruments, the Atmospheric Imaging Assembly and the Helioseismic and Magnetic Imager, to capture the Sun's harder-to-reach regions. Here on Earth, the corona would only be visible to us as a ghostly halo surrounding the Sun during a solar eclipse.

[*next page*]

SOLAR FLARE

This solar flare was captured on September 1, 2010, by the Skylab 3 Apollo Telescope Mount (ATM). A solar flare is a sudden and dramatic change in the brightness of a star, and it occurs when magnetic energy builds and then gradually releases. Explosions occur at different frequencies and rates, and there's no way to tell how long or intense a flare will be. They typically range from a few seconds to an hour. A solar flare also has several stages. In its most active stage, hard X-rays, radio waves, and gamma rays pulse out from the star. A solar flare cannot be seen with the naked eye, but optical, space, and radio telescopes can be used to detect them. Extremely strong flares can knock out our electrical and communications grids altogether. The light displays known as the aurora borealis (the northern lights) and the aurora australis (the southern lights), at the North and South Poles, respectively, demonstrate one of the more beautiful side effects of a solar flare. These displays of light occur when particles are stimulated in the magnetosphere, the area around an astronomical object in which energetic particles are controlled by the object's magnetic field.

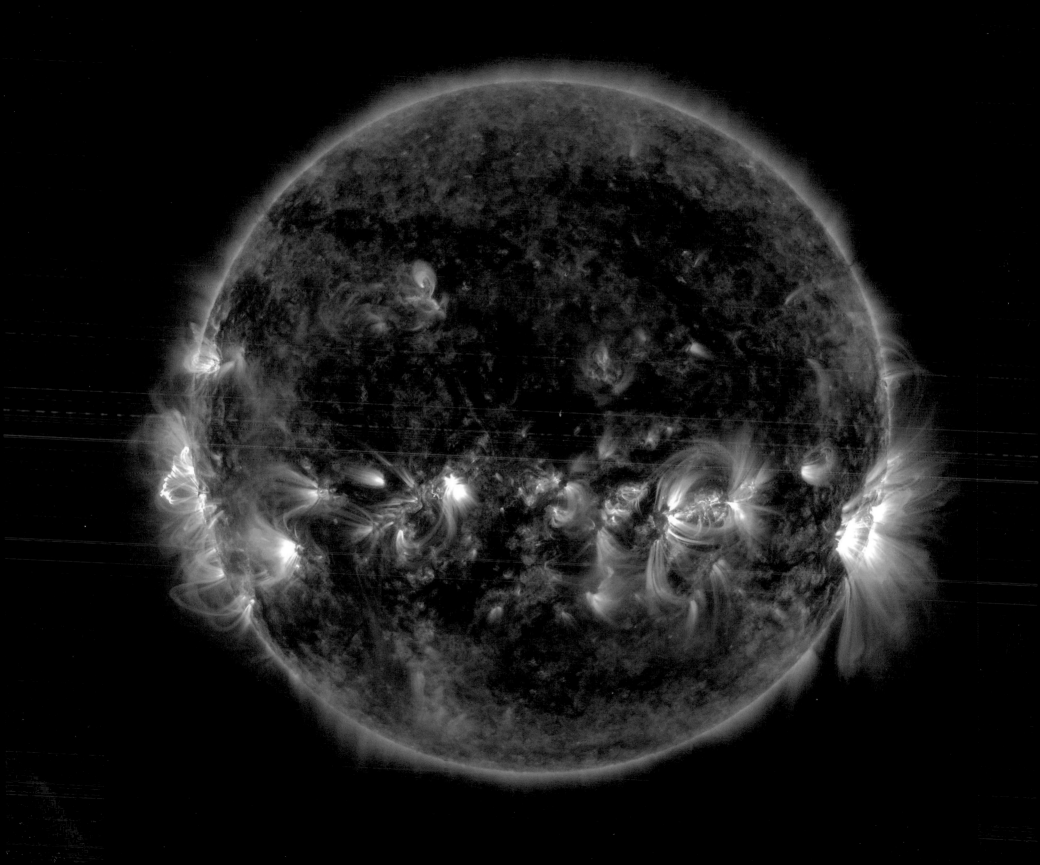

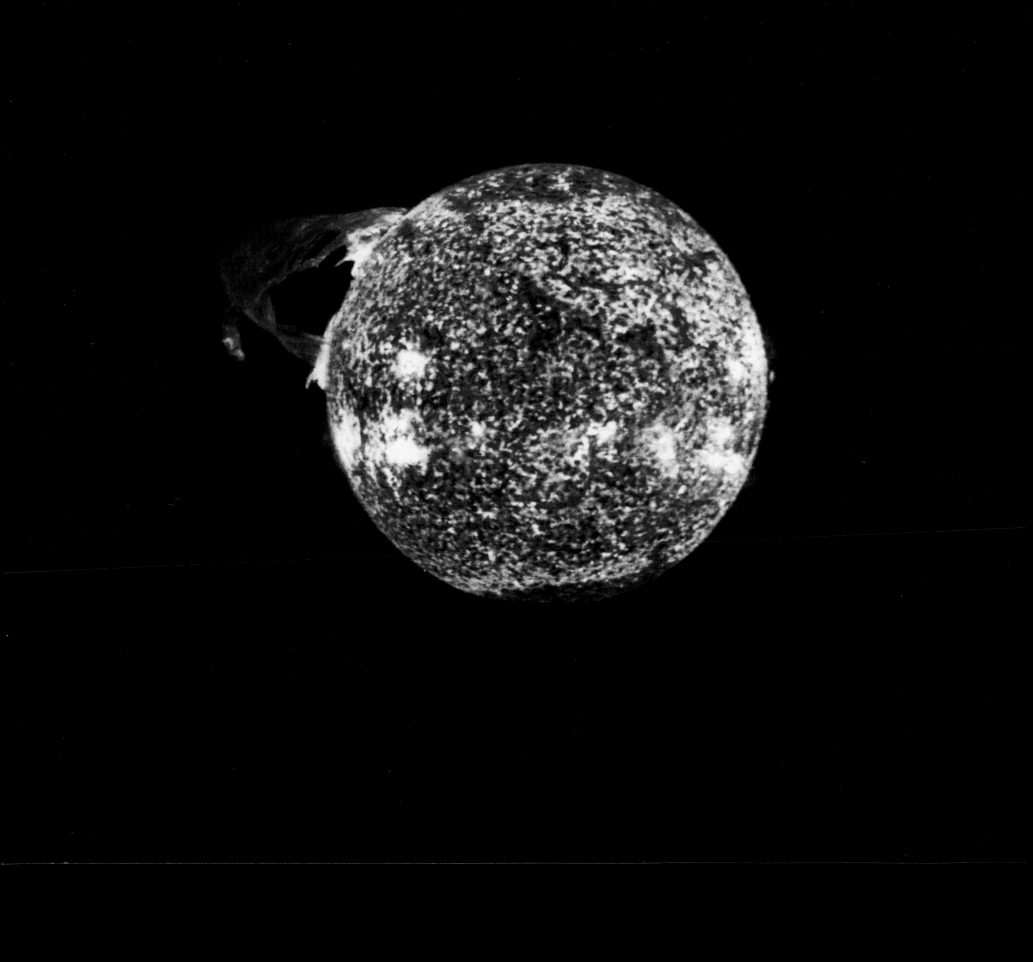

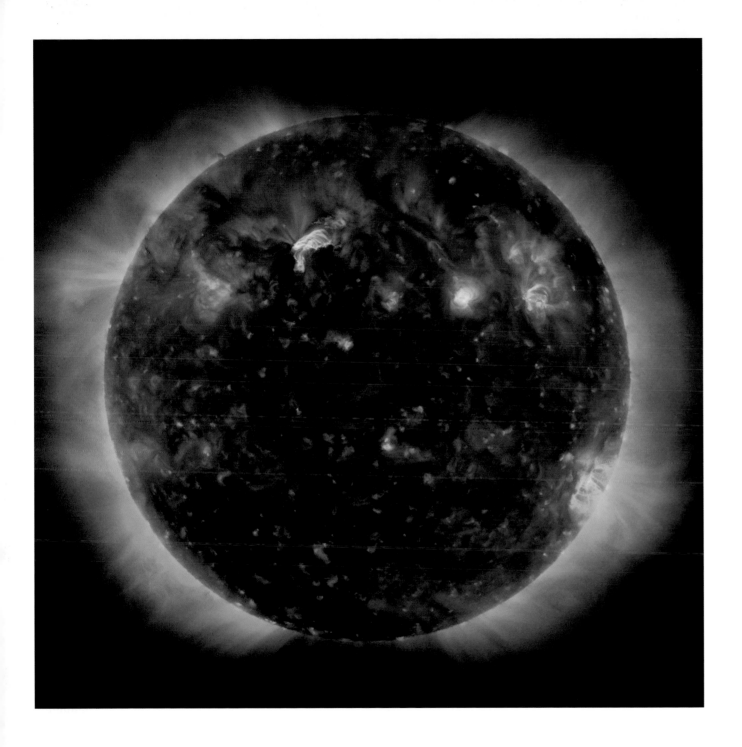

A WAVE OF SOLAR FLARES

This image, which reveals a wave pattern of solar flares across the Sun, was taken by the Solar Dynamics Observatory (SDO) in 2010. The energy from one flare alone is equivalent to millions of 100-megaton hydrogen bombs going off simultaneously, which is still less than a tenth of the energy released by the Sun in a second. In 1859, scientists Richard C. Carrington and Richard Hodgson were the first to report seeing a solar flare when they each independently noticed a gigantic flash of white light in the sky. The blue regions show us the hot surface of the Sun, while the luminous wave-like patterns represent the solar flares and their paths. A solar flare's radio and optical energies can be detected by a telescope, but its ultra-hot gamma rays and X-rays, which never make it past the Earth's atmosphere, can only be detected by telescopes in space. The Earth's atmosphere scatters shorter wavelengths of light (such as violet, blue, and green), which means that our naked eyes can only see the Sun in its longer wavelengths (such as yellow and orange). The SDO and other telescopes often use brightly colored filters to signal light (such as X-rays and ultraviolet light) that wouldn't be visible to us on Earth.

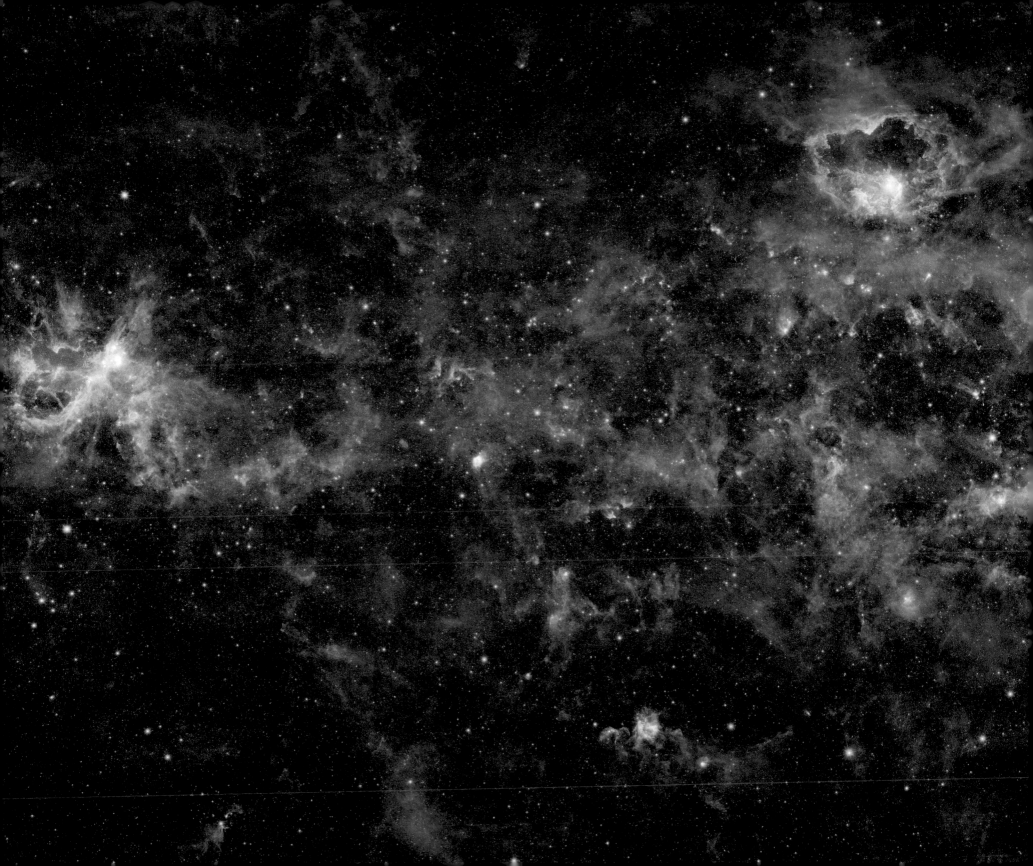

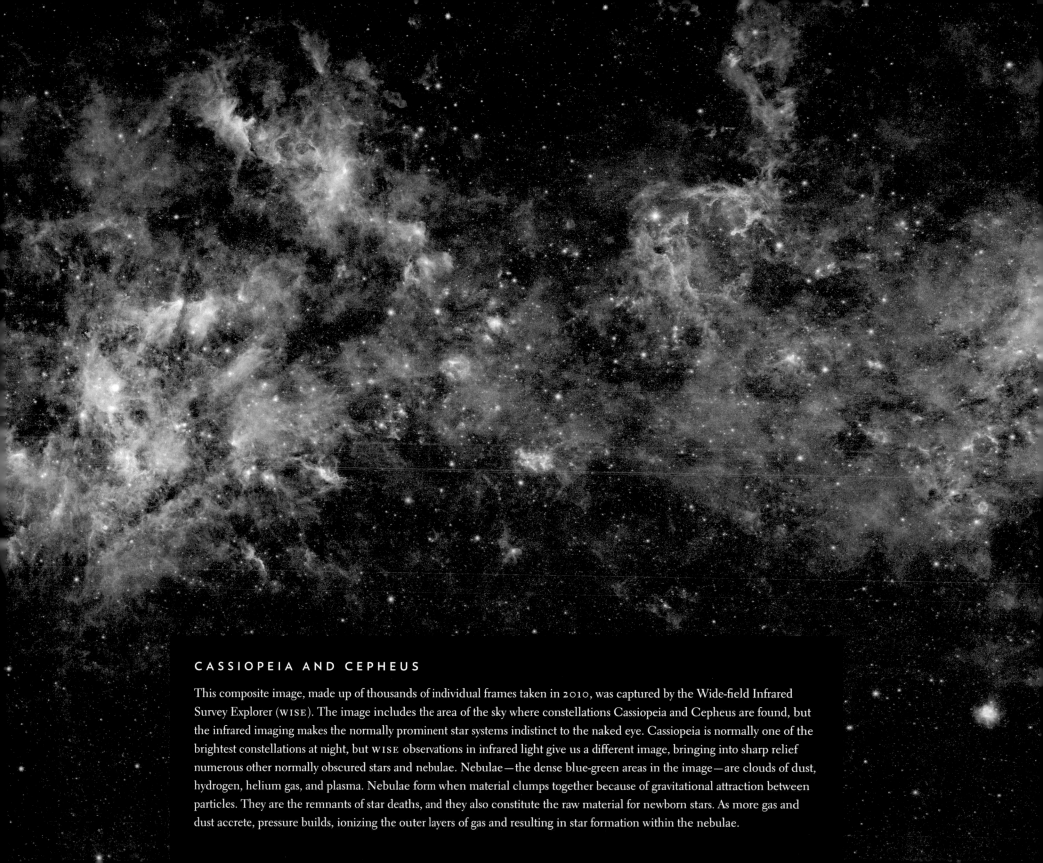

CASSIOPEIA AND CEPHEUS

This composite image, made up of thousands of individual frames taken in 2010, was captured by the Wide-field Infrared Survey Explorer (WISE). The image includes the area of the sky where constellations Cassiopeia and Cepheus are found, but the infrared imaging makes the normally prominent star systems indistinct to the naked eye. Cassiopeia is normally one of the brightest constellations at night, but WISE observations in infrared light give us a different image, bringing into sharp relief numerous other normally obscured stars and nebulae. Nebulae—the dense blue-green areas in the image—are clouds of dust, hydrogen, helium gas, and plasma. Nebulae form when material clumps together because of gravitational attraction between particles. They are the remnants of star deaths, and they also constitute the raw material for newborn stars. As more gas and dust accrete, pressure builds, ionizing the outer layers of gas and resulting in star formation within the nebulae.

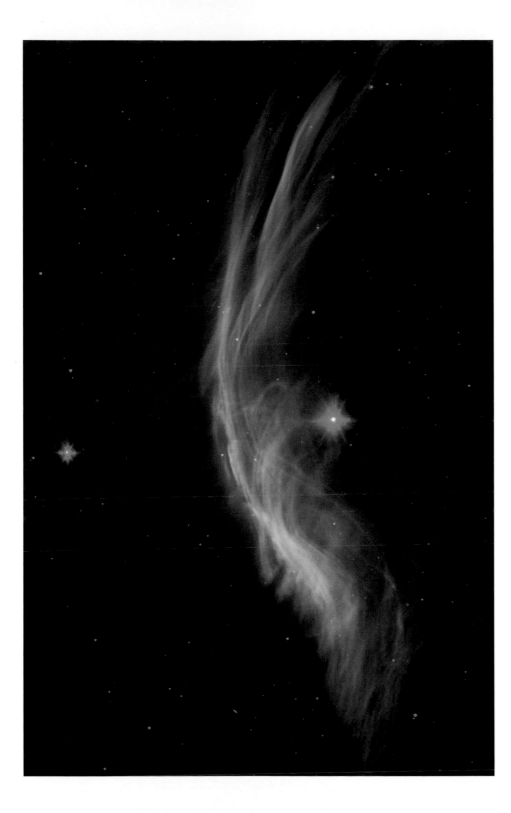

[*left*]

ZETA OPHIUCHI

This infrared image of the giant star Zeta Ophiuchi was taken by NASA's Spitzer Space Telescope in 2012. The young star is 370 light years from Earth and is twenty times more massive than the Sun, as well as eighty thousand times brighter. Zeta Ophiuchi was once believed to be part of a binary star system. When its partner died, Zeta Ophiuchi was suddenly free of the other star's gravitational field and rocketed out into space like a cannon. The star would be even brighter if it were not obscured by dust clouds. Stellar winds travel from this star at 54,000 miles (86,905 kilometers) an hour: speedy enough to break the sound barrier in the material around it. As the faster-moving winds flow out from the star, they collide with slower-moving areas of gas and dust, creating a bow shock that is only visible in infrared light. A bow shock is similar to a sonic boom, which can occur when an airplane or other fast-traveling vehicle moves faster than the speed of sound. The area around the bow shock ripples out at infrared wavelengths and creates an arc.

[*right*]

RHO OPHIUCHI CLOUD COMPLEX

This 2008 image by the Spitzer Space Telescope shows the Rho Ophiuchi cloud complex, a dark nebula of gas and dust that is 407 light years from Earth. This nebula of rich molecular hydrogen is nestled in the constellations of Scorpius and Ophiuchus. The molecular hydrogen in Rho Ophiuchi enables the formation of new stars, and X-ray and infrared studies have revealed over three hundred new stars forming in the cloud. These details of the nebula are revealed in multiple wavelengths, which can offer us precise information about the temperature and age of the stars. The youngest stars are swathed in discs of gas as they continue to form. Stars further along in their life are bluish-white and have completely shed their external blankets of gas and dust. Many of the new stars are packed into a cloud of thick, dense gas in the lower center of the image. The nebula is illuminated by the red supergiant Antares, which is forty thousand times brighter than our Sun and 520 light years away from us. The clouds in Rho Ophiuchi emit light in every known wavelength, but the gas is so opaque that the clouds appear dark, even in infrared light.

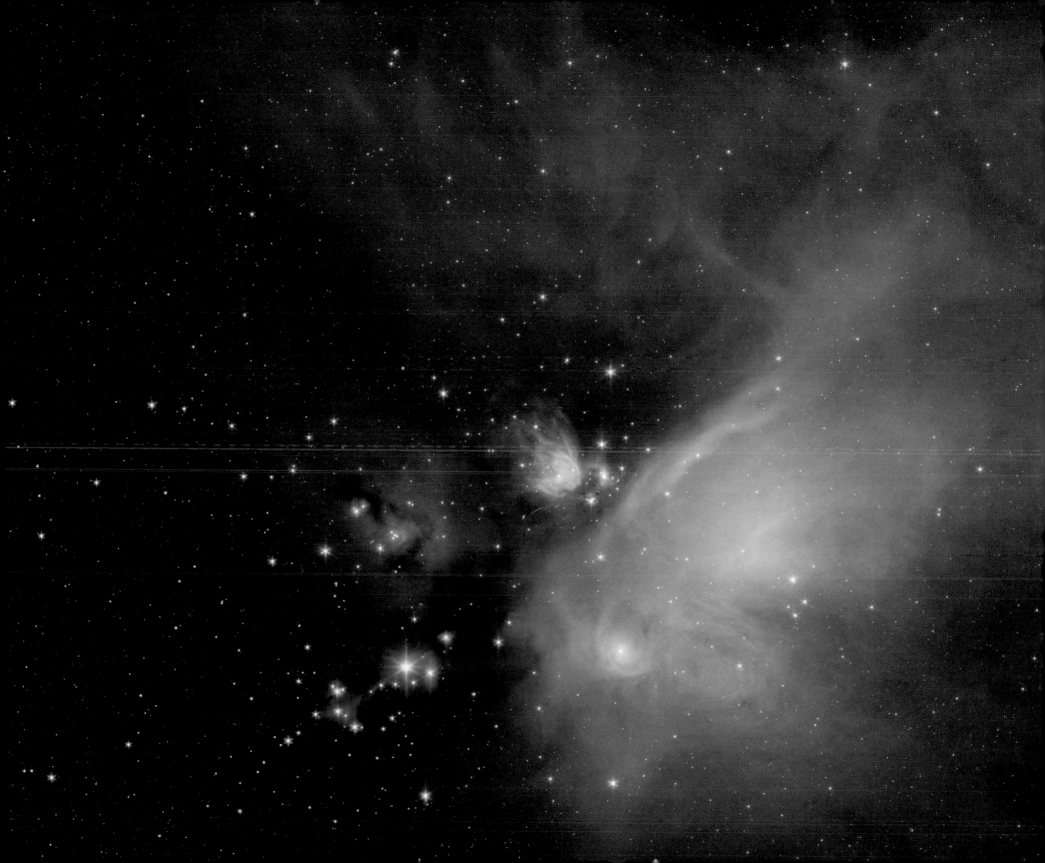

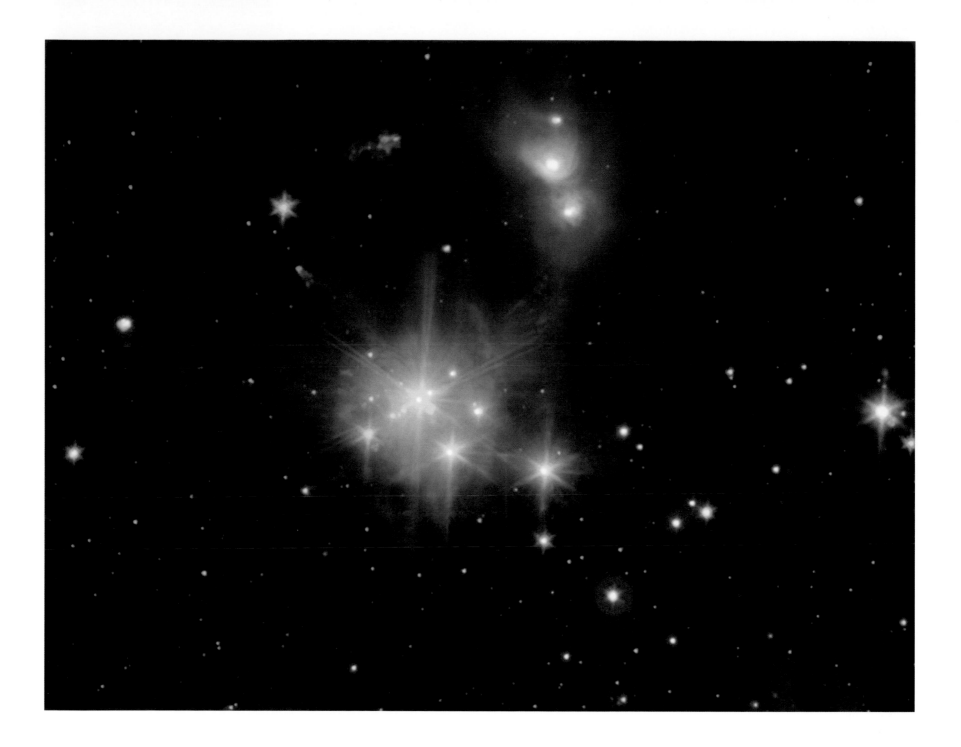

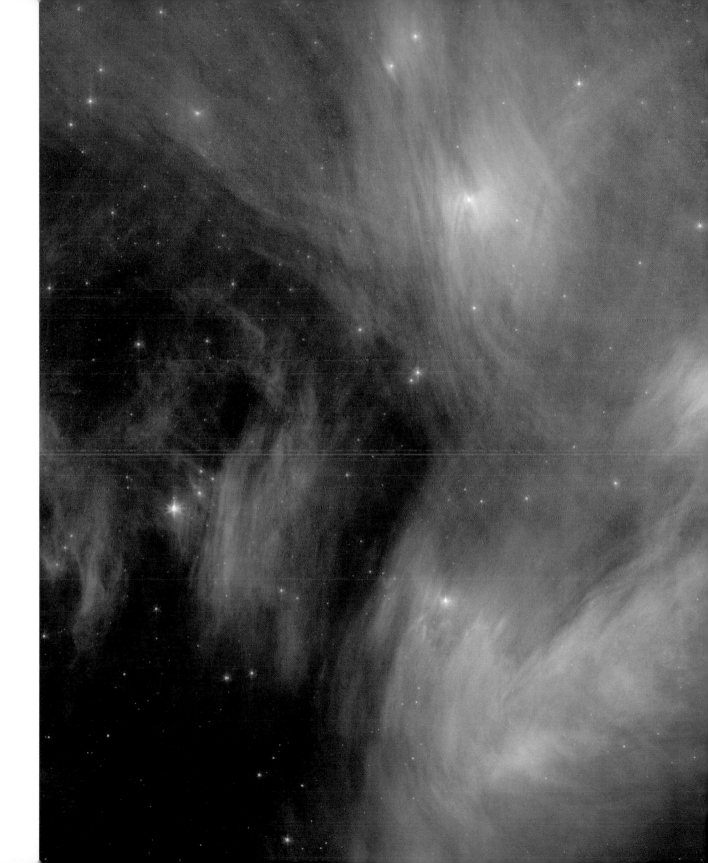

[*left*]

A STAR CLUSTER
IN CORONA AUSTRALIS

Corona Australis ("southern crown" in Latin) is an
extremely active constellation in our galaxy and can
be seen from the Southern Hemisphere. Roughly 420
light years away from us, Corona Australis contains
the Coronet Cluster, a region where new stars are
constantly born. This composite image, taken in 2007,
shows the Coronet in X-ray wavelengths, captured
in purple by the Chandra X-ray Observatory, and in
infrared wavelengths, captured in orange, green, and
cyan by the Spitzer Space Telescope. By studying the
region at different wavelengths, scientists hope to better
understand the evolution of very young stars.

[*right*]

THE PLEIADES

This image featuring the Pleiades star cluster (also
known as the Seven Sisters) was captured in 2007
by the Spitzer Space Telescope. Scientists estimate
that the Pleiades contains somewhere between
250 to 500 stars. The poet Alfred, Lord Tennyson
famously described the Pleiades as "glittering like a
swarm of fireflies tangled in a silver braid," which
perfectly captures the beauty of the intricate filigree
of dust and stars pictured here in yellow, green, and
red. A diaphanous veil of dust surrounds the stars,
which are 400 to 500 light years away in the Taurus
constellation. The stars in the Pleiades are only a
hundred million years old, much younger than our
five-billion-year-old Sun, which is believed to have
once been part of a similar constellation of stars before
setting out on its own cosmic journey. The photo also
reveals infrared imagery of brown dwarfs, extremely
small and cool stars, which tend to be very faint when
viewed in optical light.

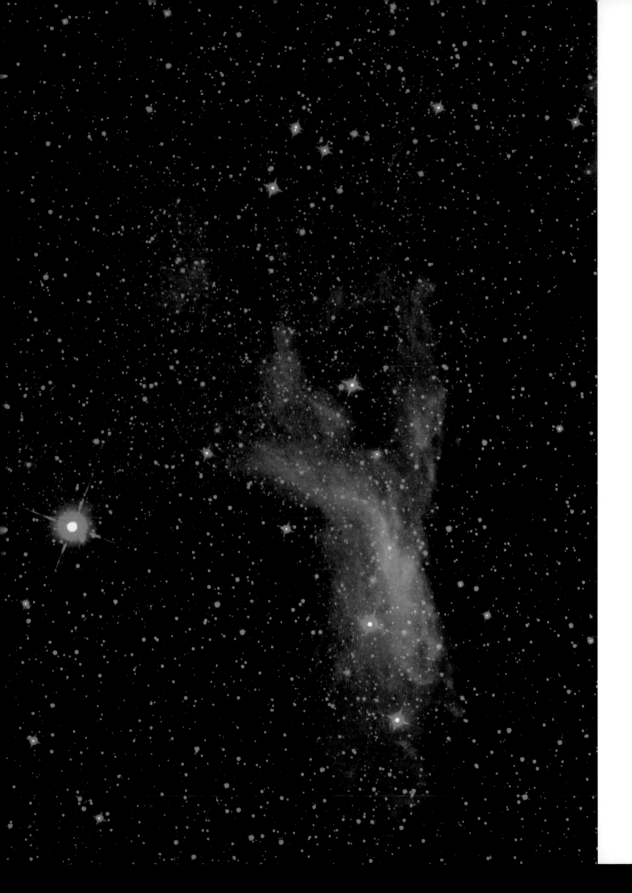

[*left*]

REFLECTION NEBULA

A reflection nebula is visible only because of light that shines upon it from a nearby source. This infrared view of the reflection nebula DG 129 was taken by NASA's Wide-field Infrared Survey Explorer in 2010. DG 129 is in the constellation of Scorpius and is roughly 500 light years away. It's often viewed by astronomers as an arm and hand rising out of cosmic darkness.

[*right*]

COMET DUST IN HELIX NEBULA

The Helix Nebula, which appears like a giant eye, lives in the constellation Aquarius, about 695 light years from Earth. It's known as a planetary nebula. This misnomer emerged from early astronomers who discovered planetary nebulae but mistook them for planets, since they were roughly the same color, size, and shape of Uranus and Neptune. The Helix Nebula was created from material expelled by a dying star. When a stars runs out of hydrogen fuel for fusion reaction, it uses helium instead. When the helium runs out, the star dies and leaves behind a white dwarf, a small but extremely dense and hot body of gas, visible here as a tiny white dot in the center of the picture. Outer shells of gas blown out as the star dies coalesce with other gas and dust clouds to create nebulae. In this image, captured by the Spitzer Space Telescope in 2010, infrared light from the outer gaseous layers is captured in blues and greens. The red in the middle of the "eye" shows the final layers of gas blown out when the star died. The brighter red circle in the center is a disc of dust around the white dwarf; it's likely that this disc was created by comets streaking around the star. When the star blew off its outer layers, its planets and comets careened into each other, creating a hailstorm of comets and planetary debris.

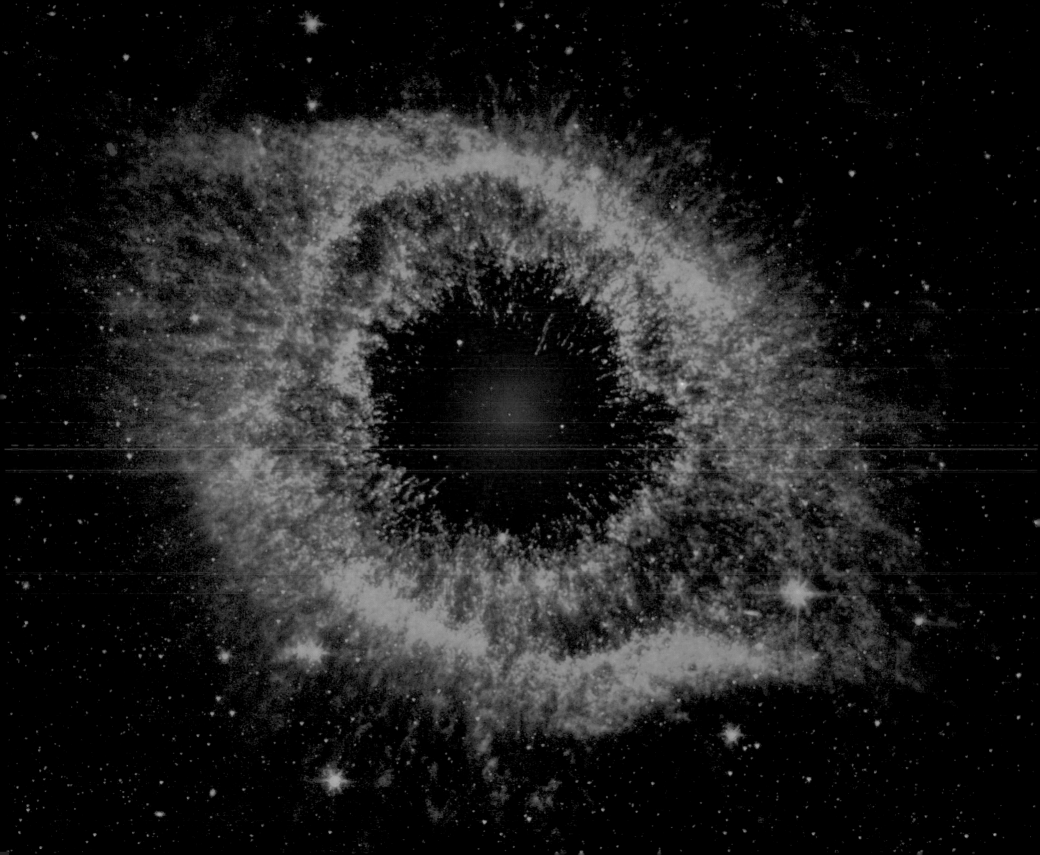

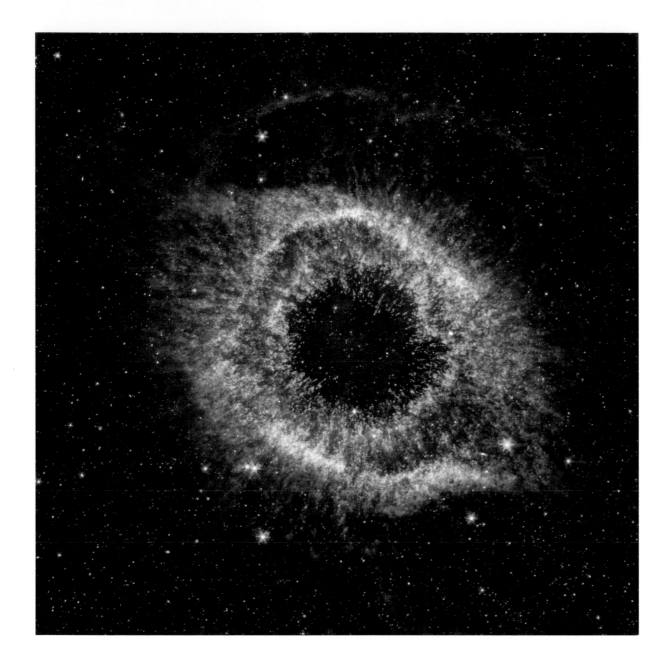

[*left*]

HELIX NEBULA: THE EYE OF GOD

In this image of the Helix Nebula, taken by the Spitzer Space Telescope in 2007, we see the picturesque remnants of a titanic star's final hurrah. The field of space we are observing here is 6 light years wide. The Helix Nebula is one of the closest planetary nebulae to us. The nebula is often known as the Eye of God because of its stunning central region. The glow of the nebula is recognizable at whatever wavelength it's being observed under, from ultraviolet to infrared.

[*right*]

THE STELLAR CORE OF THE HELIX NEBULA

NASA's Spitzer Space Telescope and Galaxy Evolution Explorer captured this image of the famed Helix Nebula in 2012. As the dying star's layers spin out into space, they give off ultraviolet radiation that is emitted from its blazing hot stellar core. The Galaxy Evolution Explorer captured ultraviolet light in blue, while Spitzer revealed an infrared trail of dust and gas in yellow. The purple center arises from the combination of ultraviolet and infrared light kicked off by a disc of dust circling the central white dwarf.

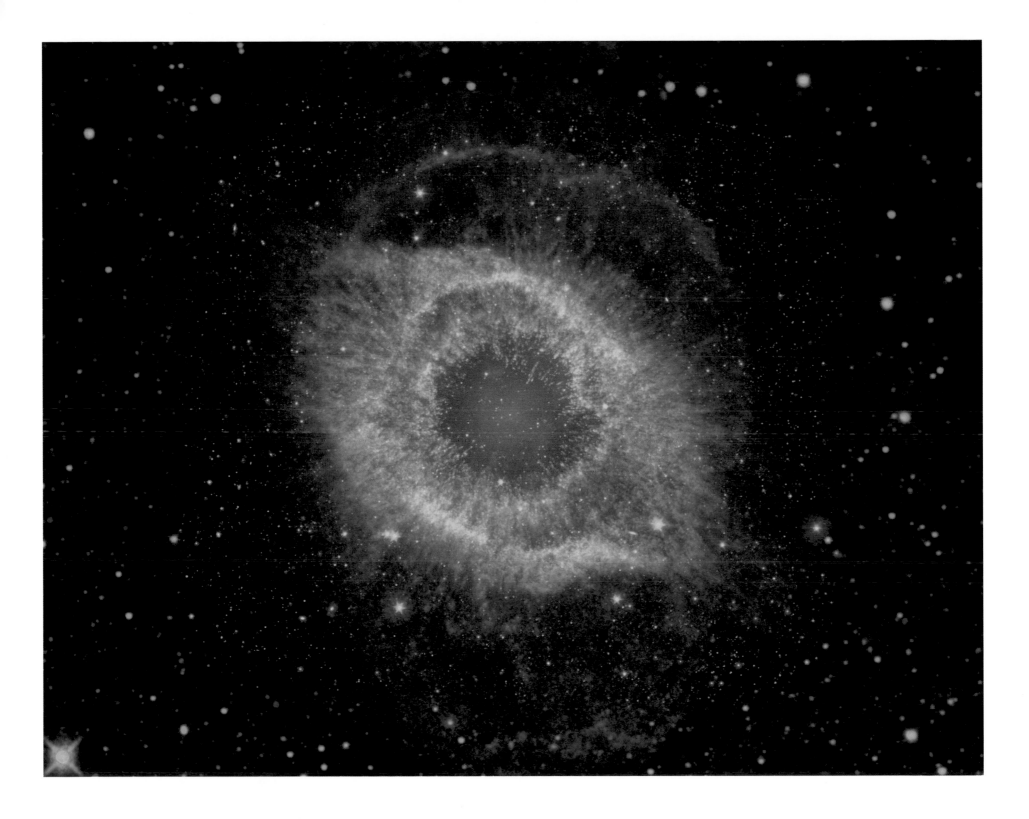

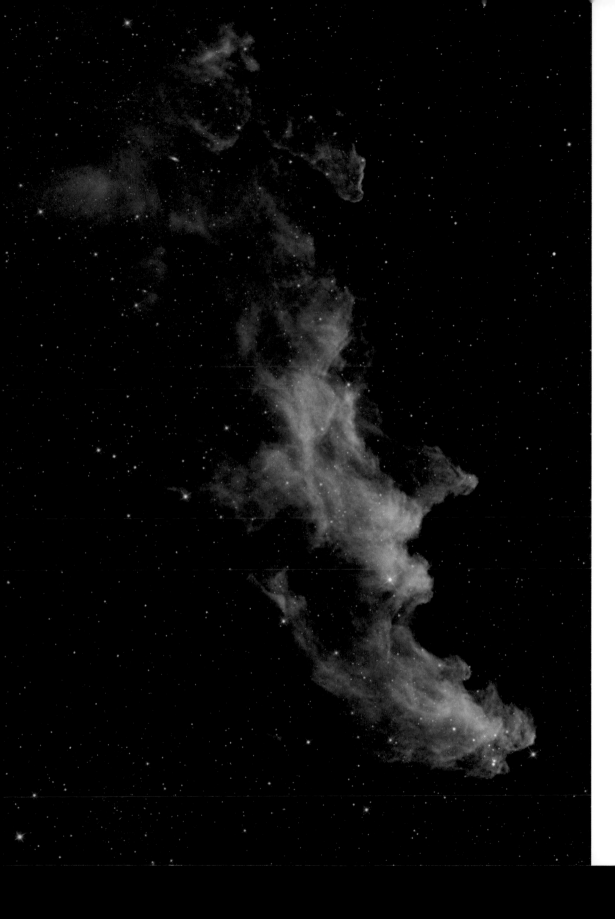

[*left*]

WITCH HEAD NEBULA

Although it's formally known as IC 2118, this nebula is more commonly called the Witch Head Nebula, as its faint outline resembles a screaming crone. This infrared portrait, taken by the Wide-field Infrared Survey Explorer and released on Halloween in 2013, captures the Witch Head Nebula's filmy demeanor, concealing the fact that the area is home to a massive star-making region. Situated in the Eridanus constellation, about 900 light years from Earth, this nebula is mainly lit by reflected starlight from the star Rigel, about 40 light years away from the nebula (and not pictured). Rigel, a blue supergiant (a hot, luminous star—larger than our Sun but smaller than a red supergiant), is the sixth brightest star in the sky and the brightest star in Orion.

[*right*]

ORION NEBULA

Over 1,300 light years away, the Orion Nebula is the bright spot—often mistaken for a single star—in the middle of the sword in the eponymous belted constellation. It's pure pandemonium in this hot molecular cloud, as the Orion Nebula is a cosmic baby-star-making factory. This is the closest star nursery to us, and it's full of more than a thousand new incandescent bodies. In this composite image, the colorful clouds observed through the Hubble's visible-light perspective are hydrogen- and sulfur-rich (visible in the primarily green and blue swirls), while the Spitzer Telescope reveals an infrared array of molecules known as polycyclic aromatic hydrocarbons (visible in red and orange wisps)—commonly found in everything from burnt toast to exhaust fumes. The exquisite halo effect stems from high-speed stellar winds pluming out from the giant stars in the center. The green and blue specks in the image are stars that were captured by Hubble, while the orange-yellow dots are infant stars captured by Spitzer.

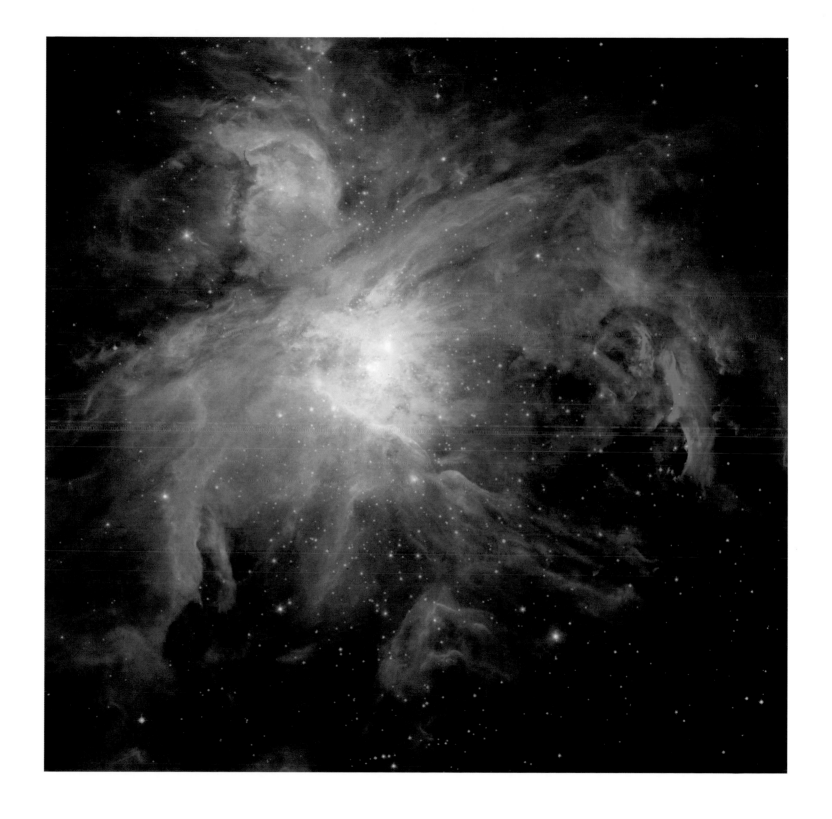

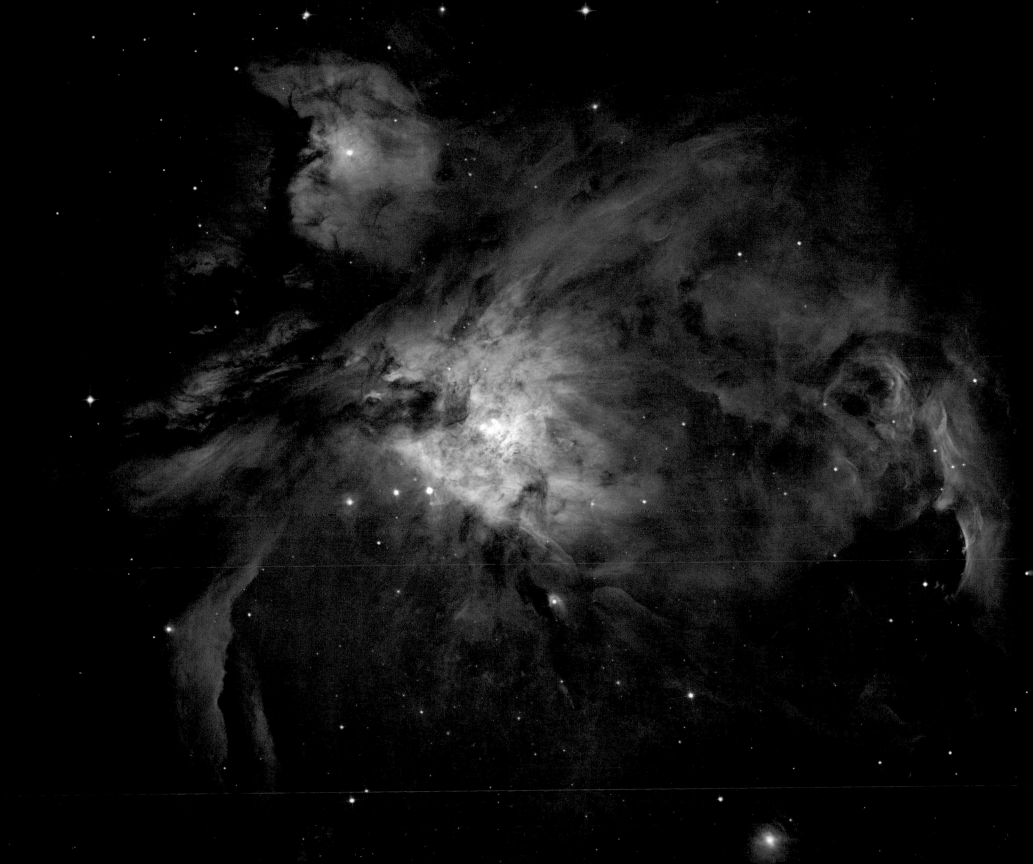

[*left*]

THE TRAPEZIUM
IN THE ORION NEBULA

This image of the Orion Nebula was formed from 520 frames captured by the Hubble between 2004 and 2005. The nebula is home to thousands of new stars, and over three thousand stars are imaged here. The stars take refuge in the nooks and crannies of a giant canyon of dust and gas. The area at the center of the nebula is called the Trapezium, which is home to some of the most massive stars in the nebula. The four primary stars that make up the cluster are known as A, B, C, and D, and they are surrounded by a halo of approximately a thousand low-mass stars similar to our Sun. The giant stars emit ultraviolet light, which inhibits the further growth of smaller stars that still have discs of gas surrounding them. An H II region (an area where star formation has recently taken place) can be seen as a bright glow in the upper left of the image. The region is being carved out by a single star's bright ultraviolet light.

[*above*]

BROWN DWARFS

Don't be fooled by the name; the faint red stars in this 2006 Hubble photograph are actually brown dwarfs, pejoratively known as "failed stars," in the Orion Nebula. The most common stars in Orion, brown dwarfs are only visible when captured in infrared light. About 1 percent the mass of our Sun, brown dwarfs are extremely small and cool stars, since they cannot sustain nuclear fusion in their cores. The image reveals nearby jets of hot gases and dust reflecting starlight from neighboring stars, which are much brighter than the diminutive brown dwarfs.

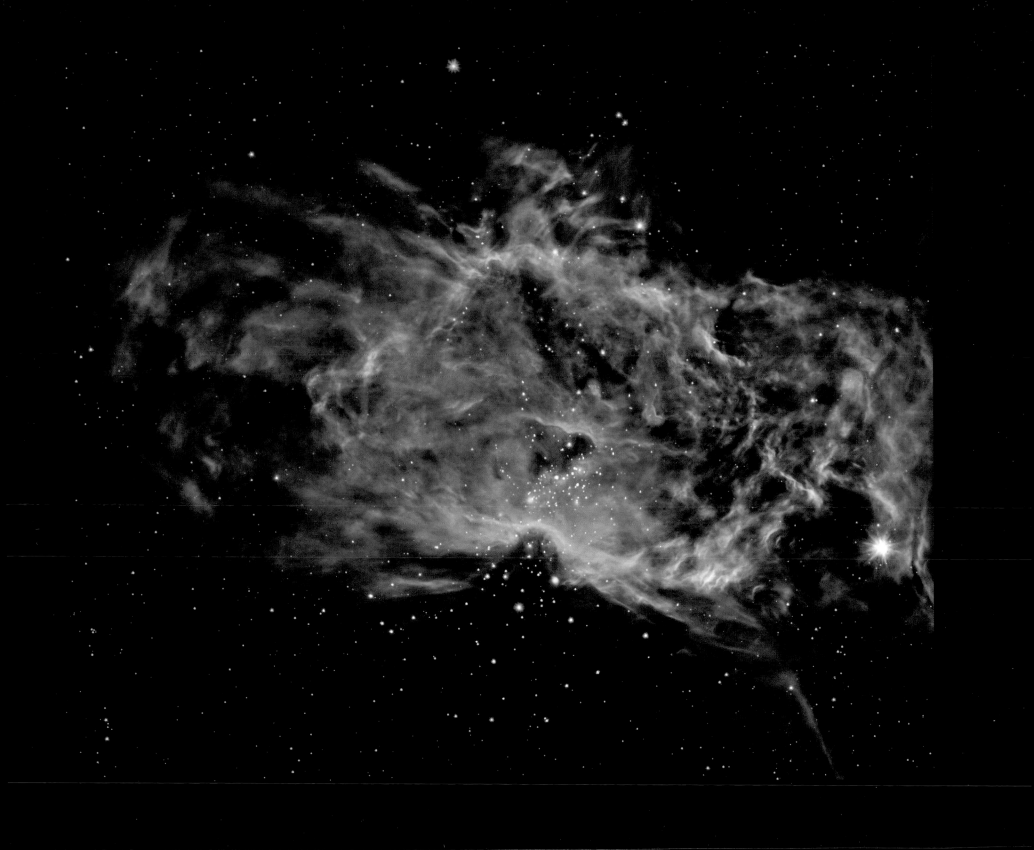

HH 110: COSMIC SKYROCKET

HH 110 is a Herbig-Haro (HH) object. HH objects are created when twin jets of gas are released in opposite directions from a new star. Although HH 110 has been compared to Fourth of July fireworks, it's more like Old Faithful—a hot geyser of gas bouncing off a cloud of molecular hydrogen about 1,500 light years from Earth. This composite image comes to us courtesy of data captured by the Hubble's Advanced Camera for Surveys in 2004 and 2005 and by the Wide Field Camera 3 in April 2011. HH objects tend to be widely varied in shape and are billions of times less dense than a typical plume of smoke from a fireworks show. Sometimes an HH object might hit a colder pocket of gas, and the result is a lot like a traffic pile-up: the gas in the front of the jet slows due to the collision, while the gas in back continues to career through. This causes temperatures to rise, while the area in the front begins to glow and resemble the front of a boat— which is why it's known as a bow shock. Measuring the velocity, position, and irregularities of the jet can provide us with valuable information about an HH object's source star. Unfortunately, scientists have been unable to determine HH 110's source star.

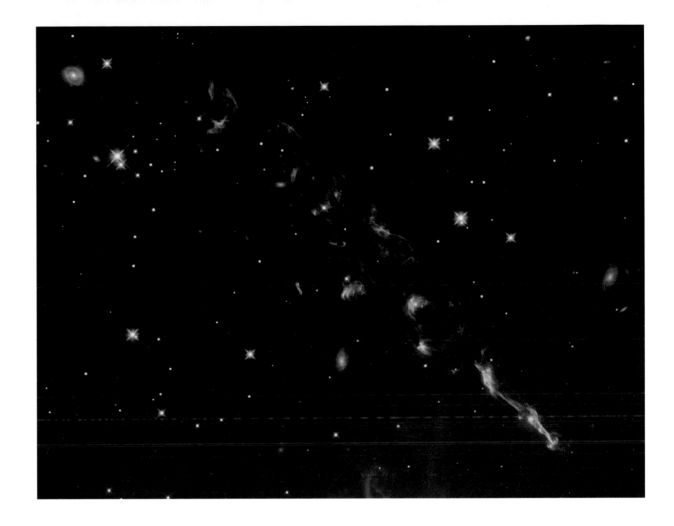

STAR FORMATION IN THE FLAME NEBULA

This stunning composite image shows us a star cluster known as NGC 2024 within the Flame Nebula, which lies 1,400 light years from Earth on the eastern edge of the Orion constellation. The Flame Nebula is lit by a star within it that is twenty times as massive as the Sun; however, the star is invisible due to dust in the nebula that makes it appear four billion times dimmer than it actually is. Captured here by NASA's Chandra X-ray Observatory and the Spitzer Space Telescope, NGC 2024 has provided scientists with valuable information about the formation of star clusters. Stars at the center of NGC 2024 are 200,000 years old on average, while those at the edges are roughly 1.5 million years old. Various theories abound on why this is so—some scientists believe that because gas in outer regions is thinner and more diffuse than it is at the center, stars are unlikely to form at the outskirts. Others have suggested that older stars gradually drift away from the center of the cluster as they age.

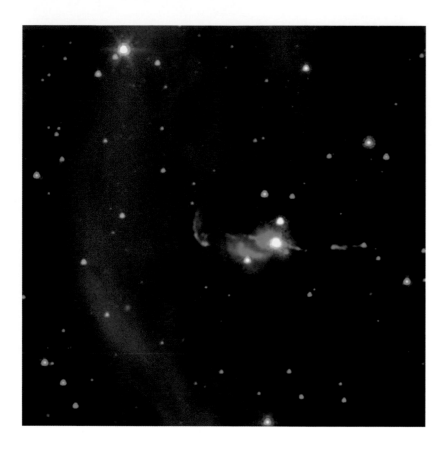

[*above*]

HERBIG-HARO 34

This image taken by the Spitzer Space Telescope in March 2012 features a small star flanked by two jets, which appear as wavy green lines extruding from the star. While the right jet was originally captured in visible light, the left jet could only be detected with Spitzer's infared technology, as the jet was hidden behind a dark cloud of dust and gas. Known as the Herbig-Haro (HH) 34 system, it's roughly 1,400 light years away in the Orion constellation. HH objects result from twin jets of gas released in opposite directions from a relatively young star. The jets themselves emerge from a gaseous sphere surrounding the new star, and HH 34's sphere has a radius of approximately three astronomical units (one unit is equivalent to the distance between the Earth and the Sun).

[*right*]

ETA CARINAE

In 2005 the Spitzer Space Telescope took this dramatic image of the vista surrounding Eta Carinae, the bright star at the center of the Carina Nebula. About 7,500 light years from Earth, Eta Carinae is a supergiant (roughly a hundred times the mass of the Sun and a million times brighter), making it one of the most massive stars in the galaxy. The surrounding nebula is sculpted by the blinding luminosity of Eta Carinae. The star's infrared light wages an assault on the nebula's dust particles, creating cavities in the material and ushering denser pillars of material back toward the star. In the image, the dust is shown in red, while hot gas glows green. In 1843, Eta Carinae shed a large portion of its mass in something known as a supernova imposter, a major stellar explosion that doesn't actually destroy its home star. Astronomers believe that Eta Carinae will ultimately go supernova in the next million years or so, as it is burning its nuclear fuel at a rapid rate.

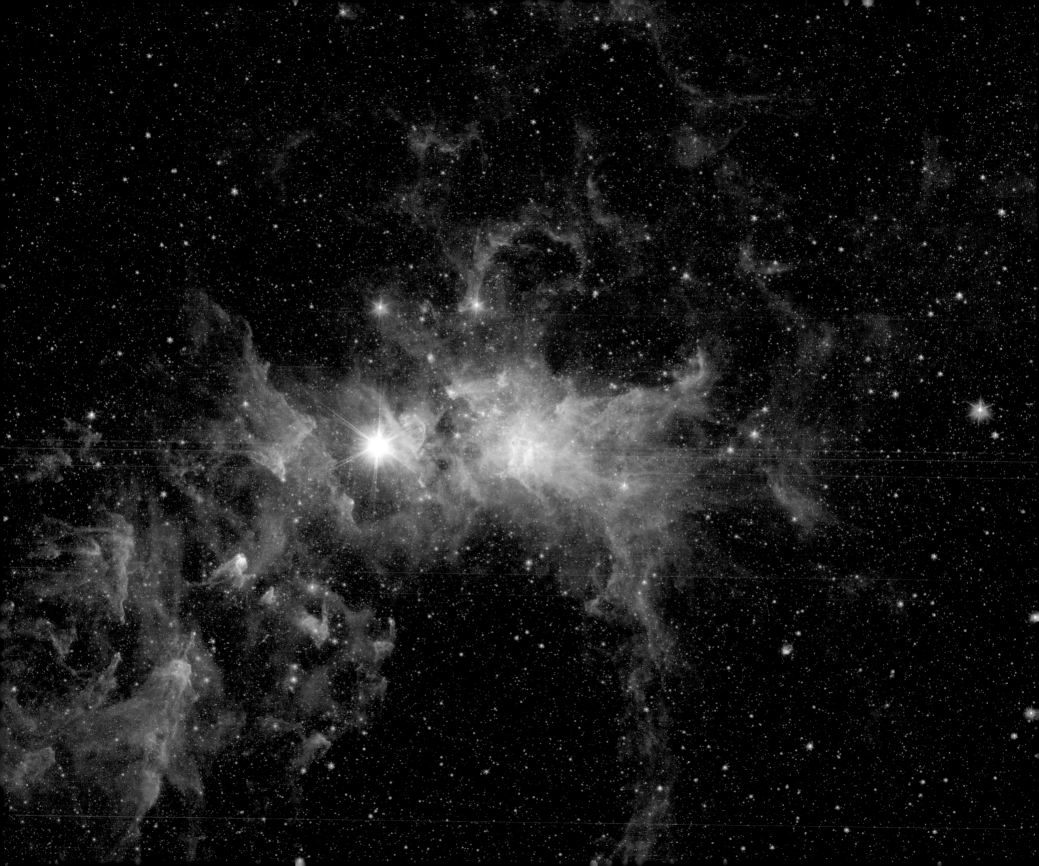

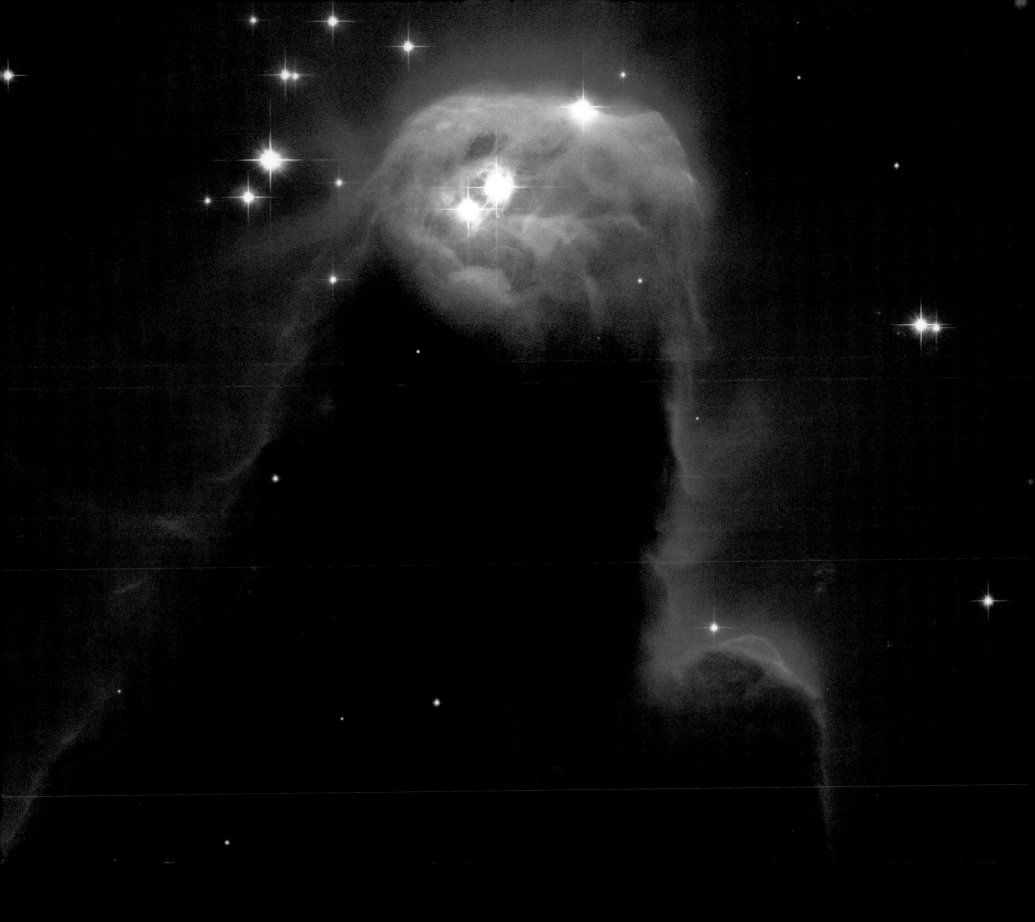

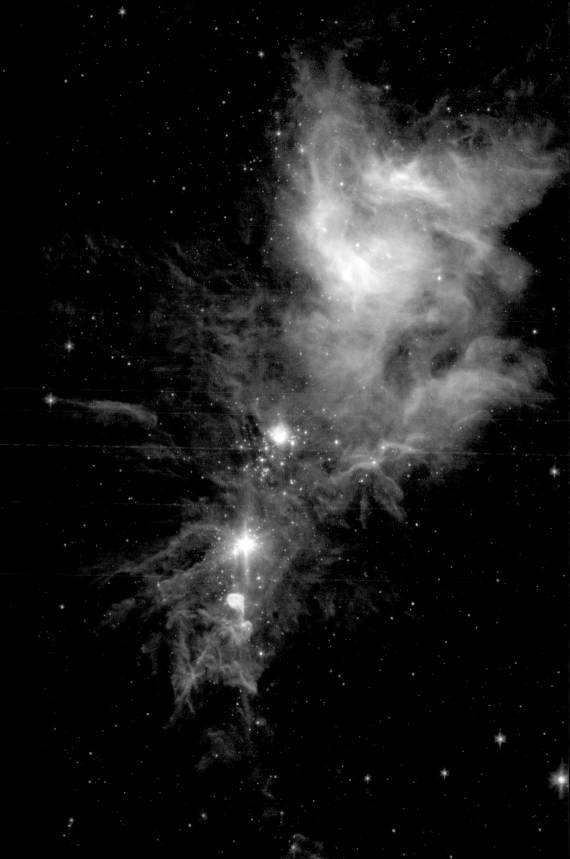

[*left*]

CONE NEBULA

The deep red emanation pictured here arose from a swirl of dust
and gas. The Cone Nebula, captured by the Hubble in 2002,
resides in a highly active star-forming region 2,500 light years from
Earth in the constellation Monoceros. The upper part of the nebula
is 2.5 light years across—equal to twenty-three million round-
trips between the Earth and Moon. The blue-white light from
surrounding stars is reflected by the dense thicket of dust while
ultraviolet light heats the cloud, causing it to glow red. Over time,
only the densest regions of the Cone Nebula will remain, while the
rest of the cloud will dissipate due to the ravages of stellar winds.

[*right*]

STELLAR SNOWFLAKE CLUSTER

This 2005 Spitzer Space Telescope image reveals the Christmas
Tree Cluster, so named because of its triangular shape, which
is found 2,600 light years away in the constellation Monoceros.
One of the Christmas Tree's most spectacular ornaments is the
Snowflake Cluster, an elegant arrangement of protostars (newborn
stars) that are obscured by thick dust—they appear pink and red
because their blue light is absorbed by the dust. The bright wisps of
green in the image are organic molecules mixed with dust, lit up by
nearby star births. The large yellowish dots that are close to the pro-
tostars in the Snowflake Cluster are enormous infant stars formed
from the same cloud. The stars are arranged almost like the spokes
of a wheel, which is a common arrangement among protostars. This
cluster is only about a hundred thousand years old, and over time,
the wheel-like pattern will be broken as the stars drift apart and
evolve. In the larger Christmas Tree Cluster, the majority of stars
aren't visible to us due to the infrared imaging of the Spitzer.

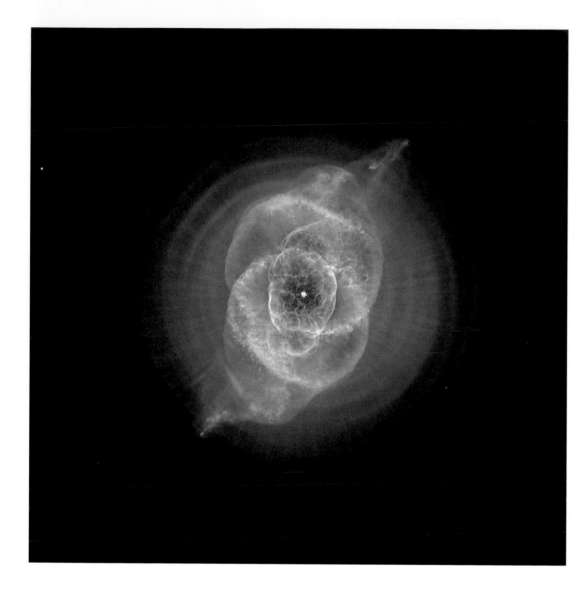

[*left*]

CAT'S EYE NEBULA

In May 2002, the Hubble Space Telescope took this image of
NGC 6543, also known as the Cat's Eye Nebula, which is 3,262
light years from Earth. This glowing space phantasm is a planetary
nebula—the result of Sun-like stars ejecting their outer gas layers.
There are many theories on what creates this distinctive visual
pattern; some scientists believe it's the effect of the central star's
magnetic activity, while others believe that the rings were later
by-products created by wave formations in the gas. Whatever the
case, scientists have observed that the nebula is rapidly expanding.

[*right*]

CYGNUS

In this image taken by NASA's Wide-field Infrared Survey Explorer
in 2011, the star-forming clouds in the "heart" of the constellation
Cygnus float through dark lagoons of night sky. The star Sadr,
1,800 light years from Earth, is a luminous yellowish spot in the
upper left portion of the image and represents the heart of the swan;
it is usually extremely bright, but the surrounding clouds cloak its
luminosity here. Cygnus is an emission nebula, heated by nearby
stars that cause it to emit visible light. There is a dark rift in the
nebula called Lynds' Dark Nebula, and the curved faint red cloud
in the mid-upper right area of the image, tucked among green gas
clouds, is known as the Crescent Nebula. If the Cygnus Nebula
were visible to the naked eye, it would appear to us as a quarter of
the size of the full moon.

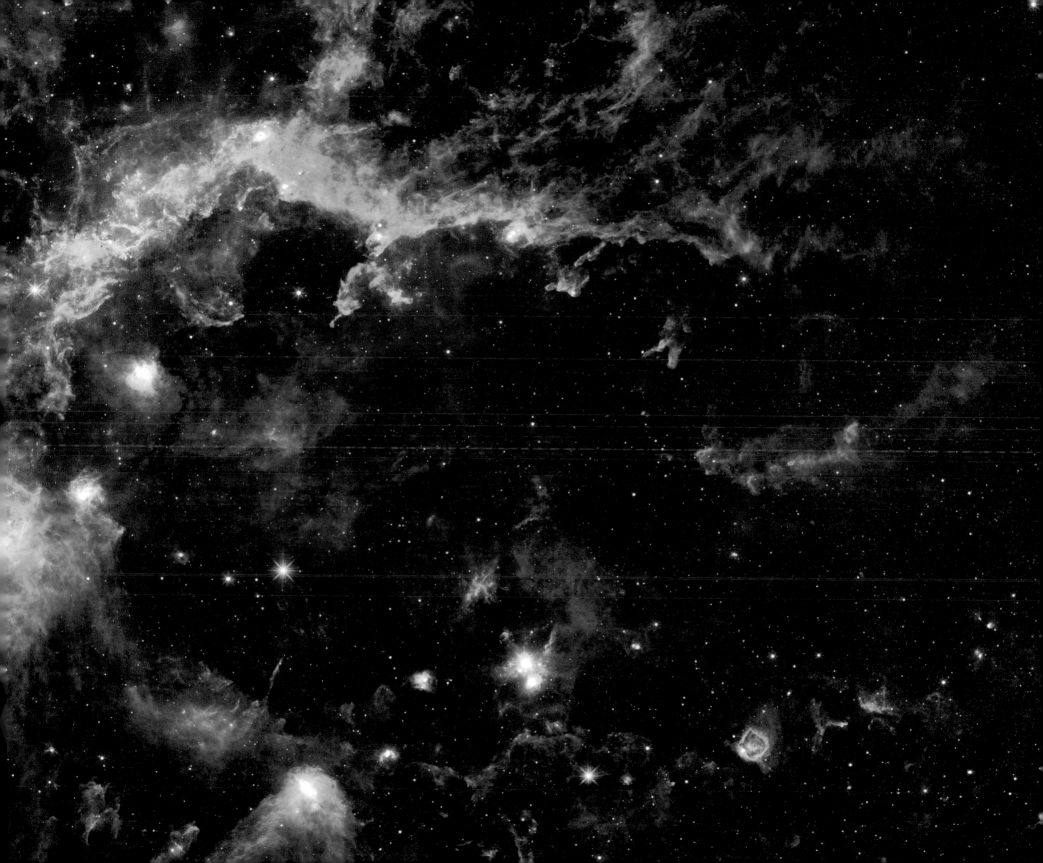

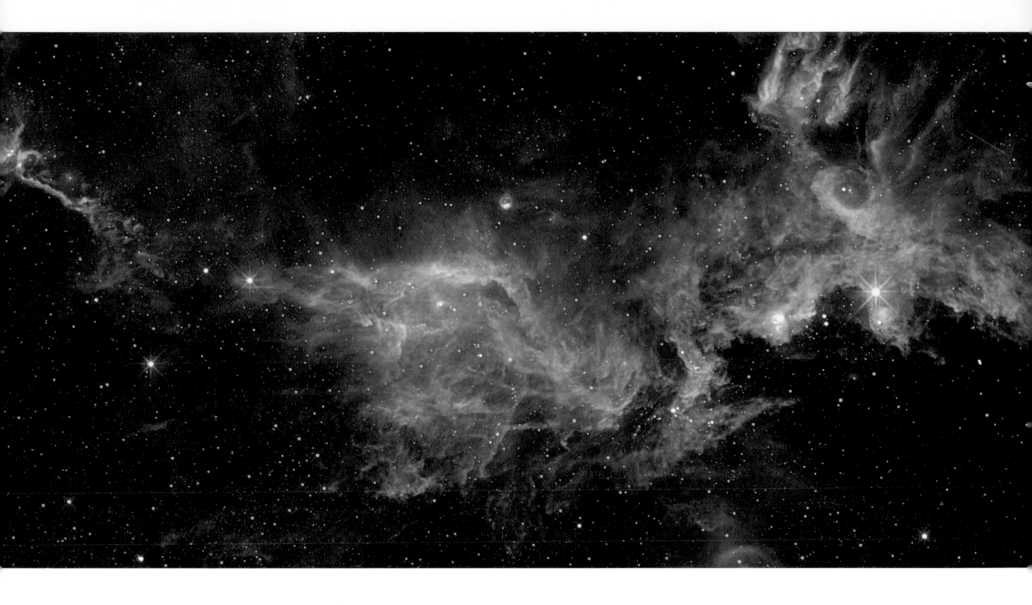

SEAGULL NEBULA

The Seagull Nebula is revealed in an infrared image taken by the Wide-field Infrared Survey Explorer (WISE) in 2010. All four infrared detectors on WISE were used to create this image, and the field of the image is seven times as wide as the Moon and three times as high. The Seagull Nebula resides 3,800 light years from Earth. Close to the seagull's "eye" in the center of the image is a cluster of stars that comprises the brightest, hottest areas of the nebula, causing the dust to glow infrared. Of course, whether or not you can see the "seagull" depends on your perspective; this infrared mosaic makes for a variety of possible interpretations.

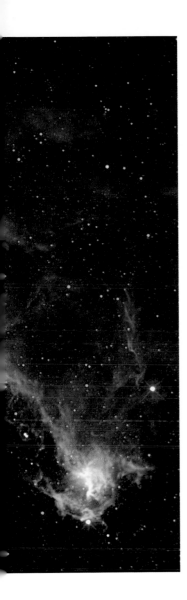

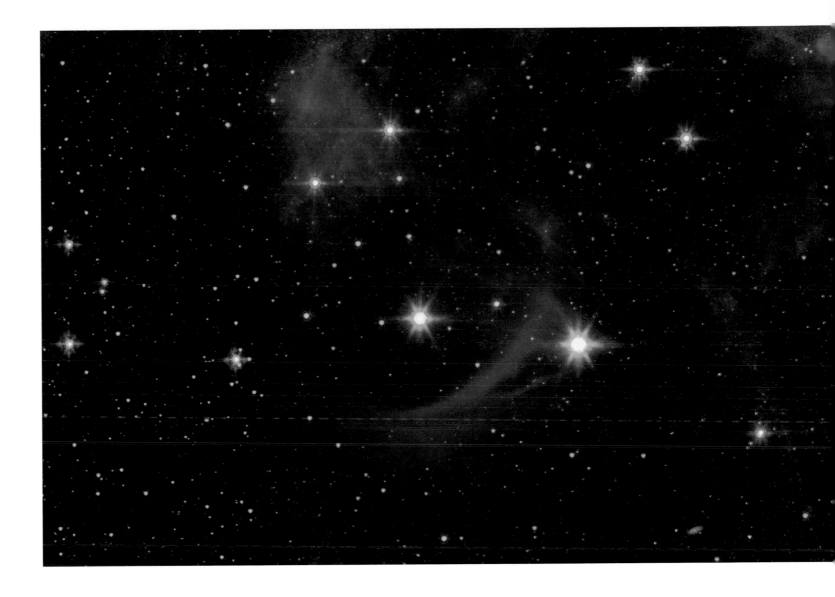

KAPPA CASSIOPEIAE

Kappa Cassiopeiae is a mammoth blue supergiant, 4,000 light years from Earth, whose velocity-fueled journey creates bow shocks as the star's magnetic fields, particle winds, and invisible gases collide. The Spitzer Space Telescope's infrared detectors registered Kappa Cassiopeiae's bow shocks (seen in red encircling the blue star), which are so impactful that they are generated 4 light years ahead of the star—that's the same distance between us and our nearest star neighbor, Proxima Centauri. Our Sun also has bow shocks, but because the Sun is more sluggish in its transit, they are virtually undetectable. This image was captured on February 20, 2014.

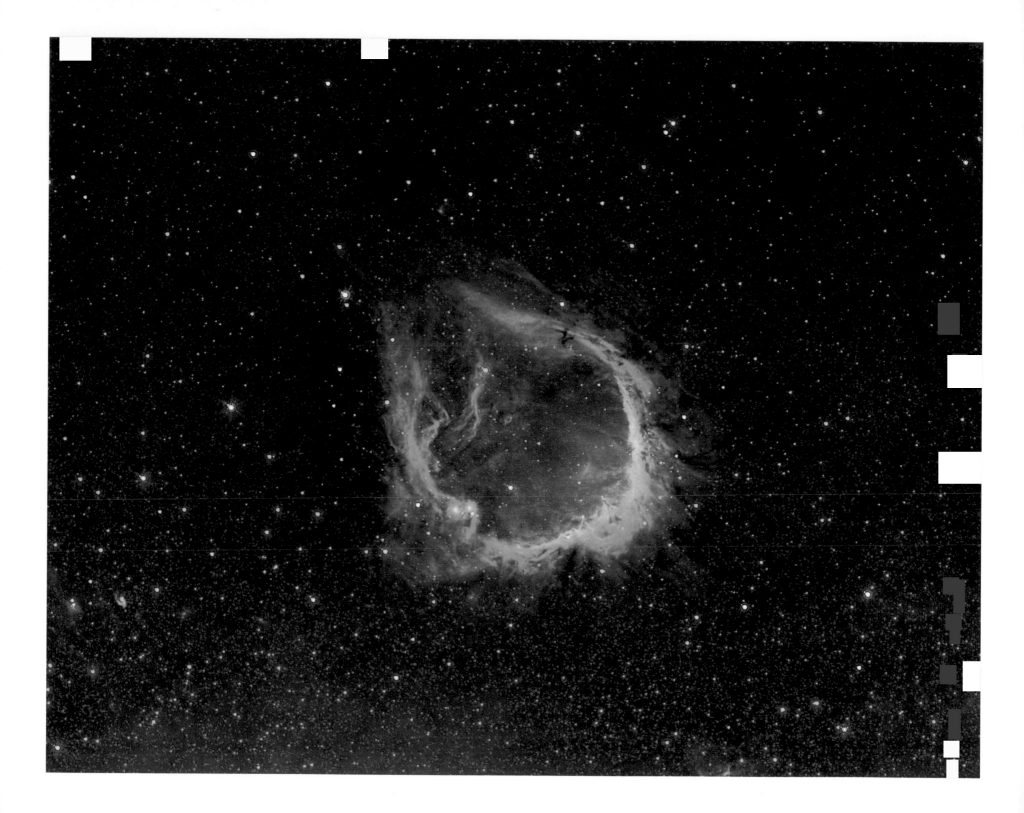

STAR BUBBLES

About 4,300 light years away, RCW 120 is a nebula in the constellation Scorpius whose verdant display is only detectable in infrared light. The glowing ring of green seen in this Spitzer Space Telescope image, captured on June 14, 2011, is common among O stars—hot, bluish-white stars that are the most massive known to us. When stellar winds collide with cosmic dust, the ring is formed around the giant star. The green region is slightly cooler than the red center, which is a hotbed of star birth and death. Star bubbles, which are areas of gas carved out by stellar winds, are so common that laypeople with telescopes can participate in charting and cataloging them, such as via the Milky Way Project—which is just one of the many public astronomy projects available through Zooniverse, a web portal that lets volunteers participate in public scientific research.

[*right*]

A CATERPILLAR OF GAS AND DUST

In this image, the caterpillar-like configuration of gas and dust is a full light year long and 4,500 light years from Earth. It gets its shape from the harsh winds of ultraviolet light streamed by neighboring O stars, which are at least 15 light years away (not pictured) and are part of the massive Cygnus OB2 star system (which is different from the Cygnus Nebula). The "caterpillar" is actually a star in its incipient stages, accreting material from a nearby envelope of gas. As it continues to collect gas and dust, the star will eventually grow to anywhere from one to ten times the size of our Sun. This approximation isn't exact because, if the ultraviolet radiation from neighboring stars blows apart the accreting pockets of gas and dust, the mass of the star might be considerably smaller than it was born to be. This image is a composite created from data from the Hubble Telescope's Advanced Camera for Surveys in 2006 and the ground-based Isaac Newton Telescope in 2003.

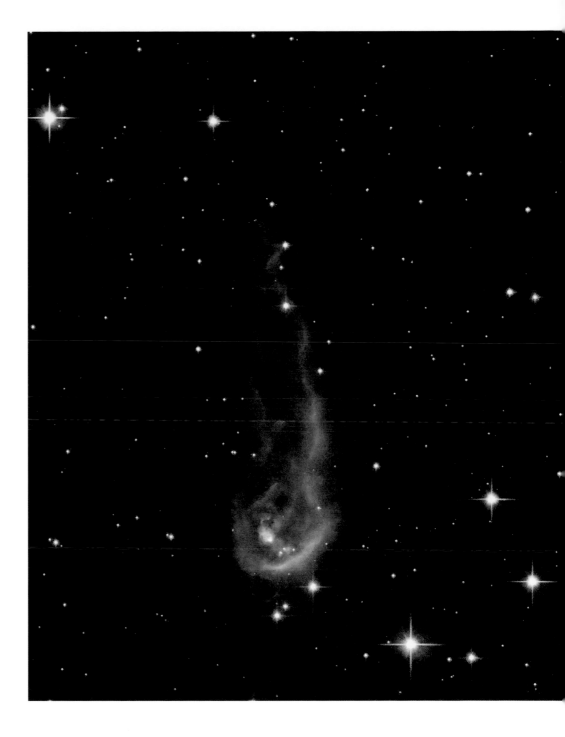

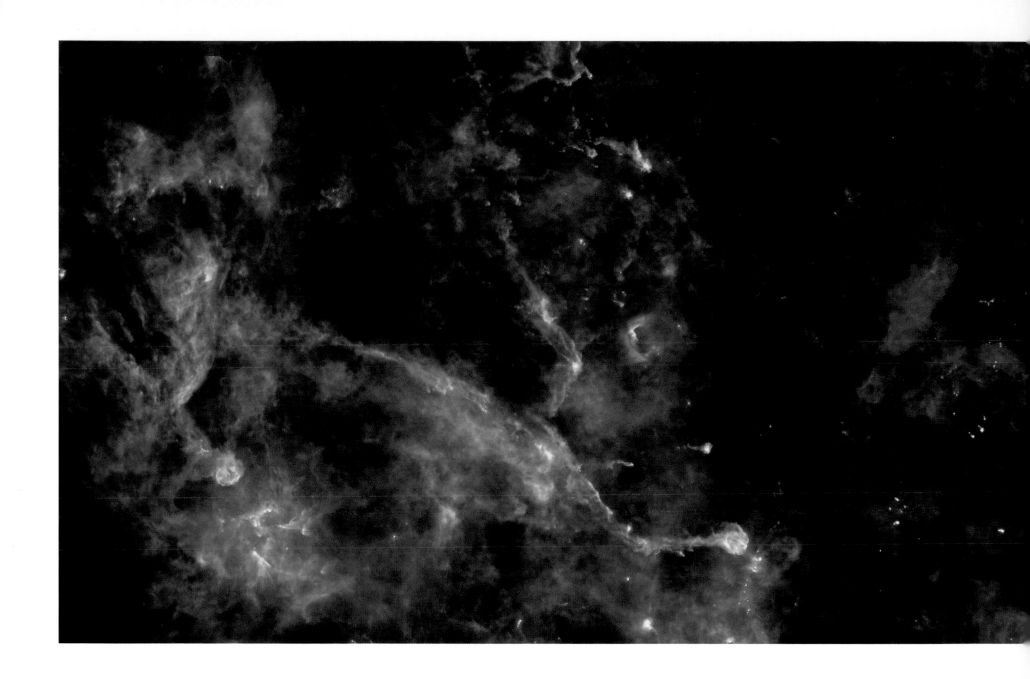

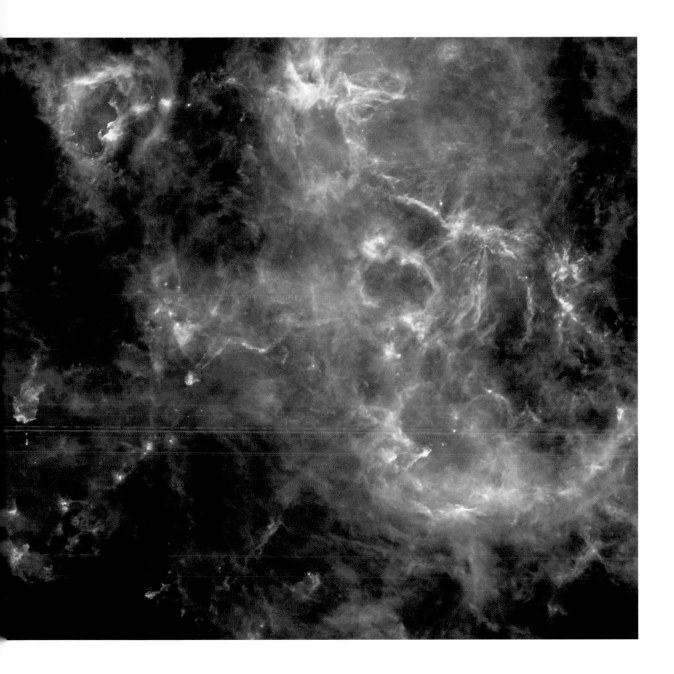

CYGNUS-X

Cygnus-X is a star-formation zone 4,600 light years from us. It's an area with a daunting number of protostars and is in close proximity to the largest molecular cloud known to us. This composite image, created from images captured by the Herschel Space Observatory on May 24 and December 18, 2010, reveals enormous clouds of gas and dust that will someday lead to the formation of new stars. Because light in the region tends to get absorbed by interstellar dust, it's easiest to study the area at different wavelengths of the electromagnetic spectrum, not merely at visible light. The Herschel has sharp vision in far-infrared wavelengths, which makes it specially equipped to study stellar nurseries like Cygnus-X in impeccable detail.

[*above*]

WHITE DWARFS

About 5,600 light years away in the constellation Scorpius, Messier 4 (abbreviated M4) offers us a captivating look at some of the oldest reaches of our universe. M4 is a globular cluster containing white dwarfs, and it includes some of the first stars believed to have been formed— about twelve to thirteen billion years ago. This image, captured by the Hubble Space Telescope in 2002, magnifies an extremely small region of the globular cluster (only 1 light year across). The bright white spots in the image are the white dwarfs, which are typically hard to detect; in fact, this image was captured over the course of 67 days, with about 8 days of exposure. Scientists speculate that the cluster took shape in the enormous halo of dust and particles that surrounded the Milky Way in its early years. The stars are tightly constricted by their gravitational pull on one another, which gives the cluster its dense, spherical appearance.

[*right*]

JELLYFISH NEBULA

At 5,000 light years away, the Jellyfish Nebula's otherworldly filaments resemble its namesake creature (although the filaments aren't as distinct in this image as they are in non-infrared images). In 2010, NASA's Wide-field Infrared Survey Explorer took this image of the nebula, which was assembled from the debris of a star that exploded five to ten thousand years ago. Color differences show us different energies and wavelengths of infrared light. The central northern shell in the picture, in violet, is radiating light from iron, neon, silicon, and oxygen gas; the smaller southern shell, in cyan, is denser and radiates light from hydrogen gas. The northern shell probably comes from a faster shock wave, while the southern shell emerged at slower speeds.

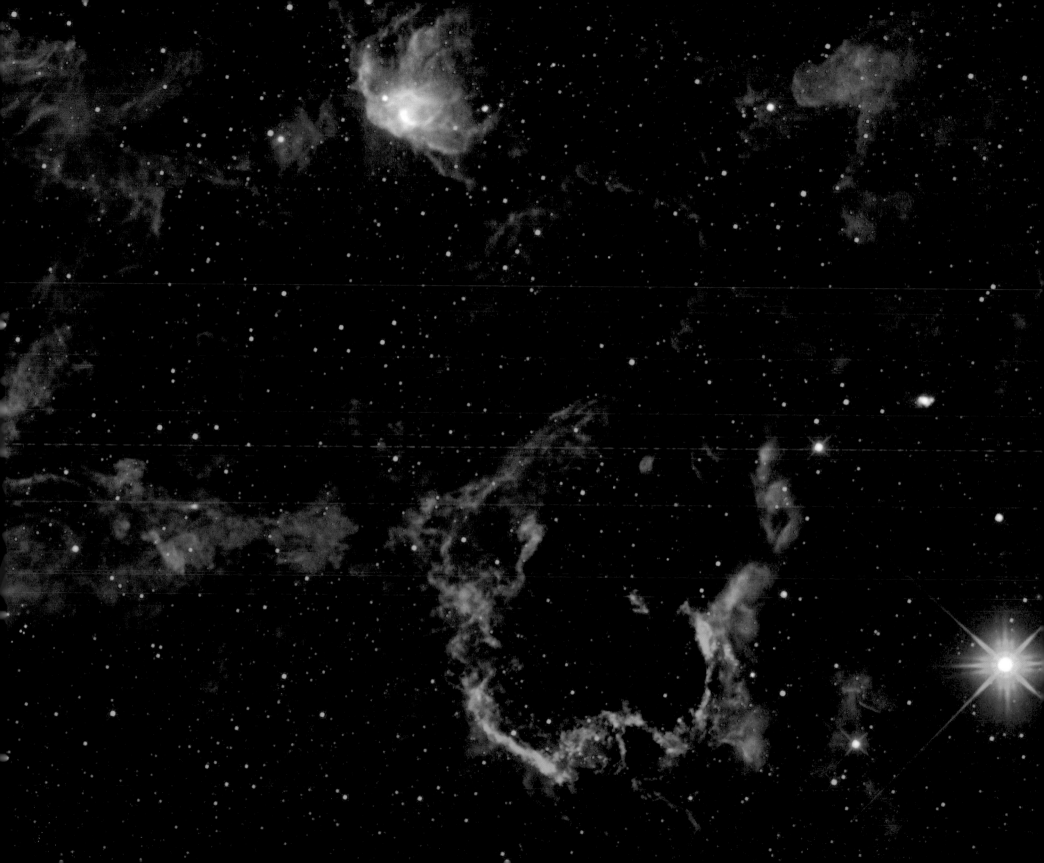

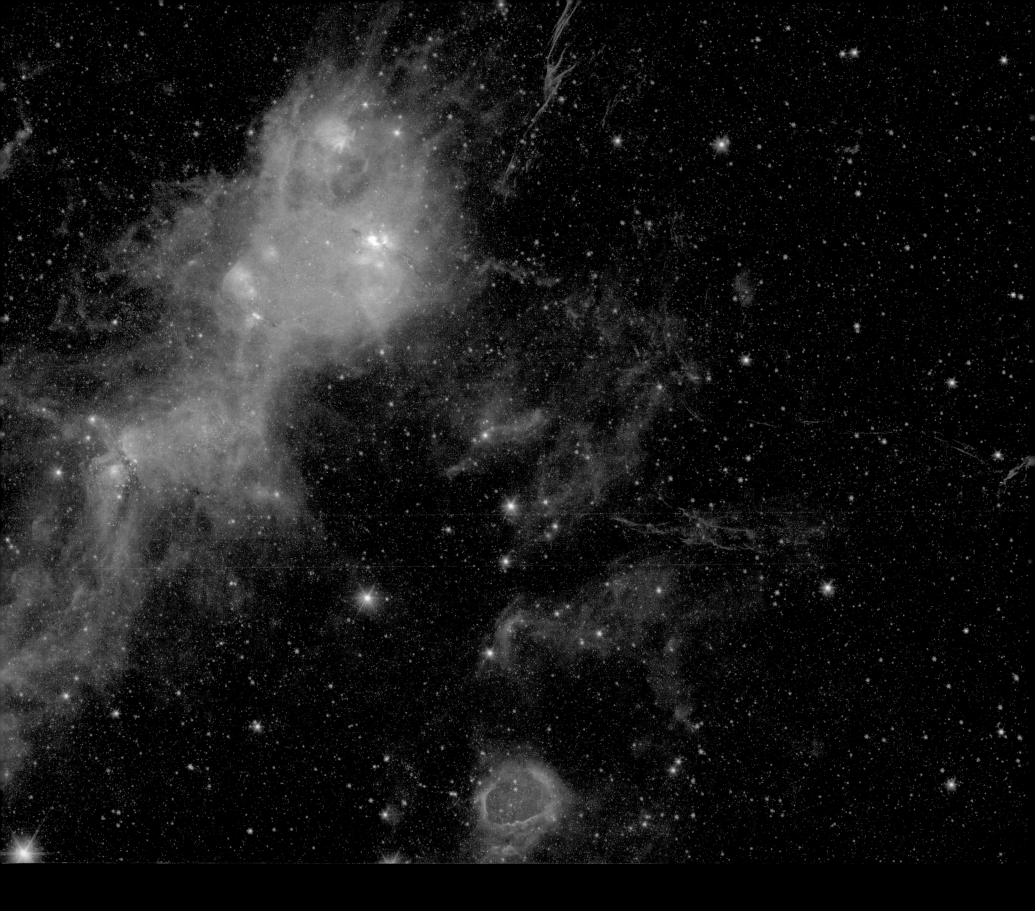

W3 AND W5 MOLECULAR CLOUDS

This image was taken in 2013 as part of the Galactic Legacy Infrared Mid-Plane Survey Extraordinaire 360, or simply, Glimpse 360—a project that gives us a complete 360-degree image of the Milky Way. The Glimpse 360 project directed the Spitzer Space Telescope away from its customary orientation (the galactic center) to perform a 360-degree recording of the entire galactic plane. This image magnifies portions of the bright pink w3 and w5 star-forming giant molecular clouds, which can be found over 6,200 light years away within the Perseus arm of our galaxy. The clouds themselves are the remains of a star that went supernova. Meanwhile, the Perseus arm is situated at the distal (or farthest) end of the center of our galaxy and has a total radius of over 10,700 parsecs (or 34,898 light years).

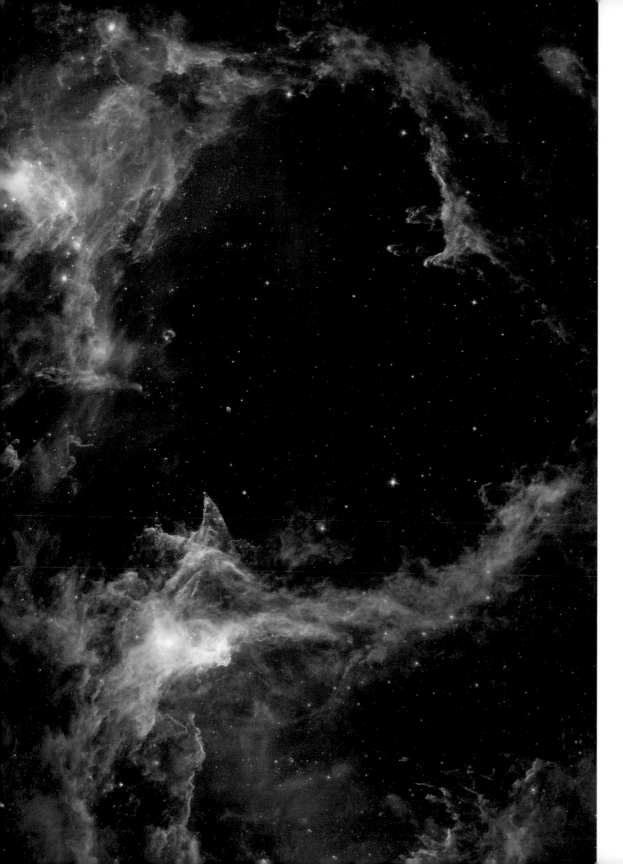

[*left*]

W5: THE STAR CRADLE

NASA's Spitzer Space Telescope captured this celestial image of W5, a giant molecular cloud and cradle of stellar creation. The blue dots floating in the cavity of the ghostly halo are ancient stars, while the pink dots lining the pale cloudy areas are younger stars. Gaseous pillars, which flow out from older stars, birth new stars once the gas cools and contracts. W5 spans approximately 2,000 light years and can be found 6,500 light years away from us.

[*right*]

CRAB NEBULA IN DETAIL

This 2005 Hubble Space Telescope image is the most detailed picture of the Crab Nebula ever taken. It is composed of twenty-four individual exposures, all taken at the highest possible resolution. The Crab Nebula, which is about 5 light years in length and 6,500 light years away from us, is one of the most famous supernovae to grace the night skies; it was first seen by Chinese astronomers in the year 1054, and its scattered remnants still float through the Milky Way today. In 1844, the Irish astronomer William Parsons named it the Crab Nebula because he thought it resembled the legs of a crustacean; later telescopic observations refuted this, but the name stuck. Supernovae are stars that become extremely bright due to explosions that mark stellar death and propel most of the star's matter out into space. In general, there are two types of supernovae. The first occurs in a binary star system, in which a white dwarf siphons matter from its orbiting star. When the white dwarf gets too massive, it explodes. The second type of supernova happens when a single star is at the end of its life cycle. Only an extremely massive star can go supernova (in other words, it won't happen to our Sun); when the star is depleted of nuclear fuel, its mass gradually gets sucked into the core. Eventually, the core becomes so heavy its gravitational force makes the star collapse upon itself, resulting in a detonation of cosmic fireworks.

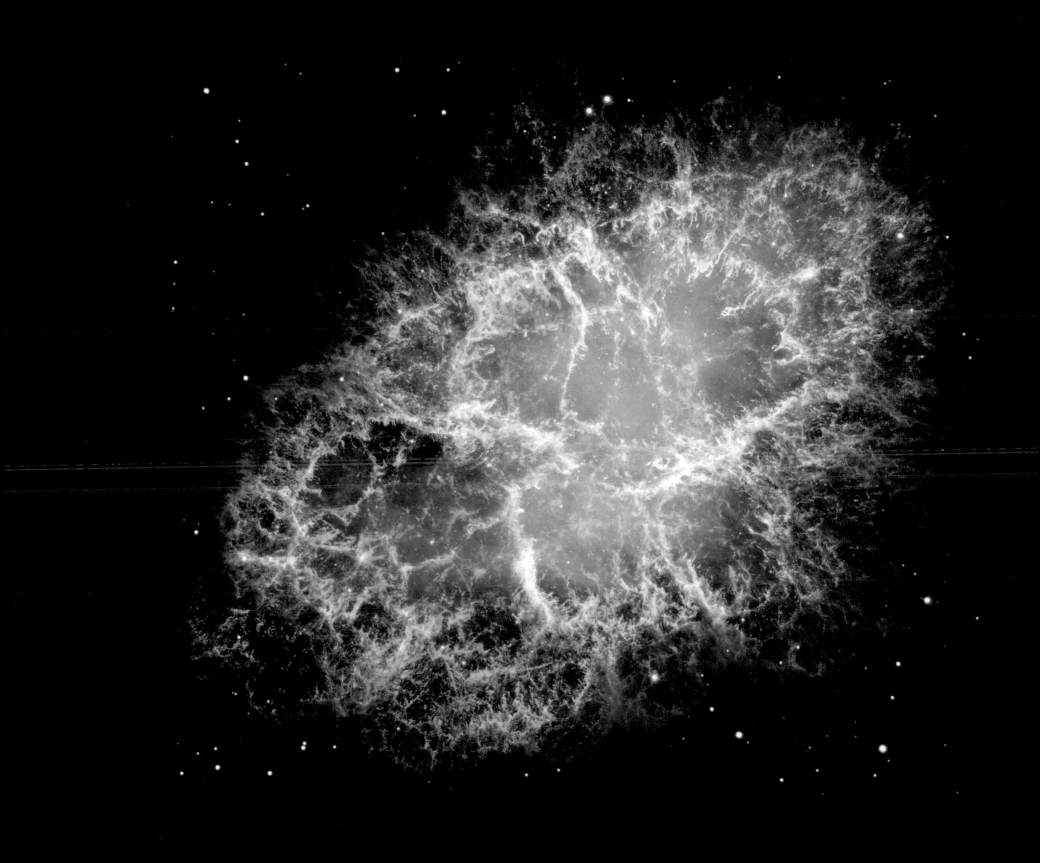

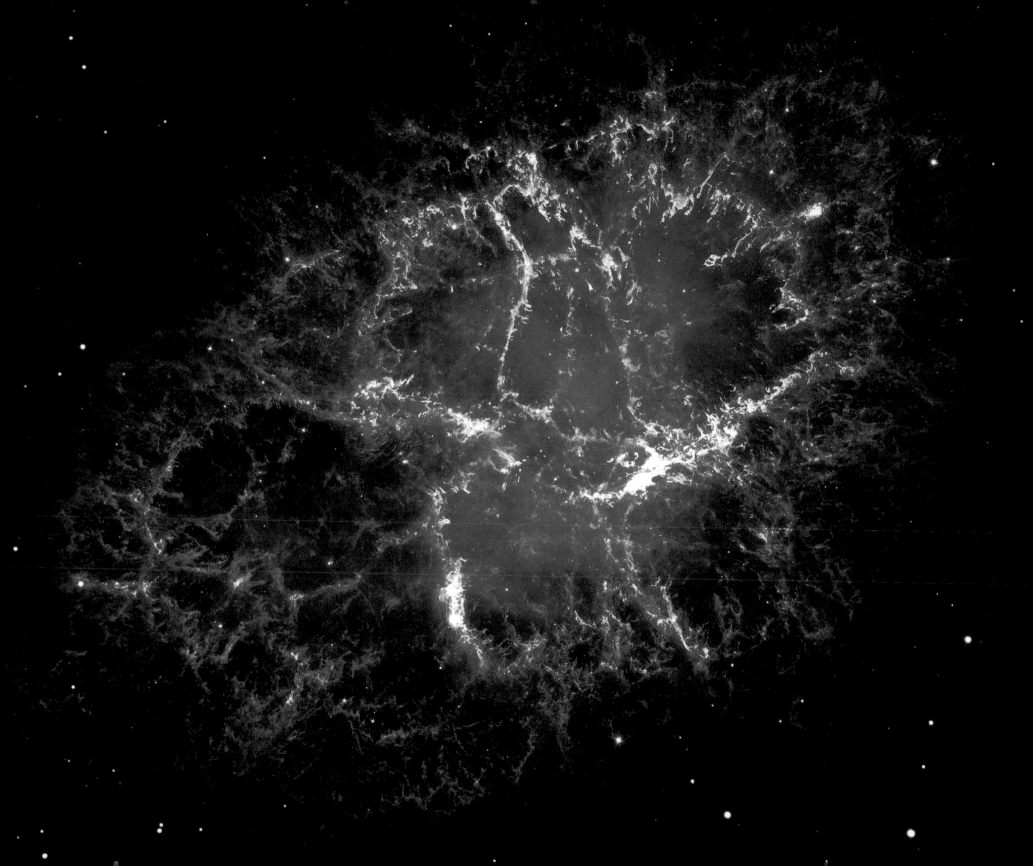

CRAB NEBULA

This image of the Crab Nebula is a composite of photographs taken by the Hubble Space Telescope and the Herschel Space Observatory; the former offers us an image of the nebula at visible wavelengths (shown in blue), while the latter gives us a far-infrared image that reveals the molecular makeup of the dust content (shown in pinkish red). The dust cloud itself is set in motion by the Crab Pulsar, a fast-moving neutron star at the core of the nebula.

CRAB PULSAR

The bright spot at the center of this high-energy bundle is the Crab Pulsar, a neutron star. Neutron stars are the smallest and densest stars in the universe; they usually have a six mile (ten kilometer) radius and spin at about seven hundred revolutions per second. A neutron star can be seen as the stellar equivalent of the mythical phoenix—it's born when a giant star's core collapses after it goes supernova. Protons and electrons unite as gravity takes over, forming the neutron star. The Crab Pulsar, a mysterious radio source in the middle of the nebula, was first discovered in 1968. The Crab Pulsar has a hundred thousand times the energy of the Sun. Unlike pulsars that primarily pulse in X-rays and gamma rays, the Crab pulses at almost all wavelengths and is thought to have four magnetic poles rather than the customary two. Astronomers believe that when it was formed from the detritus of a supernova explosion, the two additional poles were paralyzed. Taken in 2005, this composite image of the Crab Nebula features Chandra X-ray imagery in the bright light-blue center (denoting the neutron star and its radiation), optical images from the Hubble Space Telescope in dark bluish-purple and green, and infrared images from the Spitzer Space Telescope in red. The central blue area of the Crab Nebula is relatively small, as X-ray light is beamed away more quickly than optical and infrared light.

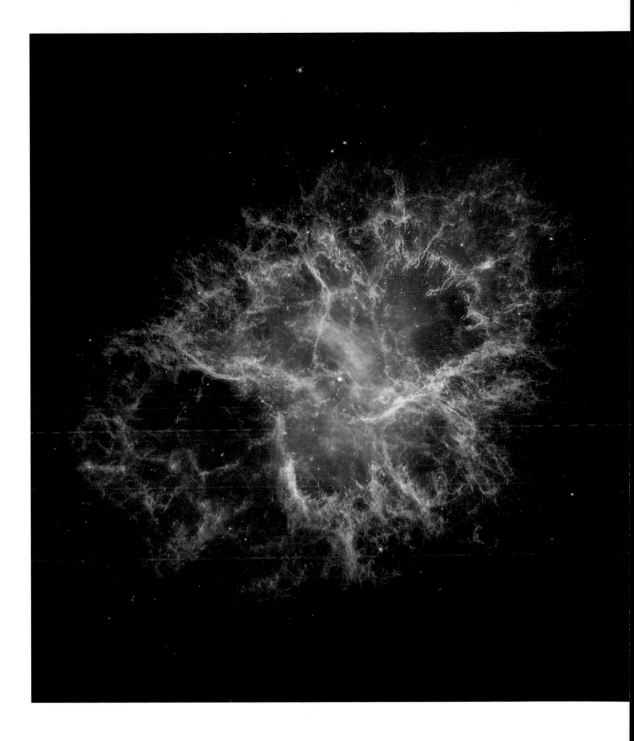

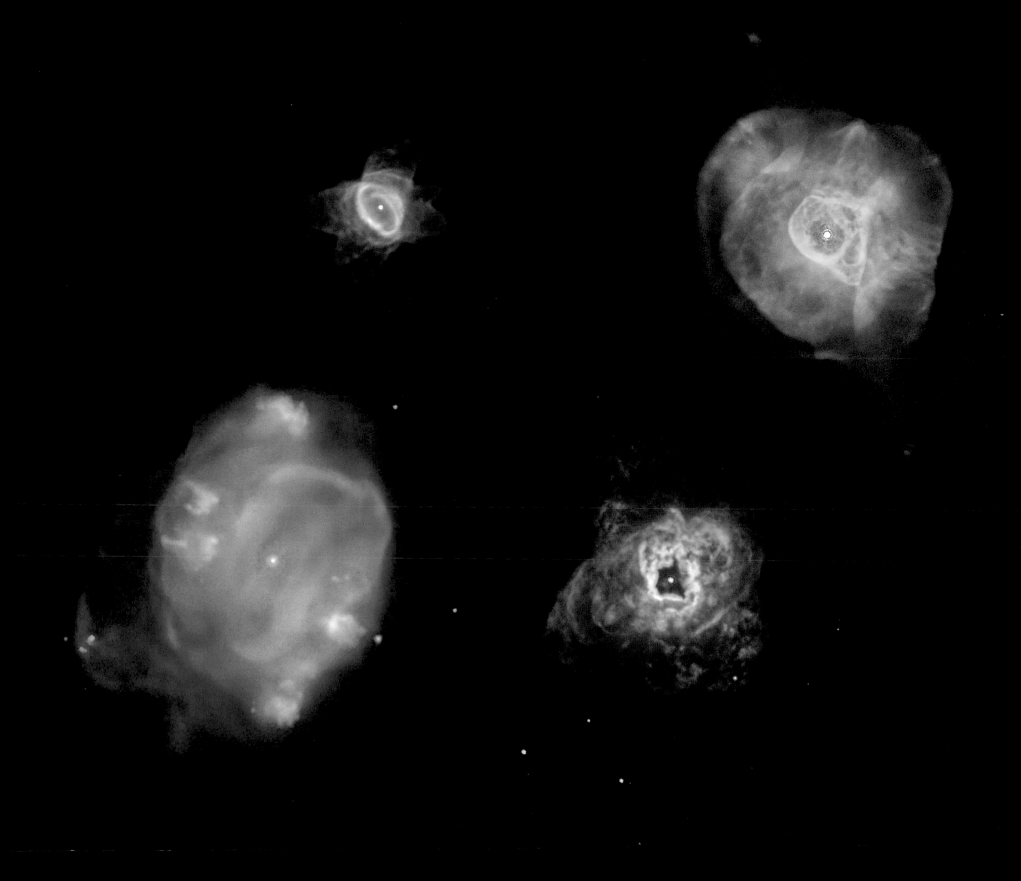

NEBULA QUARTET

This composite image from the Hubble Space Telescope features a quartet of nebulae that are each about 7,000 light years from Earth. The Wide Field and Planetary Camera 2 (which is no longer in use) took these images in February 2007, revealing a cornucopia of different shapes, features, and chemical processes—offering us a great deal of information about the materials and processes inherent in star death. At the top left is the nebula known as HE 2-47 (in the Carina constellation), also known as the Starfish Nebula. The "legs" of the starfish indicate that the nebula emitted gaseous material at least three times in opposing directions. At the top right is IC 4593 (in the Hercules constellation), which features streams of gas jetting in opposite directions, from the top and bottom. At the tail ends of these jets are balls of glowing red nitrogen gas. NGC 5307 is at the bottom left (in the Centaurus constellation), which features an asymmetrical spiral pattern that probably stems from a wobbly dying star. Finally, NGC 5315 is the nebula at the bottom right (in the constellation Circinus), whose X-shaped pattern may indicate material ejected by a dying star in two different directions.

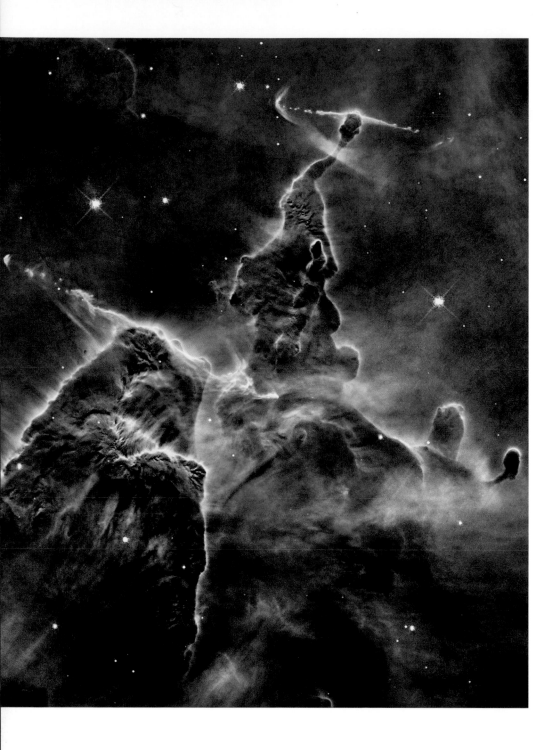

[*left*]

MYSTIC MOUNTAIN IN CARINA NEBULA

Although it resembles a fantastical landscape, the Carina Nebula presents a picture of elegant chaos far stranger than fiction. This hotbed of stellar activity, 7,500 light years from Earth, is a cradle for newborn stars—although the environment is anything but peaceful. Jets of ionized gas and charged particles from extra-hot newborn stars generate the birth of even more stars. This image shows Mystic Mountain, a massive monument of gas and dust within the nebula, which was captured in February 2010 by the Hubble Space Telescope. The pair of jets in the center of the image—labeled HH 901 and HH 902, and visible as thin streamers shooting out from a central "peak"—are shot out by swirling discs that surround the stars. The colors in the image correspond to the light emitted by different elements: oxygen is imaged in blue, hydrogen and nitrogen in green, and sulfur in red.

[*right*]

PISMIS 24

The nebula known as NGC 6357 resides 8,000 light years from Earth, in the constellation Scorpius. The central part of NGC 6357 spans 10 light years and is home to the star cluster Pismis 24, which houses bright blue stars of impressive mass—in fact, these are some of the most massive stars ever discovered. One star in this photo, taken by the Hubble Space Telescope's Wide Field and Planetary Camera 2 in April 2006, can be seen as a bright object to the left of the gas cloud, just below what looks like a pair of binary stars. The star is actually shooting radiation into pillars of dust and gas, creating an effect that's like a drop of ink blooming in water. Such patterns are generated from interstellar winds, radiation pressures, magnetic fields, and gravity. The incandescent glow in the image arises from ionized hydrogen gas in the clouds.

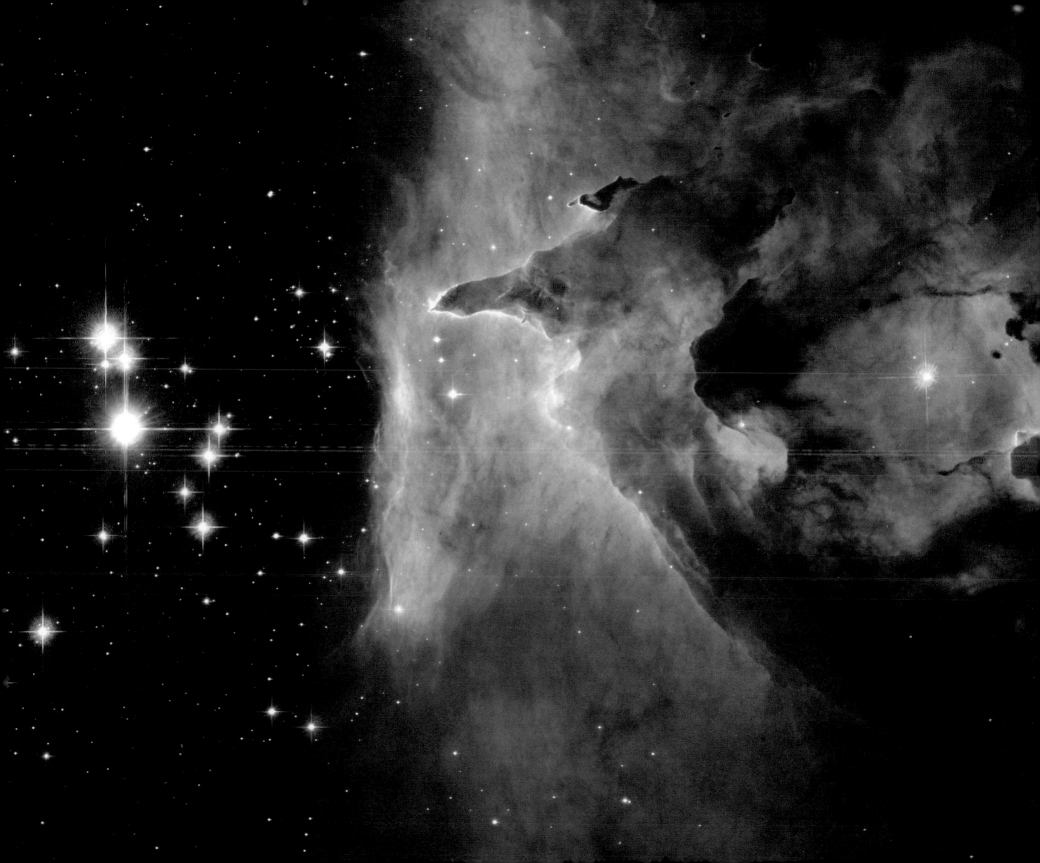

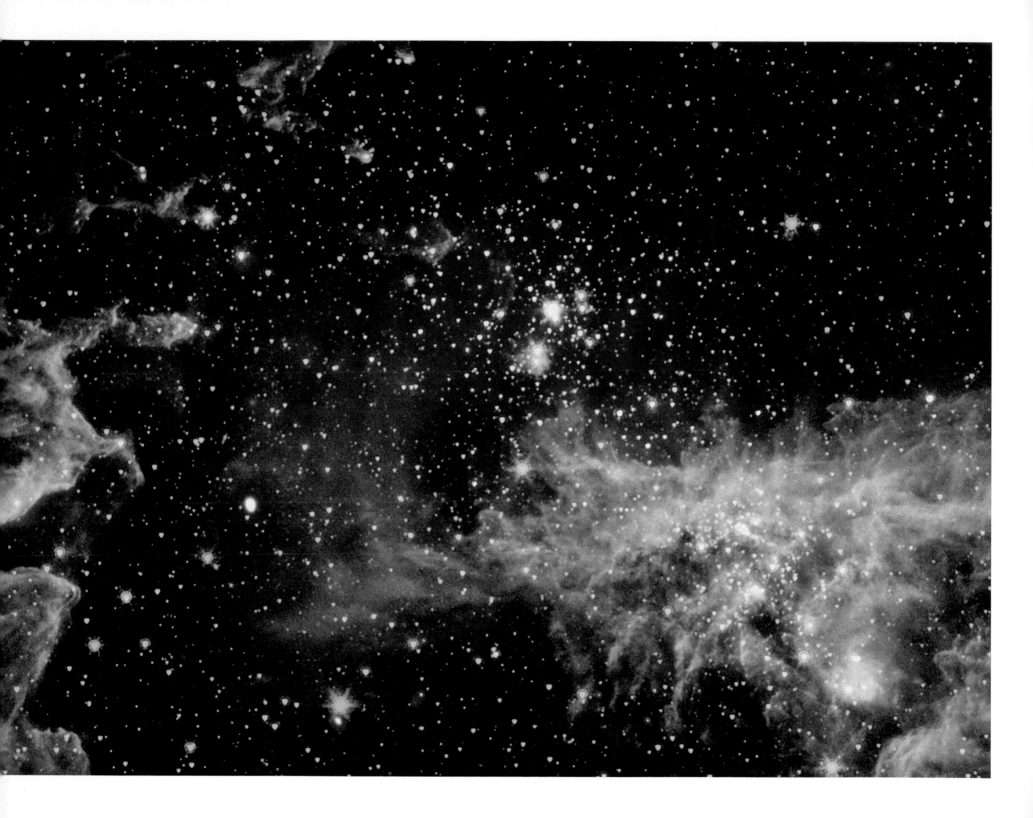

PACMAN NEBULA

Massive stars are usually too far away to study comprehensively because they tend to be surrounded by clouds of gas and dust, which are often stirred up due to activity from the star itself. NGC 281, also known as the Pacman Nebula (because it somewhat resembles the video-game character, though it's hard to discern in this close-up), is 9,600 light years away from us—but its position 1,000 light years above the galactic plane (the plane in which the majority of our galaxy's mass lines up) allows us a fairly unobscured view of it. This 2011 composite image of NGC 281 offers us X-ray data from the Chandra X-ray Observatory in purple, and infrared observations from the Spitzer Space Telescope in red, green, and blue. The purple region shows us gas that is heated to approximately ten million degrees Fahrenheit.

CASSIOPEIA A

At 11,000 light years away, the remnants of Cassiopeia A captured in this 2002 Hubble Space Telescope image may be reminiscent of colorful streamers from a parade float or a vibrant explosion of fireworks, but the celebratory display belies the actual fate of the star. Cassiopeia A was a massive star that went supernova about eleven thousand years ago—although the light of the explosion only reached the Earth in the late 1600s. It was one of the largest super-novae ever to occur in our galaxy. When Cassiopeia A was a star, it was about twenty times more massive than our Sun. But stars of that size live hard and die fast, exhausting their stores of nuclear fuel a thousand times more rapidly than stars like our Sun. Their deaths are not in vain, however; a plethora of solar systems, including our own, were born when the debris of various supernovae accreted to form new stars and planets.

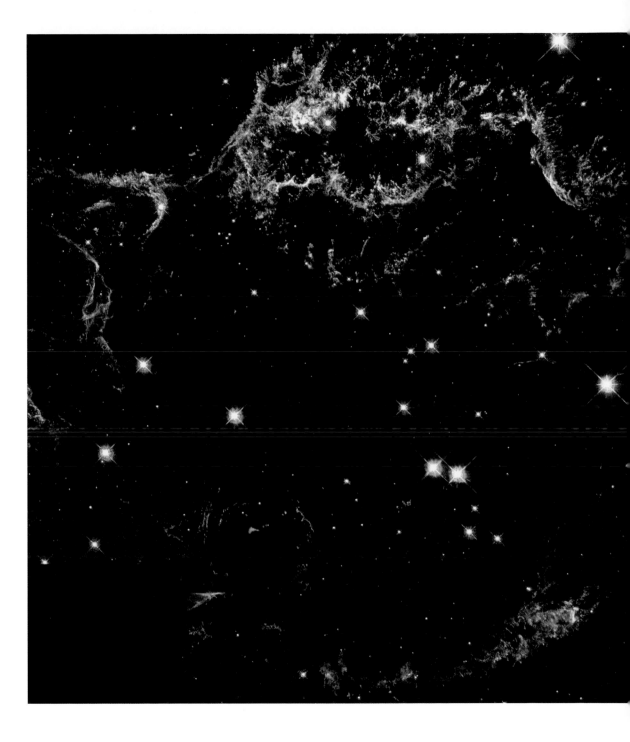

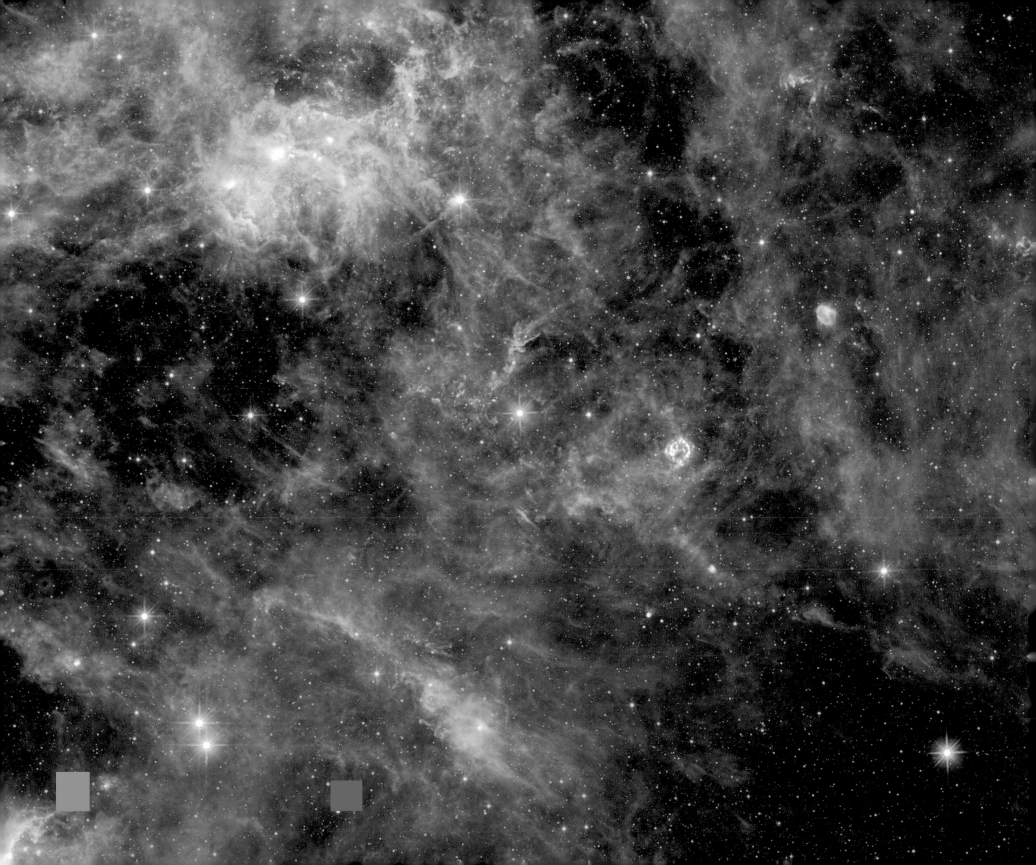

CASSIOPEIA A: A SUPERNOVA BLAST WAVE

Roughly eleven thousand years ago, the massive supergiant Cassiopeia A shrank down into a neutron star, and the star's exterior shell exploded as it went supernova. About 330 years ago, according to calculations, the light from the explosion would have been visible to people on Earth, around the year 1667, though no record of the celestial display remains today. In 1947, the supernova's radio emission was detected, and to this day, it is one of the brightest radio sources in the sky. In this 2012 Wide-field Infrared Survey Explorer image, you can see a bright green cloud designating the blast wave from the supernova. The blast wave heats its surroundings as it hurtles through space. This blast wave is moving at 11,000 miles (17,703 kilometers) per second and has already covered over 21 light years, while light from the supernova has traveled over 300 light years.

[*right*]

HIERARCHICAL BUBBLE STRUCTURE

This infrared image, taken by NASA's Spitzer Space Telescope in 2013, offers us a picture of a phenomenon discovered by volunteers at the Milky Way Project—a citizen science project. In the image, we can see a large bubble, discernible as the dark central area in the image, which was created when gas was expelled by massive, tightly clumped-together stars. The burst of energy created "holes" in space dust (designated by two bright yellowish spots, at the west and south ends of the large bubble), which further resulted in a series of smaller bubbles located close by. These gas expulsions trigger the formation of massive new stars—which in turn continue to blow their own violent bubbles into space.

[*above*]

SUPERNOVA REMNANT

The strip of color captured in this Hubble photograph is a skinny fragment of the supernova remnants from a star that exploded over a thousand years ago. The ribbon of light shows us places where the blast wave collided with surrounding gas. SN 1006 was first observed in the year 1006 and recorded by astronomers in Africa and Asia. The white dwarf went out with a bang 7,000 light years from us, and for a while, it was the brightest star viewed by humans. It outshone Venus and was visible for two and a half years before fading altogether. In the 1960s, radio astronomers discovered a circular remnant of the supernova (not visible without the detection of radio telescopes) that was the same angular diameter as the moon at the position where the supernova had been recorded. The size of the remnant led physicists to prove that the shock wave from the supernova has expanded at twenty million miles per hour over the last thousand years. The supernova remnant has a diameter of 60 light years and is now expanding at only six million miles per hour—since it has been slowed by interstellar gas and dust. The image stems from observations from the Advanced Camera for Surveys in February 2006 and the Wide Field and Planetary Camera 2 in April 2008.

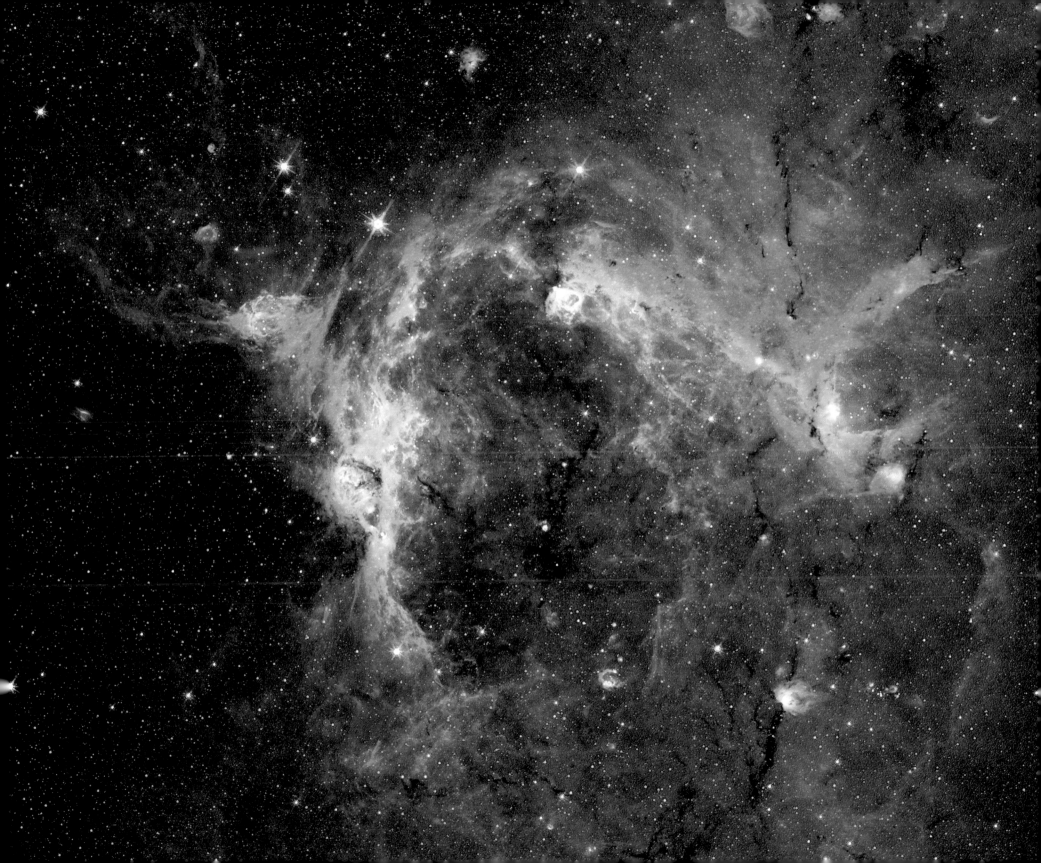

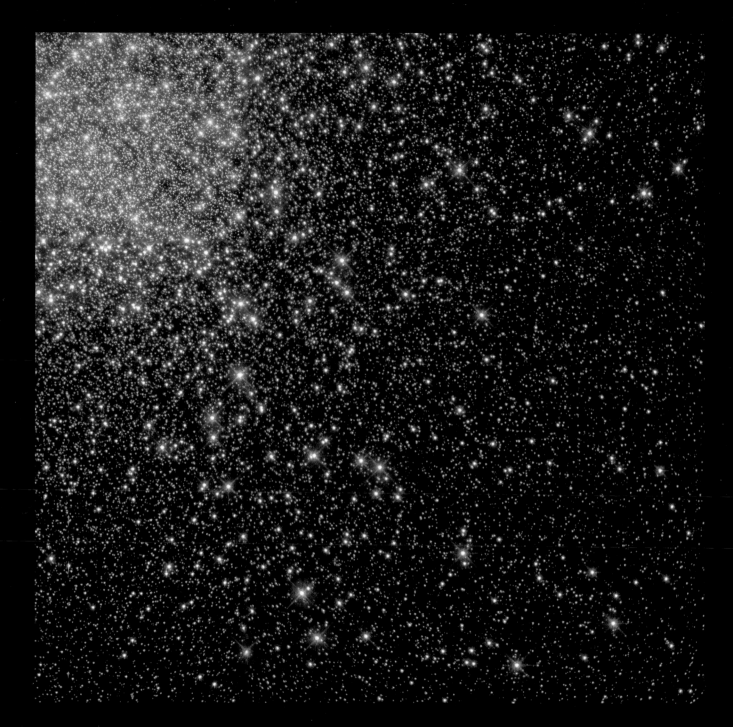

[*left*]

47 TUCANAE

The globular cluster known as 47 Tucanae is about 15,000 light years from Earth. The stars in this system are believed to be about ten billion years old and offer us an image of some of the oldest cosmic material known to science. The red stars are red giants nearing the end of their life cycle, the yellow stars are middle-aged like our Sun, and the sporadic sprinkle of blue stars signifies that new stellar life still abounds in this ancient cluster. This picture, taken by the Hubble Space Telescope's Wide Field and Planetary Camera 2 in 1999, might summon comparisons to the twinkling skyline of a bustling metropolis at night. However, it's nothing but stars here—perhaps because the cluster is too hot and hostile a breeding ground for planets.

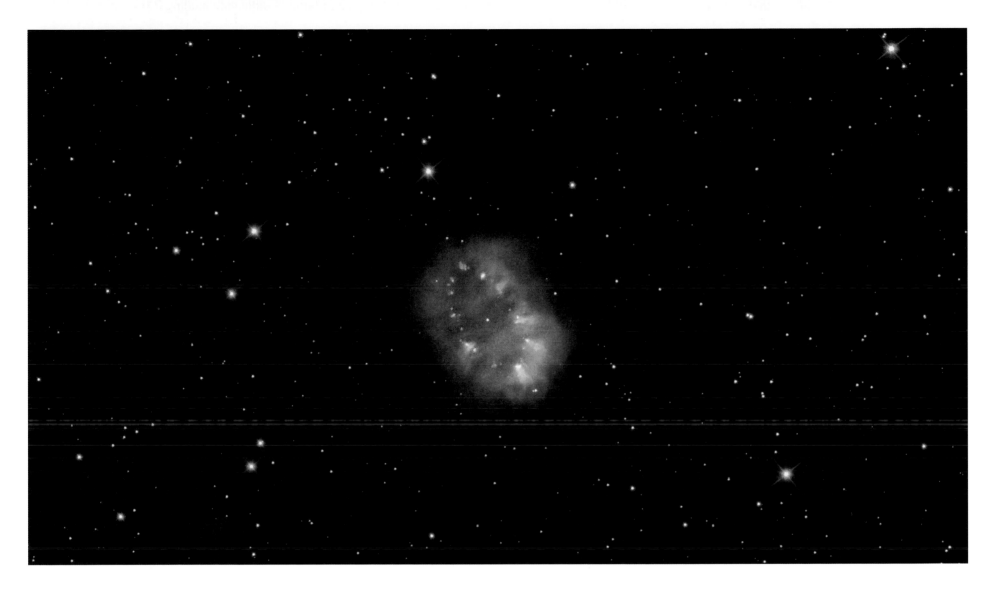

[*above*]

COSMIC NECKLACE

The Necklace Nebula, a planetary nebula, is located in the Sagitta constellation, about 15,000 light years from Earth. The nebula was discovered in 2005 by the ground-based Isaac Newton Telescope Photometric H-Alpha Survey, which studies planetary nebulae. Planetary nebulae are made up of the remnants of stars; our own Sun will someday become a planetary nebula when it dies in approximately five billion years. This particular nebula, captured here by the Hubble Space Telescope's Wide Field Camera 3 in 2011, was created when a giant star came in close contact with a star companion much like the Sun. The surviving stars still spin near one another, and while the ejected material that now forms the nebula was probably shed from the outer lobes of the stars ten thousand years ago, the stars now share material with each other. Measured across its widest part, the Necklace Nebula is 9 light years in diameter.

V838 MONOCEROTIS

This iconic image, taken by the Hubble Space Telescope's Advanced Camera for Surveys on February 8, 2004, is often compared to the vivid, erratic whorls of color in a Van Gogh painting and reveals a never-before-seen halo of dust and light skyrocketing across trillions of miles. The dust and light surround a red supergiant known as v838 Monocerotis, located about 20,000 light years from Earth at the outer edge of the Milky Way. In 2002, the star's brightness increased by several magnitudes over the course of several months, making it six hundred thousand times more luminous than the Sun. This pulse of light, also known as a light echo, most likely occurred some tens of thousands of years ago.

[*far right*]

LIGHT ECHO

In this 2005 Hubble Space Telescope image, a light echo is seen in the turbulent swirls of dust and gas around v838 Monocerotis. A light echo occurs when a flash of light bounces off a cloud of dust and becomes visible well after the flash occurred. As light from the star bounces off the dust, it creates luminous patterns in the dust and gas, brightening the objects around it in the process. The light continues to bounce around the cloud of dust, and the "echoes" of light from the dust eventually reach the Earth long after the light from the initial starburst was emitted. When the original pulse occurred, the star didn't actually explode or expel its outer layers. Instead, it grew to enormous proportions, while its surface temperature dipped to the equivalent of a household light bulb. This brief transitional state in a star's evolution toward death can sometimes be observed in unstable older stars, creating unexpected celestial spectacles.

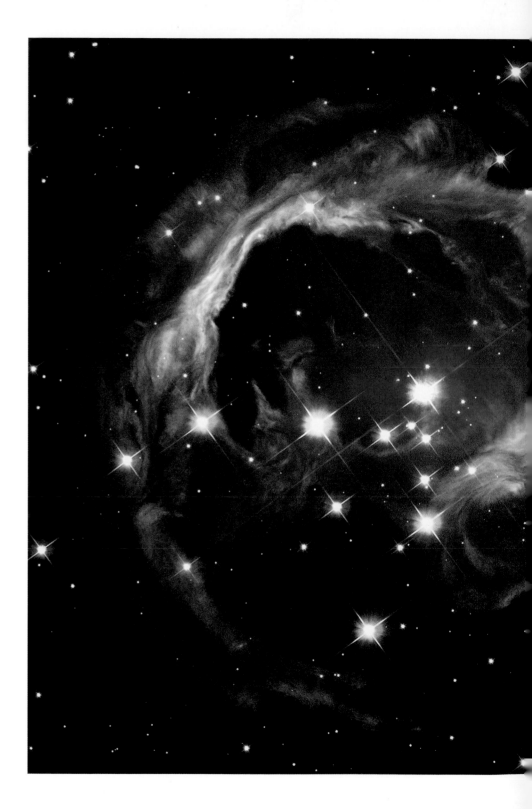

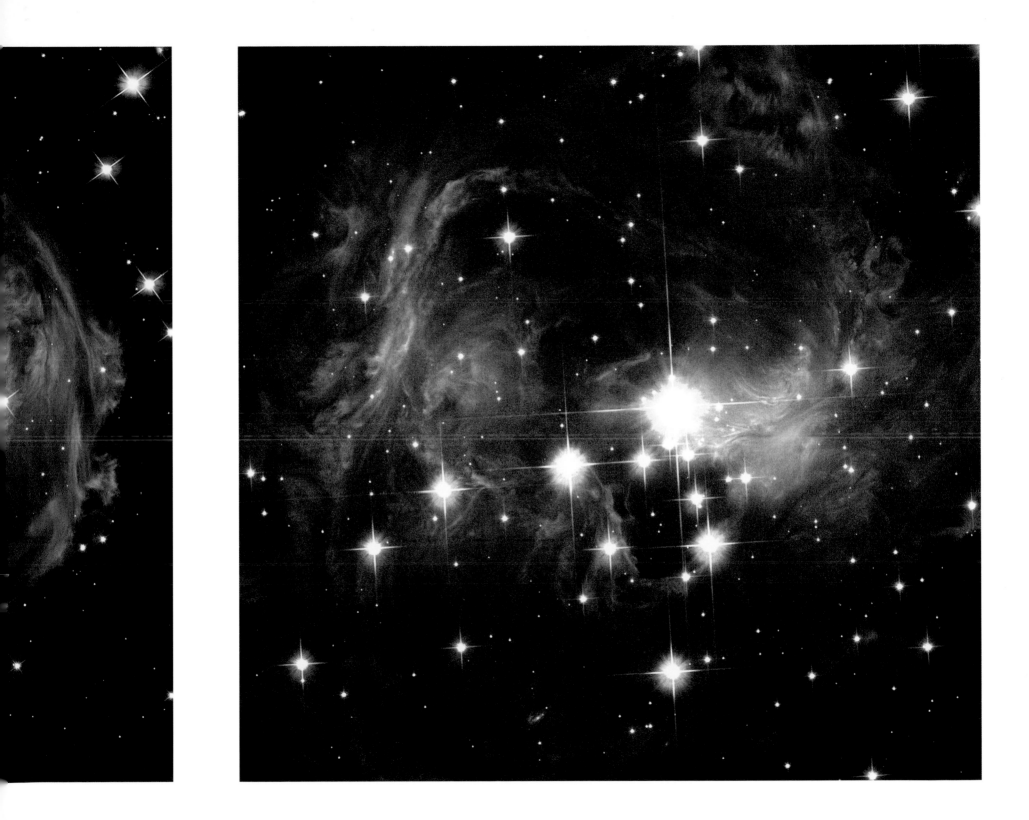

NGC 3603

This image, taken by NASA's Wide-field Infrared Survey Explorer in 2010, captures both infrared and visible light in a cluster of stars known as NGC 3603 in the Carina spiral arm of the Milky Way; it was first recorded by Sir John Herschel in 1834. The cluster is about 20,000 light years from Earth and spans a region of 17 light years. The massive stars in the cluster are extremely dense and hot and are surrounded by clouds of infrared light. At some point in the future, supernovae will tear the region apart.

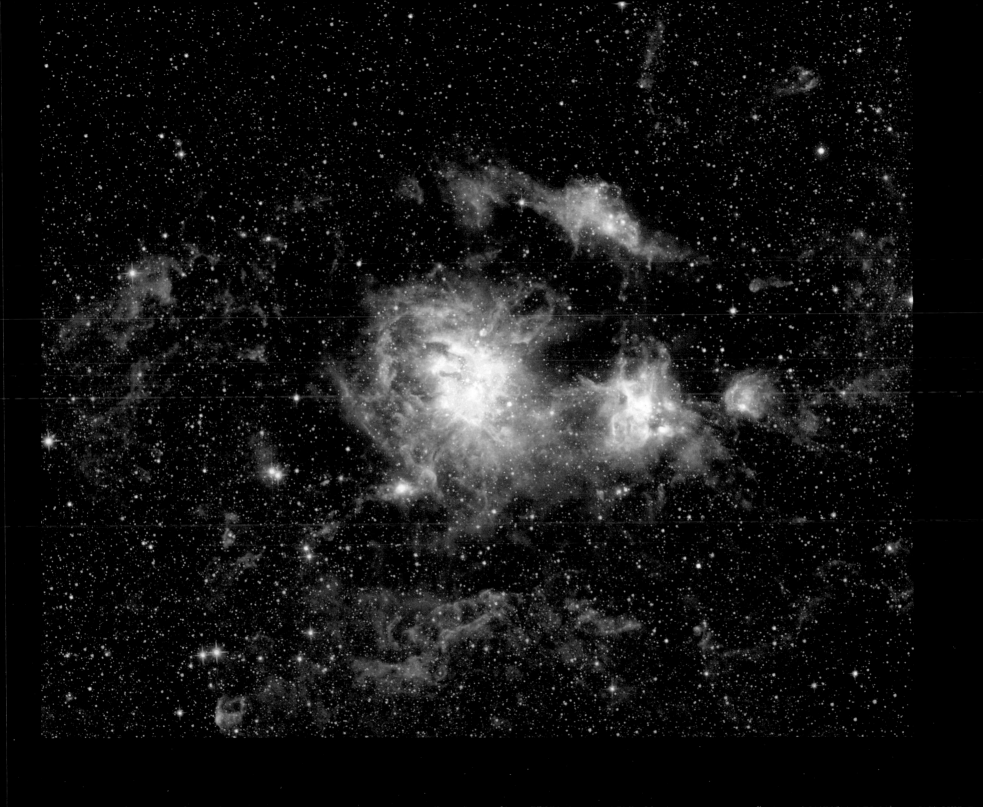

GLOBULAR CLUSTER

In this composite image from the Hubble Space Telescope, we see the globular cluster Messier 13, or M13, which is 25,000 light years from Earth. Situated in the constellation Hercules, the cluster is home to more than a hundred thousand stars, all grouped in a tight ball whose twinkling lights can be easily viewed in the northern sky. This spectacle is often compared to a giant snow globe or dense field of fireflies. The density of the area is due to a gravitational field so strong that the stars will remain in this clump for the rest of their lives. At the core of the ball, the star density is a hundred times greater than it is in other regions of the cluster—stars often collide here to form new stars known as blue stragglers, the hottest in the cluster. M13 is only one of nearly 150 globular clusters in our galaxy. Globular clusters tend to hold some of the universe's most ancient stars, which probably formed before our galaxy. The image was created from data collected in November 1999, April 2000, August 2005, and April 2006.

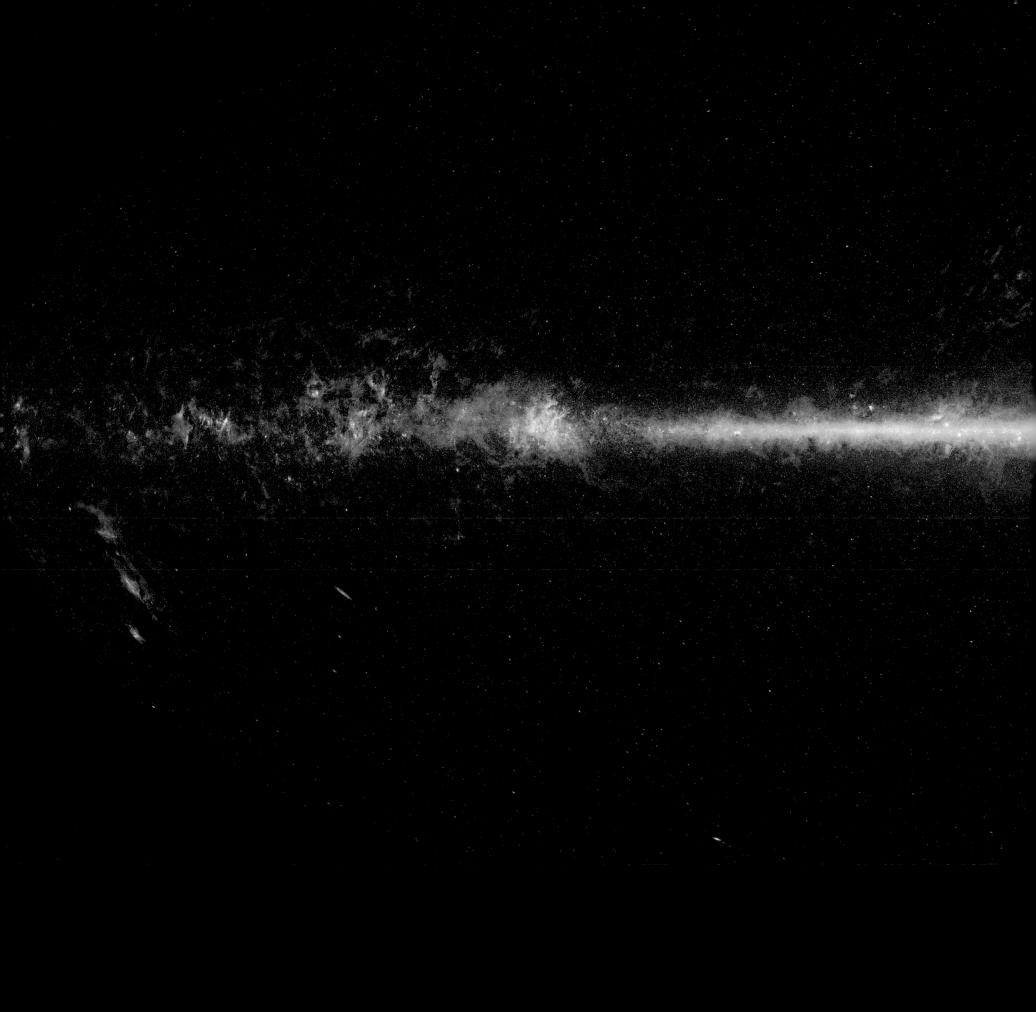

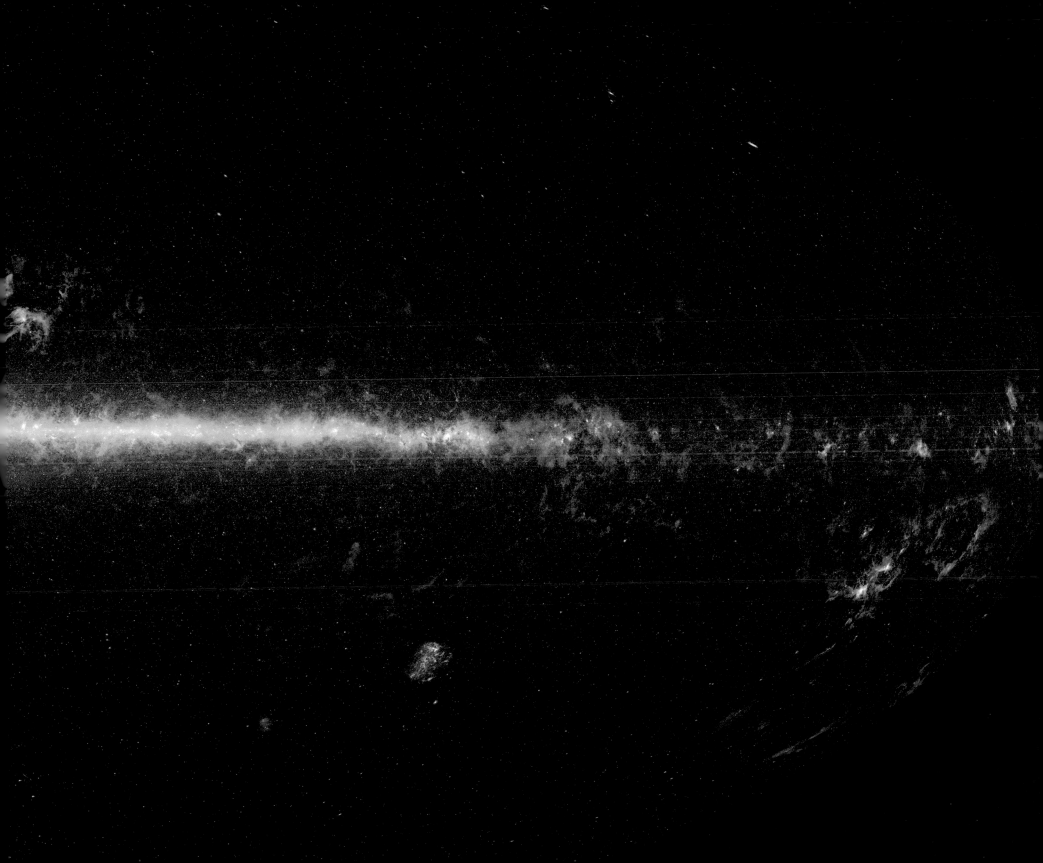

[*previous spread*]

MILKY WAY MOSAIC

The Wide-field Infrared Survey Explorer captured this remarkable slice of space in 2012, projecting it into two dimensions. The projection took the 3-D sphere of the sky (as viewed from just above Earth) and flattened it out into a line across an oval-shaped space. The image we see here is the result of taking the elliptical shape of the galaxy and pulling it out into a line. The perspective is from 326 miles (525 kilometers) above the Earth's atmosphere, where WISE was actively searching the skies until February 2011, when it went into hibernation. In this image, the disc-shaped Milky Way is a horizontal strip across the map, and the central area shows an increased cluster of stars (in blue-green) as we move toward the galactic center. For this image, asteroids and comets were taken out altogether, but image artifacts remain where slow-moving bright objects, such as planets, were captured. In fact, you can see residuals from Saturn, Mars, and Jupiter as red dots in the one o'clock, two o'clock, and seven o'clock positions right above the center of the image.

[*right*]

MILKY WAY DUST

Because of the high concentration of dust in the Milky Way, it's often difficult for us to see the center of our galaxy, at least in the visible light spectrum. In 2006, the Spitzer Space Telescope used its infrared eyes to capture an image of our elusive galactic center—about 25,000 light years from Earth. The array of dots mark individual stars. The width of the image spans 760 light years across the galactic center, and throughout the image, bright spots show regions where stars are being born. These include the Quintuplet star cluster (left-center, one of the bright spots to the left of the brightest central area), which is made up of five enormous binary stars heaped in clouds of dust and nearing the end of their lives. The brightest area in the middle of the image is the center of the galaxy, where a ring of dust known as the circumnuclear disk revolves around a supermassive black hole.

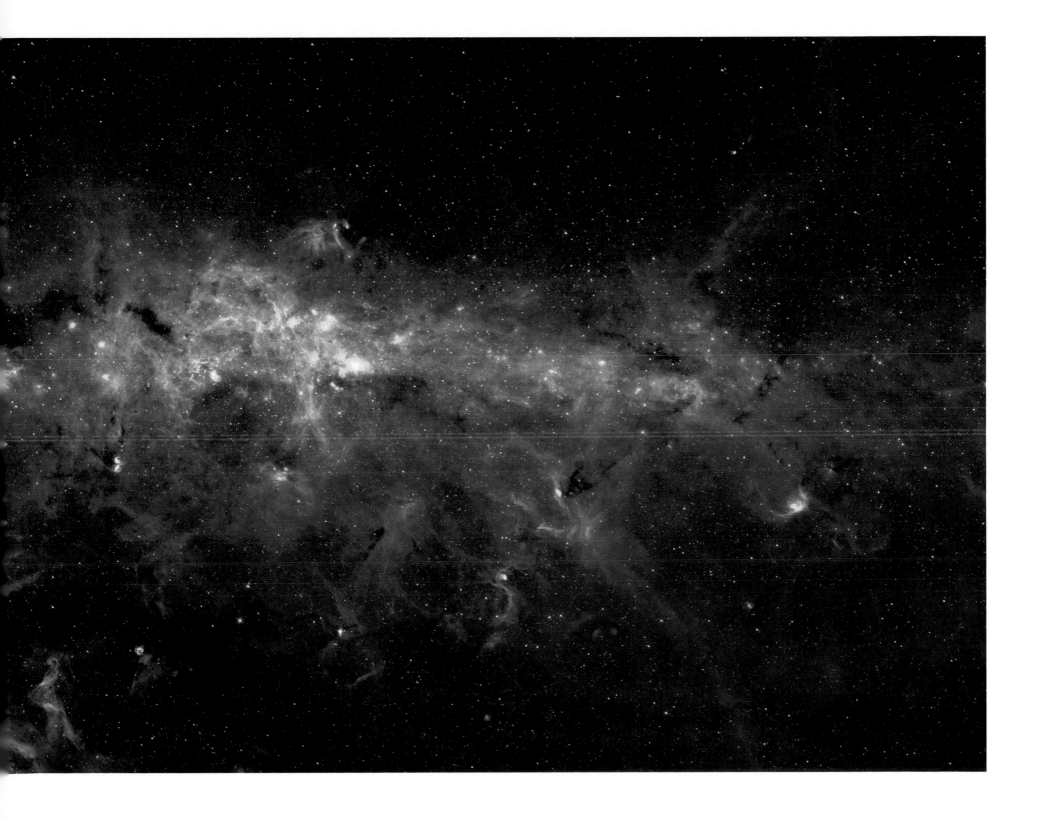

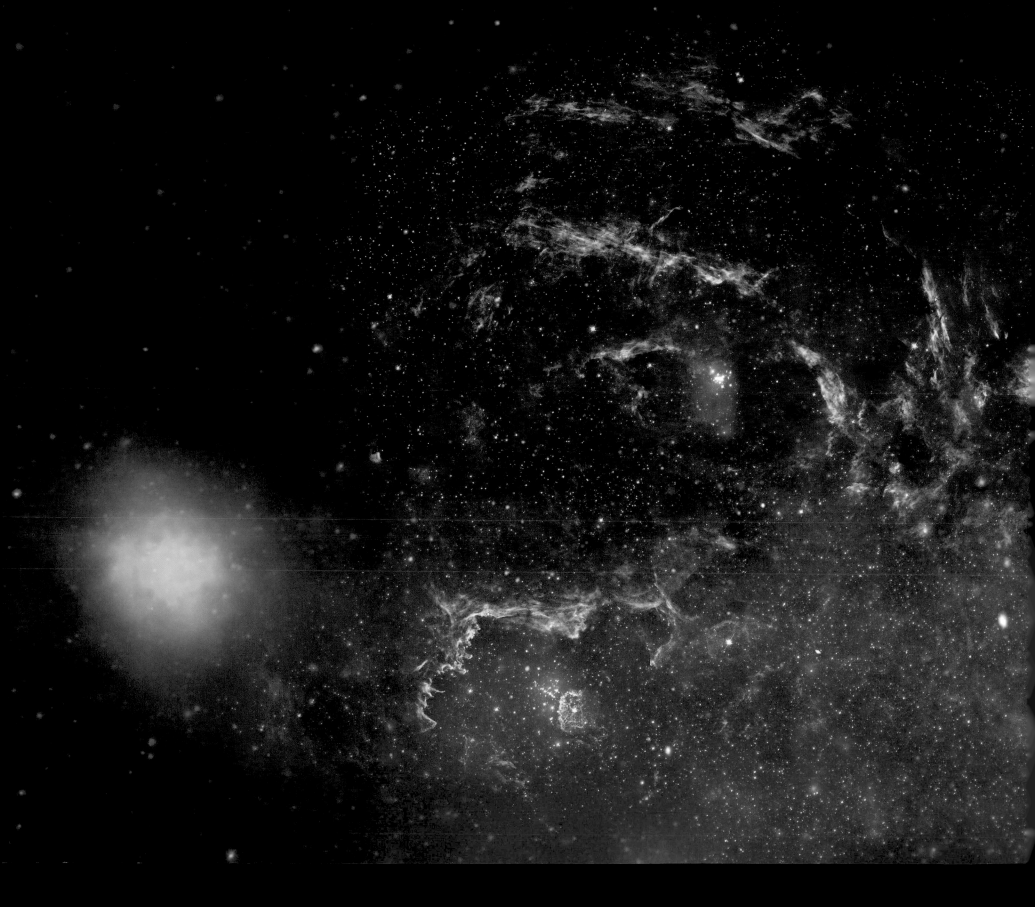

GALACTIC CENTER OF THE MILKY WAY

The Hubble Space Telescope, the Spitzer Space Telescope, and the Chandra X-ray Observatory joined forces to create this magnificent image of the central region of the Milky Way. In 2009 scientists discovered violent activity at the core of our galaxy, within the luminous white region in the right-center of the photo. The yellow areas, captured by the Hubble's near-infrared observation devices, show us where stars are forming. The red areas are glowing dust clouds lit up by star radiation and were recorded by the infrared vision of the Spitzer. The blue and violet areas, captured by the Chandra's X-rays, show regions radiated from heated gas, as well as chemical-rich hot gas from the enormous black hole at the center of the galaxy. At the far left of the image, the blue object (blue because it's seen using X-rays) is a binary star system that may harbor a neutron star.

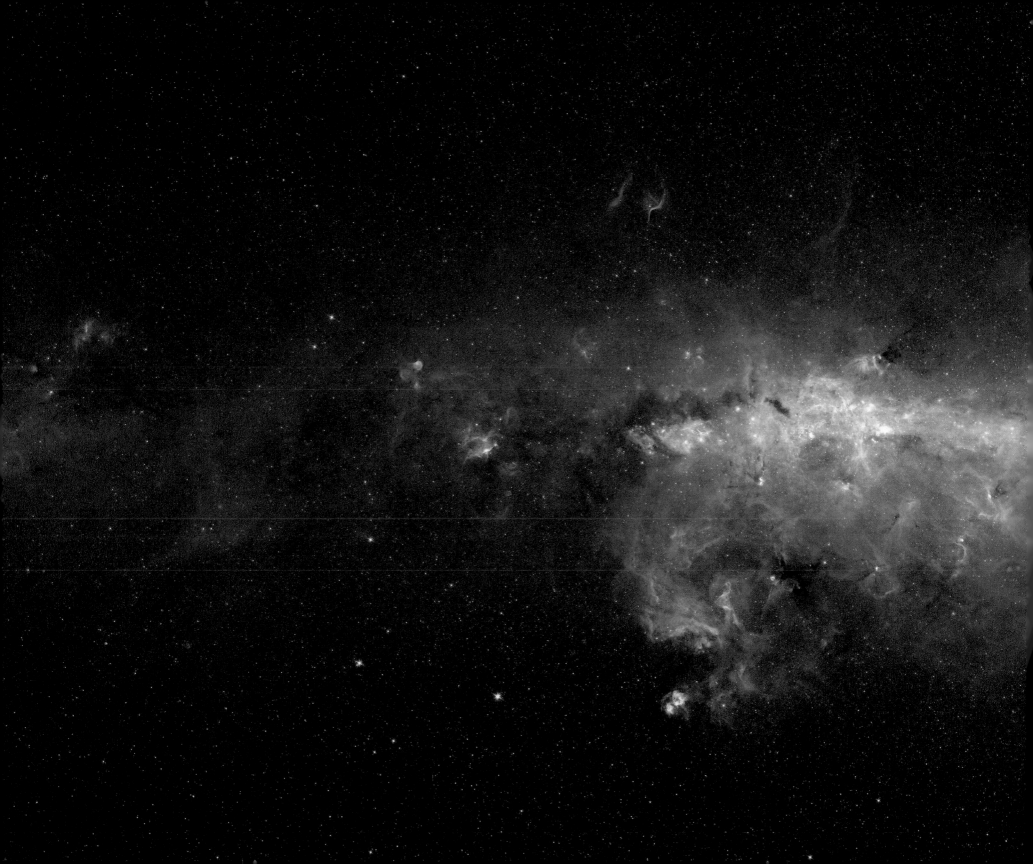

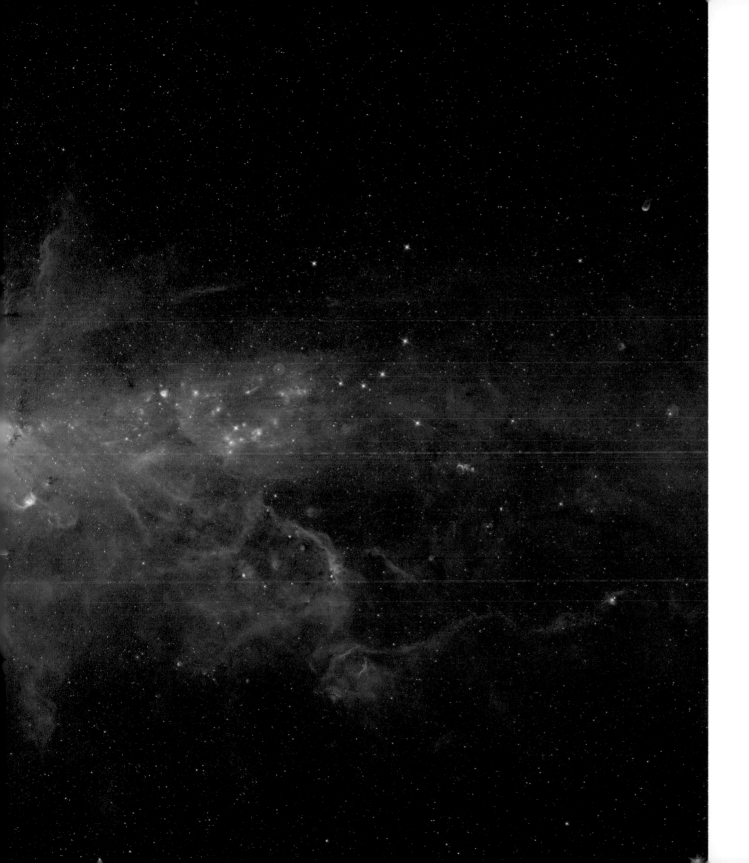

PEONY NEBULA

Close to the galactic center, 25,000 light years from Earth, the Peony Nebula Star is the second brightest star in our galaxy and was discovered and imaged by the Spitzer Space Telescope in 2008. Though the nebula star is a barely discernible tiny pink dot in the center of the photograph, it glows as brightly as 3.2 million Suns and produces light that is equivalent to 4.7 million Suns. The Peony Nebula Star's light is obscured by a thick veil of gas known as the Peony Nebula.

TARANTULA NEBULA

In 2012, the Chandra X-ray Observatory took this colorful image of 30 Doradus, also known as the Tarantula Nebula, whose spindly legs unfurl in a series of dynamic gaseous filaments. Massive outbursts of gas created these glowing spider-like appendages. X-rays are shown in blue in this composite image, and they stem from shock fronts that result from high-energy stellar activity. The Tarantula Nebula is 159,800 light years away in the galaxy known as the Large Magellanic Cloud, one of three galaxies visible to the naked eye. The nebula is home to the biggest stars in the twenty-five galaxies surrounding the Milky Way. It houses roughly 2,400 extremely massive stars at its bright central core, which are formed from multimillion-degree gas that is blown off of supernovae.

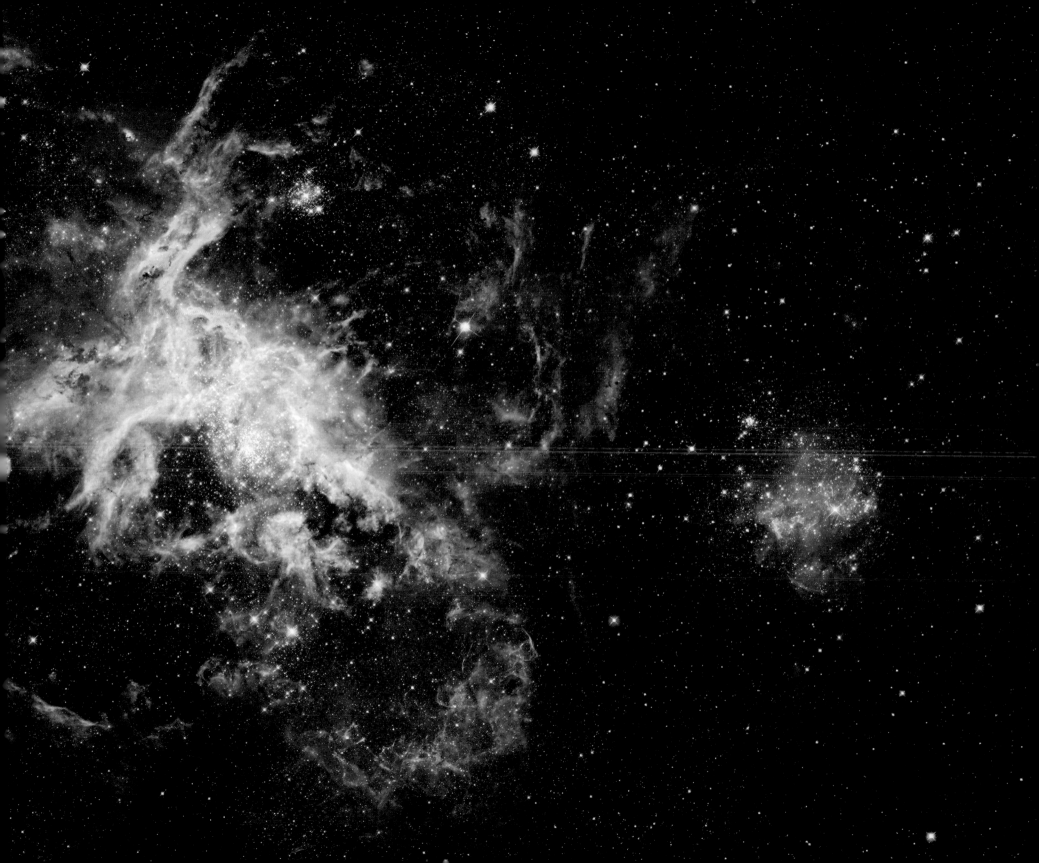

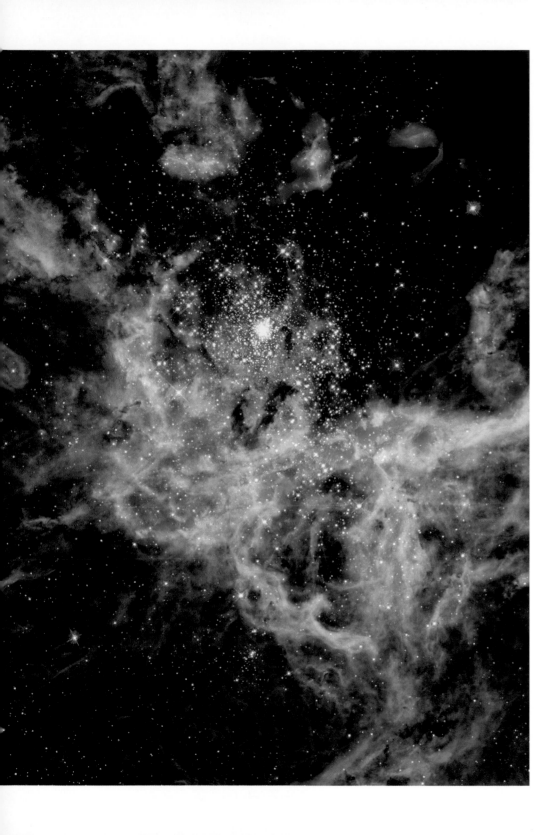

[*left*]

R136 IN THE TARANTULA NEBULA

The Hubble Space Telescope took this ethereal shot of the Tarantula Nebula. In this image, we can see the inner region of the nebula, which is home to the star cluster R136 (visible as the sparkling blue mass above the center). R136 contains youthful stellar juggernauts more than a hundred times the mass of the Sun. The stars in R136 were formed roughly two million years ago, and their ultraviolet radiation makes the entire system glow brightly. The stellar winds from R136 create intense pressure, which causes gases from the clouds to collapse and form new stars. The composite photo, created from images taken by the Hubble's Wide Field and Planetary Camera 2 between January 1994 and September 2000, uses a variety of color filters. The hot stars of R136 are blue, while the green areas highlight gas that has been energized by the R136 cluster. The pinkish areas are the gas clouds being assailed by radiation winds. The reddish-brown areas are cooler parts of the dust clouds that aren't being directly exposed to the hot radiation.

[*right*]

OLD STARS IN THE TARANTULA NEBULA

The massive Tarantula Nebula in the Large Magellanic Cloud is perhaps the most luminous star-making region in our vicinity, boasting numerous lagoons of gas, ultraviolet radiation, and eruptive activity. The nebula is believed to be extremely active because of its proximity to the Small Magellanic Cloud, a galactic neighbor. This composite image was taken in ultraviolet, visible, and red light, and it reveals the brightest star-maker in the nebula: the bright blue cluster known as R136, right of center. The image area is about 100 light years across and contains the fastest, hottest, and highest-energy stars in the galaxy, ranging from two million to twenty-five million years old. R136 is the extremely dense core of a larger star cluster known as NGC 2070. These stars shed ultraviolet light by the second, which sculpts numinous-looking pillars of gas, where new stars are born by virtue of the impact. This Hubble Space Telescope image comes from data recorded between October 20 and 27, 2009.

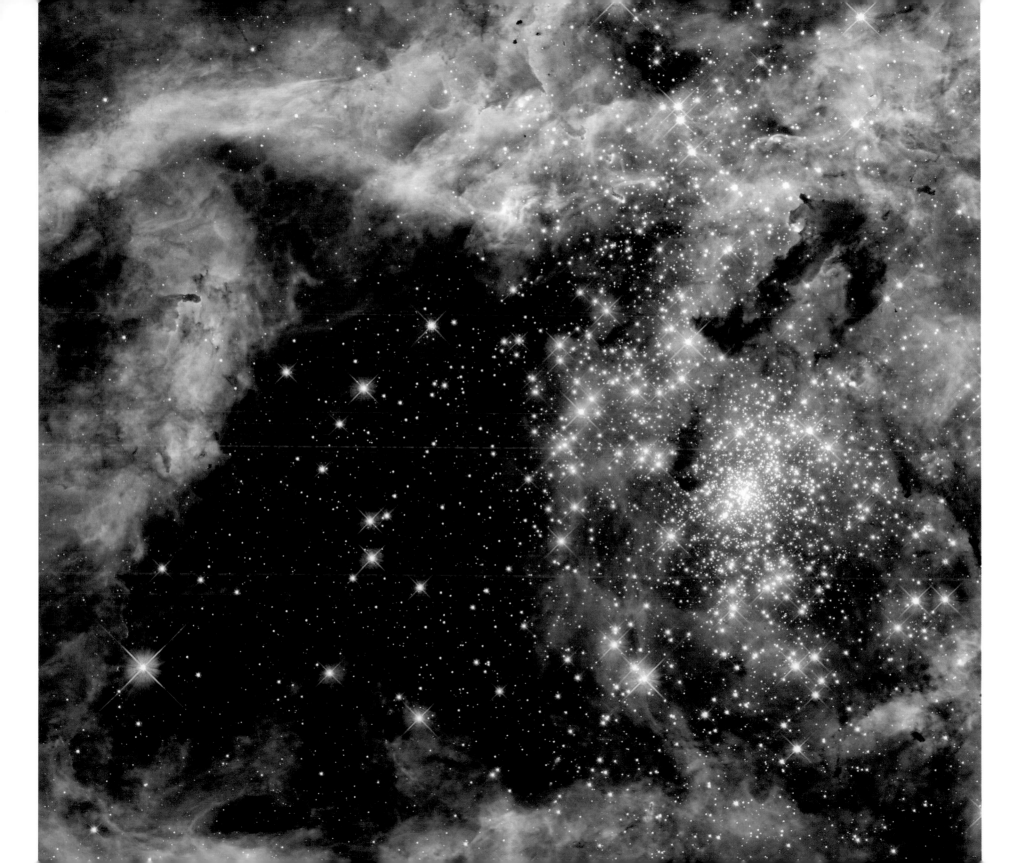

[*right*]

NGC 2070

The NGC 2070 star cluster in the Tarantula Nebula is one of the most active breeding grounds for stars. It also houses some of the most massive stars known to us. Created in October 2011, this enormous mosaic combines information recorded by the Hubble with ground-based data from the European Southern Observatory. The colors represent hot gas governing various regions of the image: red represents hydrogen, while blue represents oxygen. The bright star cluster in the center-left is filled with about five hundred thousand megastars, whose stellar winds and ultraviolet light are responsible for the creation of the beautiful shapes in the surrounding gas clouds. The cluster is close enough to Earth for us to resolve the physical characteristics of individual stars.

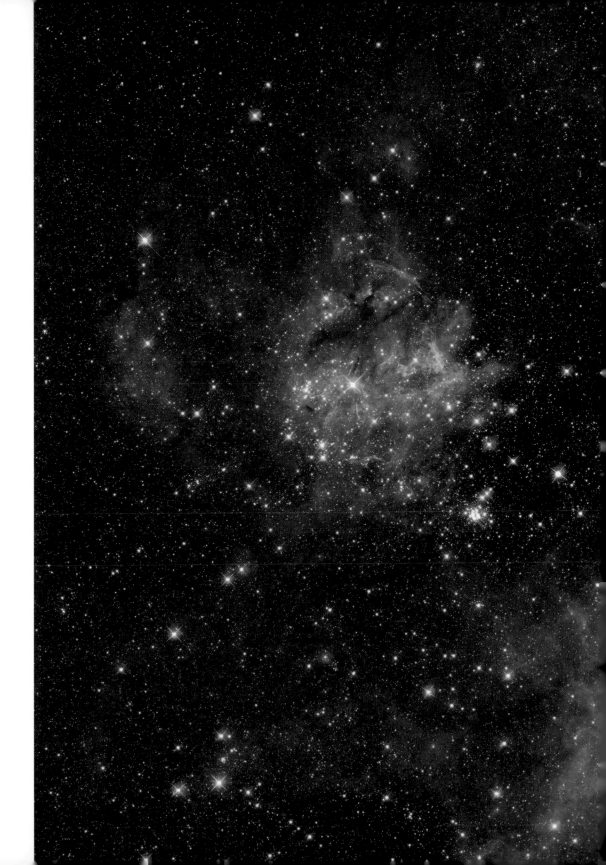

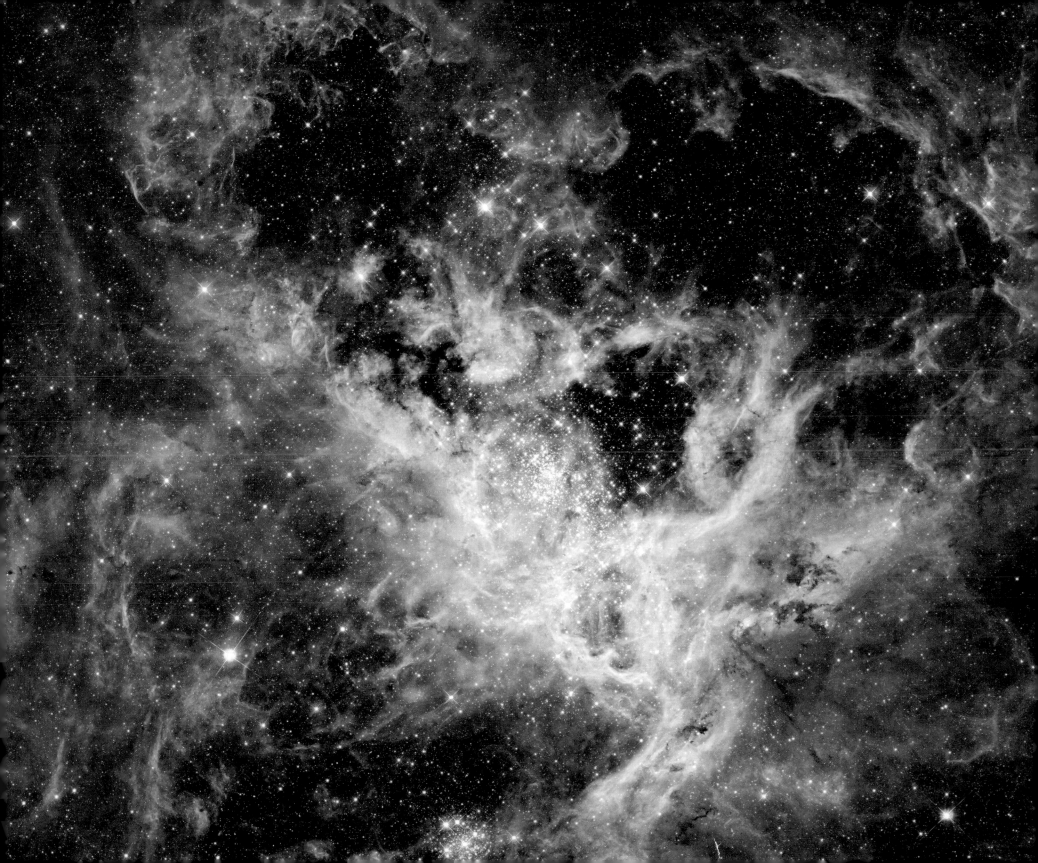

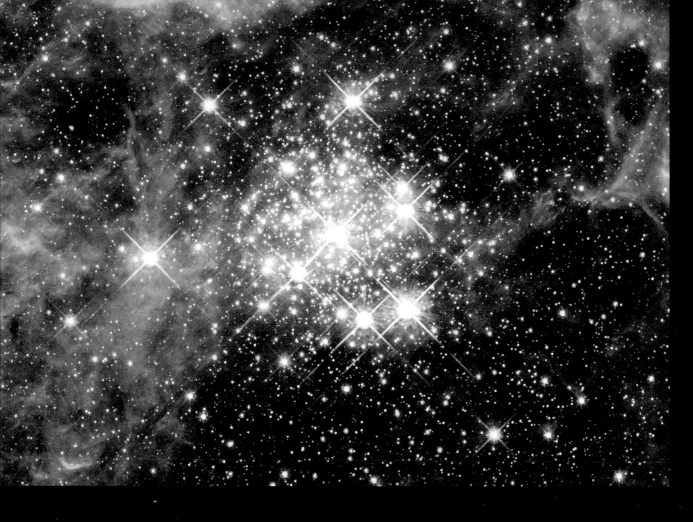

[right]

LARGE MAGELLANIC CLOUD GALAXY

The Herschel Space Observatory and NASA's Spitzer Space Telescope took this stunning infrared image of the Large Magellanic Cloud (LMC) galaxy in 2012. The circular arrangement may look like plumes of fire spiraling out of an explosion, but they are actually clouds of dust snaking out into the cosmos, reaching as far as hundreds of light years. The bright spots in the center and to the left of center are areas where new stars are forming. The coolest areas of the galaxy are pictured in red and green (captured by the Herschel), while the hottest spots are imaged in bursts of light blue (captured by the Spitzer). Roughly 163,000 light years from Earth, the LMC is a dwarf galaxy (a small galaxy composed of several billion stars) and a satellite galaxy of the Milky Way.

[above]

HODGE 301

This Hubble Space Telescope image, taken in October 2011, reveals the star cluster known as Hodge 301, which can be found about 170,000 light years away within the Tarantula Nebula in the Large Magellanic Cloud. The cluster, approximately 20 to 25 million years old, is a playground for red supergiants— the most voluminous stars in the universe. New stars are born in the Hodge 301 cluster all the time, but because they are obscured by dense gas that results from supernova explosions, they aren't visible to us.

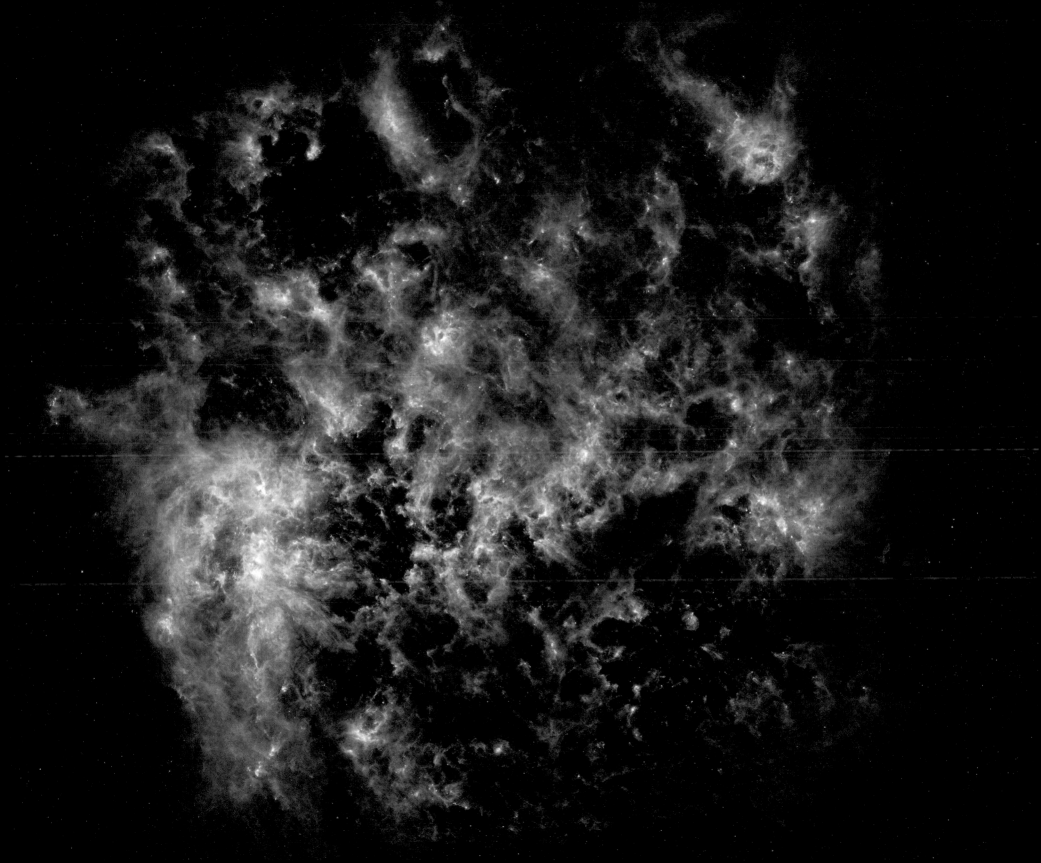

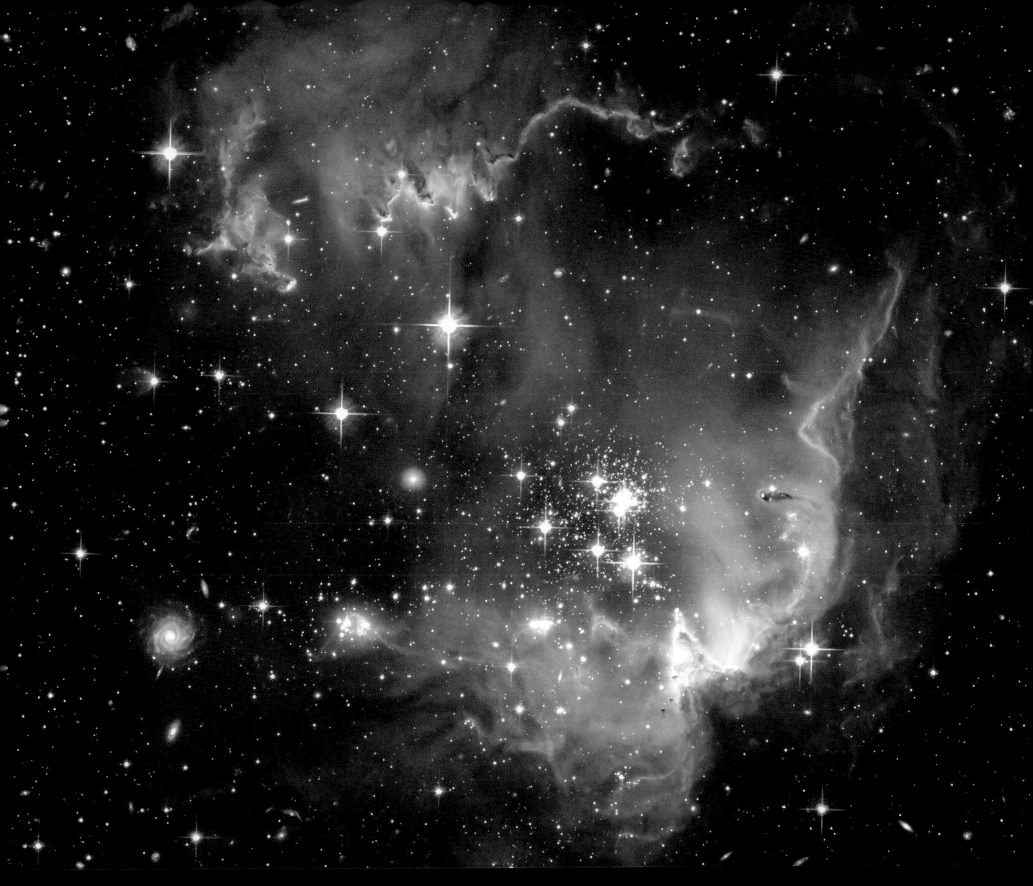

SMALL MAGELLANIC CLOUD

The Small Magellanic Cloud is a dwarf galaxy that flanks the Milky Way about 210,000 light years away from us, but it's so bright that it can easily be seen from Earth in regions along and below the equator. During the time of New World exploration, the Small Magellanic Cloud was routinely used by seafarers for navigation. The Small Magellanic Cloud is considered a fragmentary galaxy, as it contains fundamental matter that is responsible for the formation of larger galaxies. Generally, such galaxies tend to be far away from us, so the proximity of the Small Magellanic Cloud gives us an unusual opportunity to observe the formation of larger galaxies and even of the universe. New Chandra X-ray Observatory data reveals low-mass stars, much like our Sun, emitting X-ray radiation. This 2013 composite image of the galaxy's wing shows a region with stars containing fewer metals and less dust and gas than the Milky Way. The Chandra's X-ray data is shown in purple, while visible data from the Hubble Space Telescope is shown in red, green, and blue. Infrared data from the Spitzer Space Telescope is also revealed in red.

NGC 346

This 2005 Hubble Space Telescope image highlights
a fleet of tiny stars within the nebula NGC 346 in
the Small Magellanic Cloud. The stars in NGC 346
have few heavy elements, which tend to form through
nuclear fusion as stars evolve. This image shows us
about 70,000 stars—2,500 of which are infant stars.
The eldest stars are our Sun's age, a stately five billion
years old, while the younger populations are in the
ballpark of five million years old. The infant stars are
arranged along two strips of dust and gas (which are
positioned diagonally from southwest to northeast and
northwest to southeast across the blue cloud).

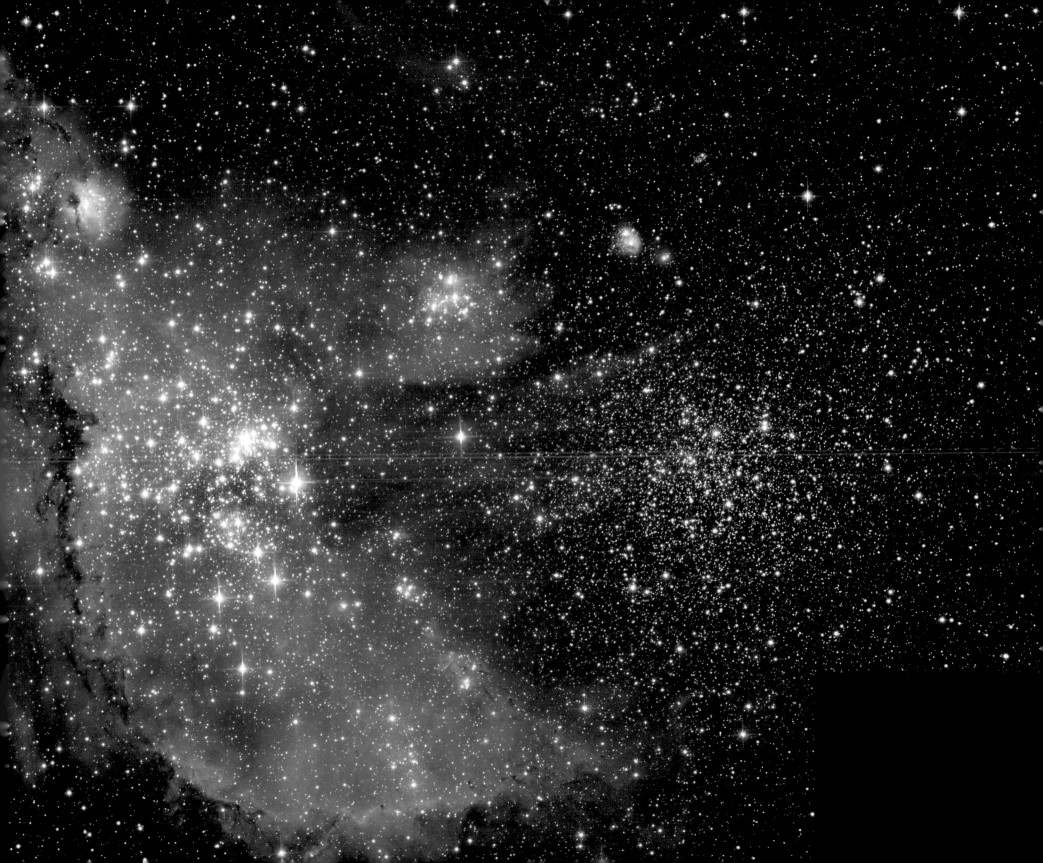

SUPERNOVA REMNANT

This Hubble Space Telescope image, assembled from exposures captured on July 4, 1995, and October 15 and 16, 2003, shows a nearby galactic explosion following the deadly wake of a supernova in the Small Magellanic Cloud. The supernova remnant is called E0102 and is located 50 light years from the star cradle known as N76 — the delicately glowing, pink-and-purple region in the upper right of the image. E0102, the wispy blue shape in the bottom-center, is only two thousand years old.

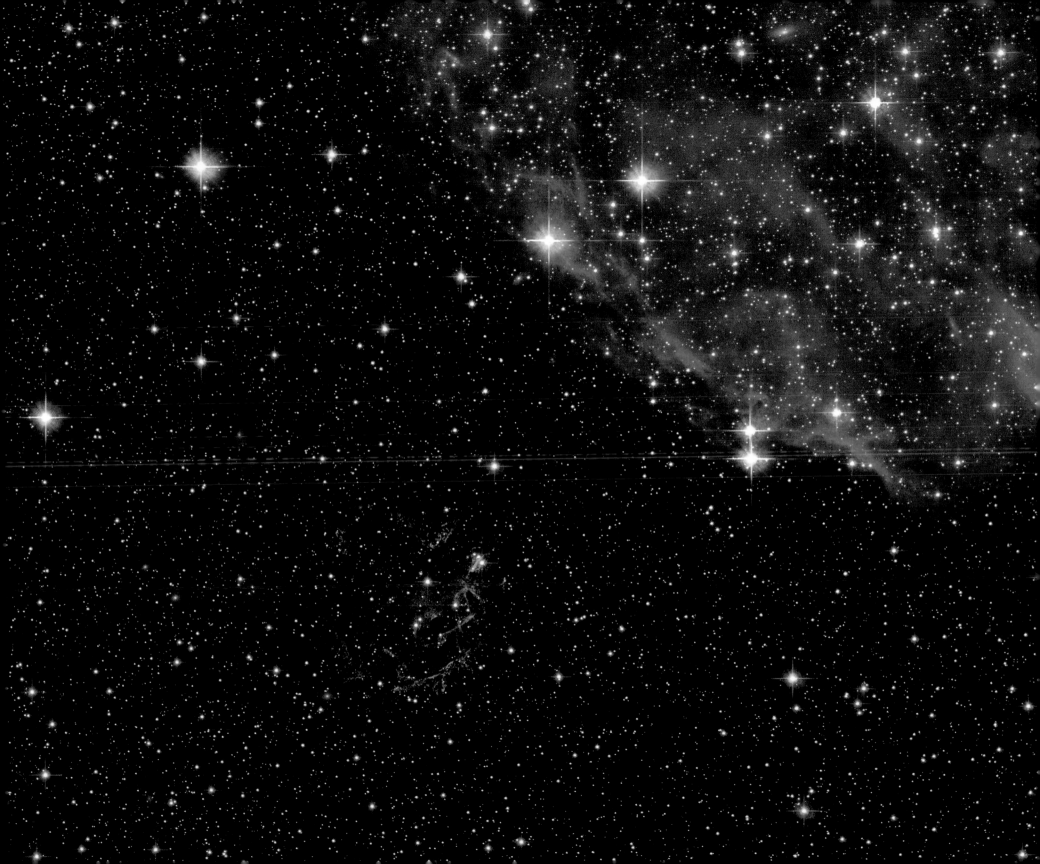

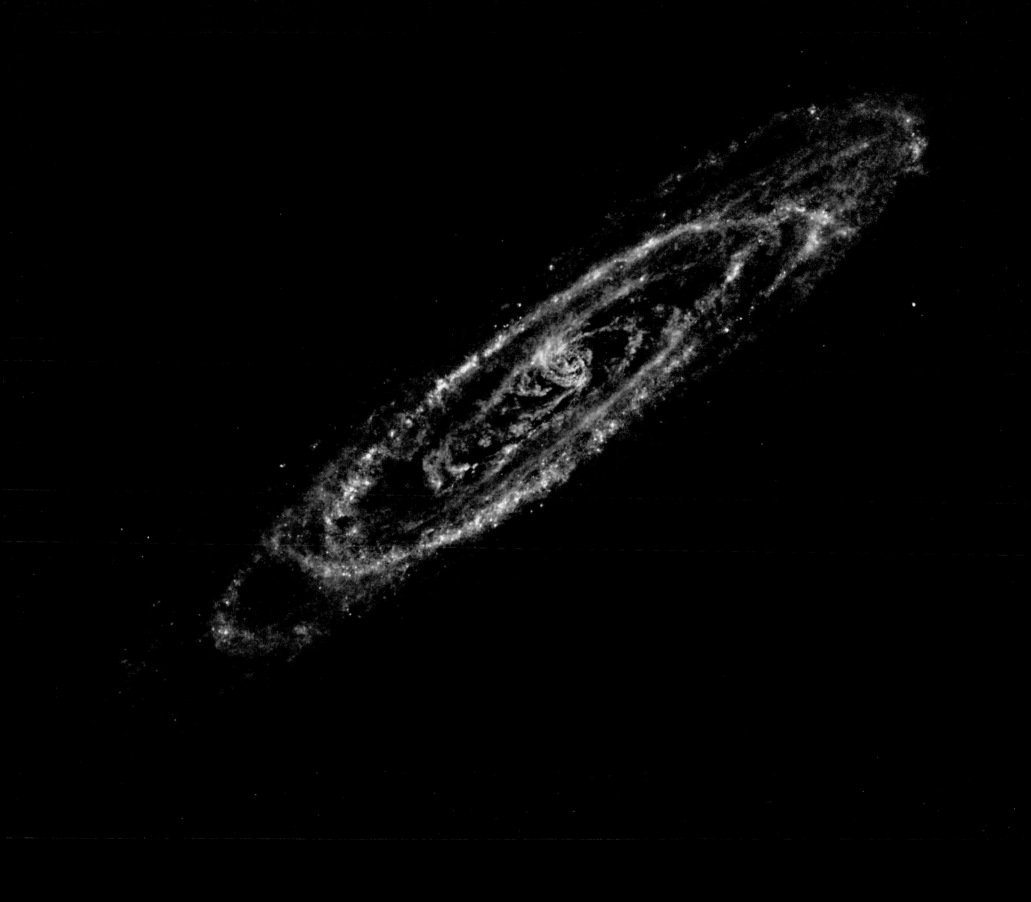

ANDROMEDA GALAXY DETAIL

Our "sister galaxy," Andromeda, is captured in stunning detail in this 2013 photograph taken by the Herschel Space Observatory. At 2.53 million light years away from us, the galaxy is the most distant object visible to the naked eye—but only from the darkest areas of the Earth, where there are clear skies and no light pollution. In this image, cold dust (matter that is only tens of degrees above absolute zero) is captured in infrared light, which appears in yellow and red. The hotter star-producing regions of the galaxy appear very dimly in blue. Although Andromeda has roughly a trillion stars compared to the Milky Way's half a billion, our galaxy is far more massive because it contains more dark matter. In a few billion years, we can expect to undergo a cosmic fender-bender with Andromeda, which will lead to the formation of one massive galaxy.

ANDROMEDA GALAXY STAR ACTIVITY

This composite image captured in 2006 by NASA's Galaxy Evolution Explorer and the Spitzer Space Telescope highlights the activity afoot in the Andromeda Galaxy. In the spiral arms of the galaxy, hot and cool stars congregate together. The hotter regions overflow with a flurry of star activity, with hot stars depicted in blue and older stars as green dots. Meanwhile, the red areas of the galactic disc are cooler regions where cocoons of dust drape newborn stars, providing embryonic sacs for their development. The Andromeda Galaxy is 260,000 light years across and has several black holes dispersed across its entire length, including a massive black hole at its center that gave the galaxy its shape.

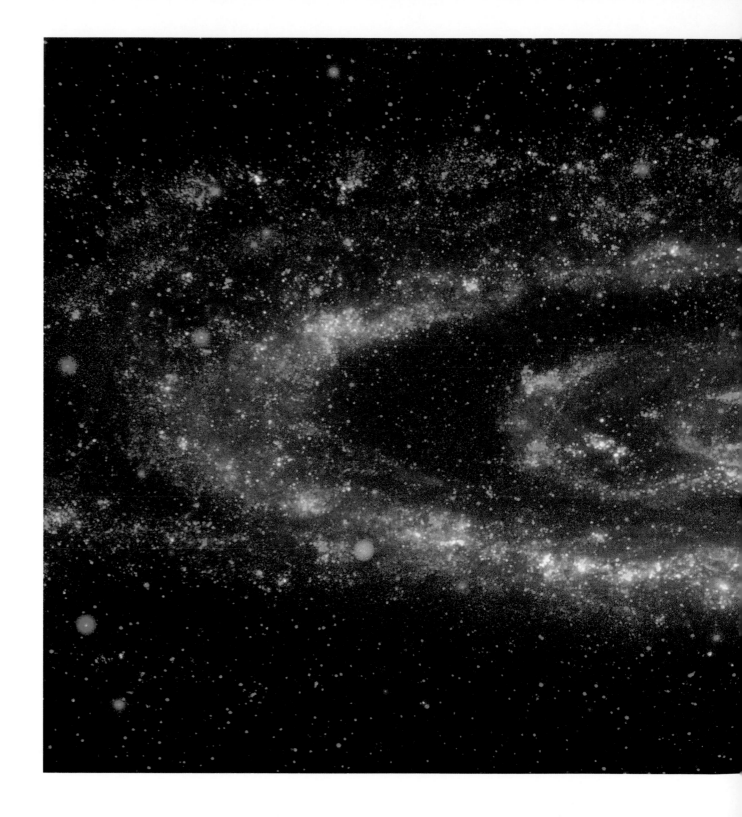

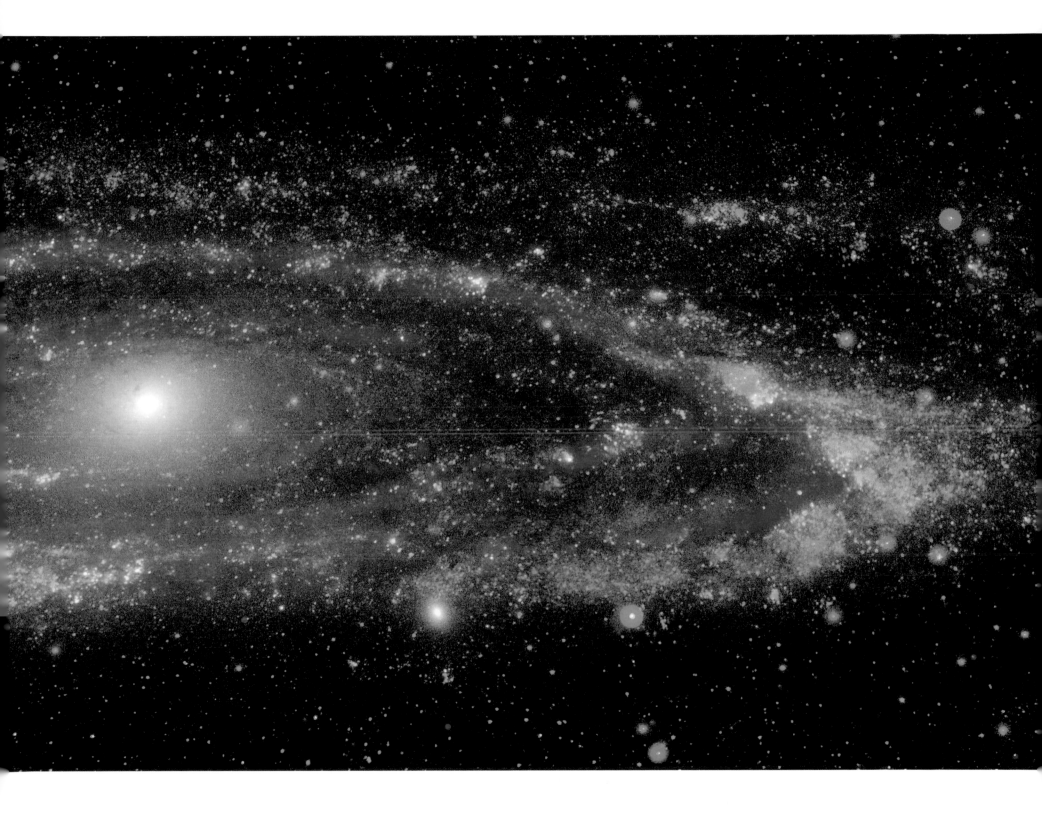

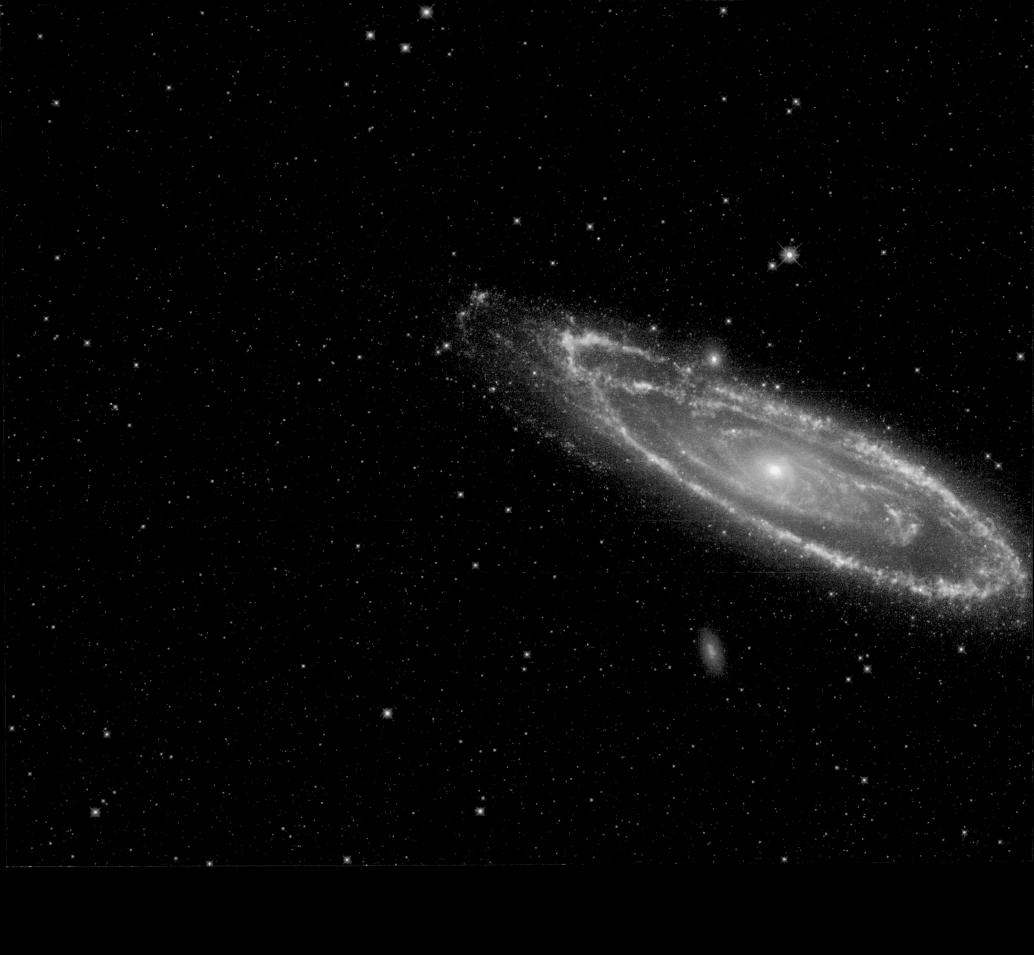

ANDROMEDA GALAXY AND SATELLITE GALAXIES

This image, taken by the Wide-field Infrared Survey Explorer (WISE) in 2010, shows the Andromeda Galaxy in an area equivalent to 5 degrees across the sky. In the galaxy, the blue areas highlight mature stars, while the yellow and red areas feature dust that is heated by massive newborn stars. We can also see two satellite galaxies in the image: Messier 32 (M32), the blue dot just above Andromeda, to the left of its center and almost touching the outer spiral arm; and Messier 110 (M110), the hazy blue oval below the central spiral of Andromeda. These are just two of the many galaxies tied to Andromeda by its gravitational pull. The Andromeda Galaxy and our Milky Way Galaxy belong to something known as the Local Group, a collection of over fifty galaxies that will eventually be mapped by WISE.

CEPHEID VARIABLE

In this vast, scattered field of stars is the star known as V1 (short for Hubble variable number one), in the lower left of the image. This star, discovered by Edwin Hubble in 1923, is part of the massive Messier 31 (M31) star cluster, or the Andromeda Galaxy. V1 is famous because it is a Cepheid variable, a massive star with oscillating luminosity, which is caused when a star expands and contracts. As Hubble discovered, Cepheid variables can be used to determine an entity's distance from Earth. Hubble used V1 to prove that galaxies like Andromeda are separate from the Milky Way—a monumental discovery on the path to investigating the scope of the universe beyond our own galaxy. The image was taken by the Hubble Space Telescope between December 2010 and January 2011.

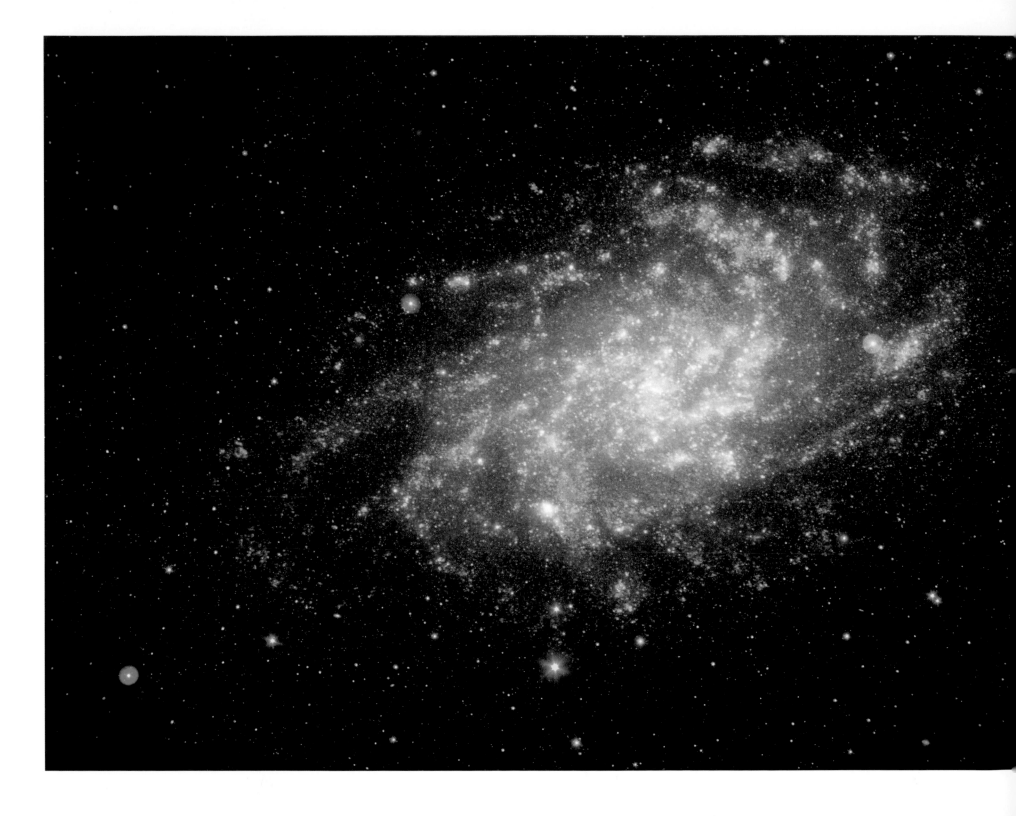

M33 GALAXY

NASA's Galaxy Evolution Explorer is responsible for studying galaxies beyond the Milky Way with its far-ultraviolet detector. Looking at the brightness, size, and distance of far-flung galaxies spanning ten billion years of interstellar history offers us an enormous amount of information about the nature of our cosmos. Here, we see a composite image of Messier 33 (M33), or the Triangulum Galaxy, taken in 2009 by the Galaxy Evolution Explorer and NASA's Spitzer Space Telescope. After the Andromeda Galaxy, M33 is our closest spiral galaxy neighbor and is approximately 2.9 million light years away from us. The Spitzer captures mid-infrared radiation, which comes from dust that has gulped down ultraviolet light from young stars. In the image, far-ultraviolet light from young stars glows blue; near-ultraviolet light from middle-aged stars is green; near-infrared light from old stars is yellow; and the dust is red. The blue flecks in the background are most likely distant galaxies.

SAGITTARIUS DWARF IRREGULAR GALAXY

This 2003 Hubble Space Telescope image of the Sagittarius Dwarf Irregular Galaxy, better known as SagDIG, offers us a crisp picture of thousands of discrete stars. The brightest stars are actually in the foreground of the picture, around the edges; they are in the Milky Way and live only a few thousand light years away from us. SagDIG, however, is the central mass of much smaller blue stars and is 3.5 million light years away. The reddish spots strewn throughout the center of the image are background galaxies that are several million light years beyond SagDIG. A dwarf irregular galaxy has no identifiable structure and is very small, with few elements of higher mass than helium. This lack of heavy elements can point to a galaxy's youthfulness, since it can mean that stars haven't been around long enough to create or disperse heavier elements. However, the Hubble can capture details about chemical composition and age, so we know that SagDIG is quite old, even though some forms are still actively being created in it. Perhaps formed in our universe's early cosmic history, SagDIG's diminutive size could mean that it is the leftover offal of a previous, larger galaxy.

INTERGALACTIC DANCE: MESSIERS 81 AND 82

In this 2011 image captured by the Wide-Field Infrared Survey Explorer, the far-off galaxies of Messiers 81 and 82 (M81 and M82) are engaged in an elegant dance in space. Twelve million light years away from us, these galaxies will continue to spin in this interlocked dance for a few million years before finally merging into a single galaxy. The dance is not without its consequences—the interaction between the whirling galaxies creates new stars. Both galaxies are referred to as starburst galaxies, due to their unusually high rate of star formation. M81, on the left of the image, is considered a "grand design" spiral galaxy, as its spiral arms are highly defined. In these arms, compressed gas and dust form new stars, and the gravitational impact of M82 leads to further compression, which increasingly defines the arms. M82 is also considered a spiral galaxy, though it wasn't classified as one until 2005 when it was viewed in infrared and a spiral structure was deciphered. M82 is known as the Cigar Galaxy due to its shape when seen in visible wavelengths. The superwinds blown out from M82's newly formed stars look like cigar smoke emitted from the galaxy.

MESSIER 83 SPIRAL GALAXY

This image is one of the most detailed images of star formation we have. Here we see the spiral galaxy Messier 83 (M83), also known as the Southern Pinwheel Galaxy, a radiant area of stars and dust. Star births are quite customary in M83, which is 15 million light years away from us. In this 2009 image, the Hubble Space Telescope captured a close-up of newborn clusters of stars, primarily blue and red supergiants, which range from one to ten million years old. The Hubble's Wide Field Camera 3 boasts a broad wavelength, from ultraviolet to near-infrared, which has the capacity to show us stars at varying phases of evolution. The newest stars live in the darker dust lanes on the spiral arms of the galaxy and bubble out red hydrogen gas. The carved-out areas in the spiral arms are created by strong winds that push back the gas, allowing us to see star clusters that may have been otherwise obscured. This gas is then funneled to the center of the galaxy, where the brightest stars are in the process of being born.

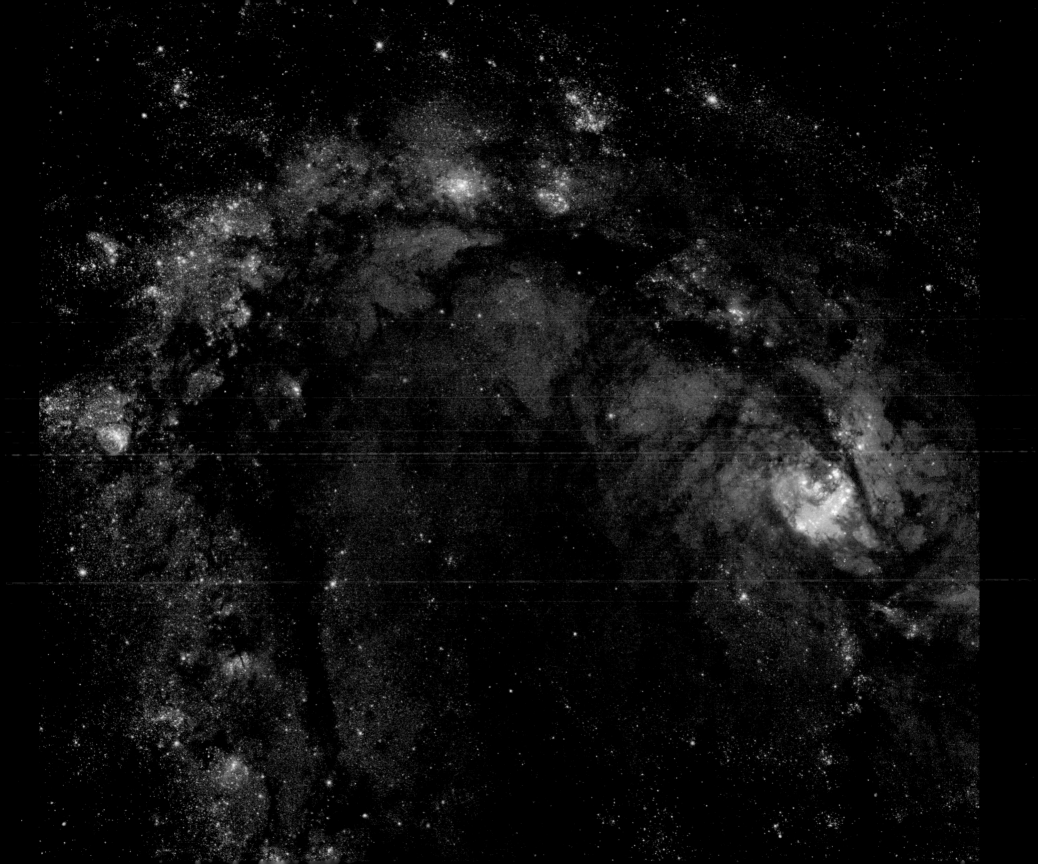

[*left*]

BLACK EYE GALAXY

In April and July 2001, the Hubble Wide Field and
Planetary Camera 2 took this color composite image
of Messier 64 (M64), which is also known as the
Sleeping Beauty Galaxy or the Black Eye Galaxy
because of the dark dust band that swathes its bright,
eye-like center. Roughly 17 million light years from
Earth, M64 is the result of a collision between two
galaxies. While M64 looks like a pinwheel-shaped
spiral galaxy, it bears a significant difference: the stars
in a spiral galaxy rotate in the same direction, but
M64's outer region rotates in the opposite direction
from its inner region. The collision that resulted in
M64's idiosyncratic features likely took place over a
billion years ago.

[*right*]

OLD SUPERNOVAE

The spiral galaxy NGC 6946, also known as the Fire-
works Galaxy, is 22 million light years from Earth.
The Chandra X-ray Observatory, which collected
the data for this image between 2001 and 2004, has
found three of the oldest supernovae in this galaxy,
and in the last century, eight supernovae have been
observed here. In our galaxy—the Milky Way—
supernovae occur about once every fifty years, but they
are generally difficult to detect, as dust in our galaxy
can block our view of the spectacular explosions.
The Chandra X-ray Observatory was launched by the
space shuttle *Columbia* in 1999, and it is the most
sophisticated observatory of its kind, boasting the
smoothest and most optimally shaped mirrors ever
made. It's particularly instrumental in helping us
understand the more chaotic, high-energy areas of the
cosmos—which give us an integral glimpse into the
nature of stellar and galactic formation.

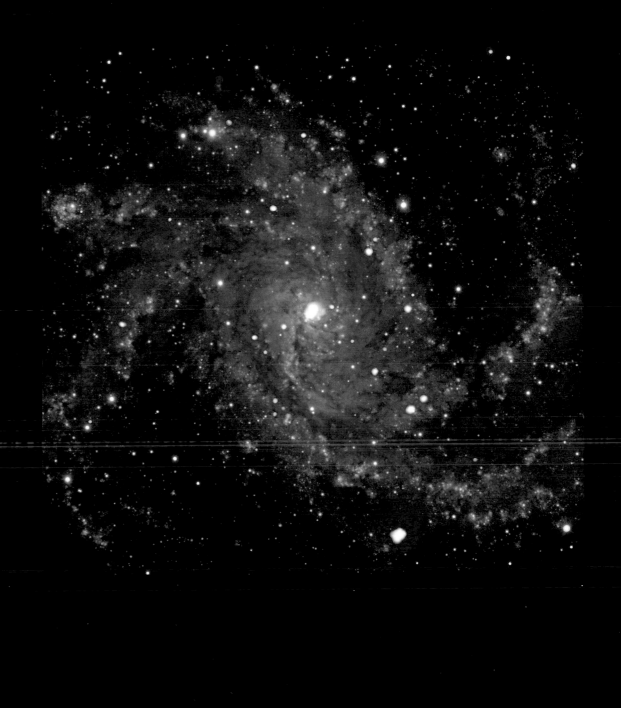

[*right*]

MESSIER 101

In a galaxy far, far away—roughly 22 million light years from Earth—we can see the distinct shape of the Pinwheel Galaxy, Messier 101 (M101). This spiral galaxy is 114,000 light years across, almost double the size of our own Milky Way Galaxy. The area in this 2004 photograph is 22,500 light years across and features one of three thousand star-making regions in the galaxy, a hotbed of ultraviolet activity. The star-making regions are primarily in the galaxy's bright spiral arms, which most likely engulfed a nearby smaller galaxy not long ago. The darker spots captured in this image show the cooler, denser areas where older stars congregate. These older stars may collapse over time, generating the birth of new stars. The small bulge in the center is close to invisible at the ultraviolet end of the spectrum, revealing that there is little star formation in this area. The Hubble detectors typically produce cosmic snapshots in black and white, like this one. The color finishes come from image processing that fleshes out particular details (such as chemical composition and luminosity) and highlights specific objects and phenomena.

[*next spread*]

SOMBRERO GALAXY

In this 2003 Hubble Space Telescope image, the luminous core of Messier 104 (M104), also known as the Sombrero Galaxy, is surrounded by wide bands of thick dust. From Earth, it resembles the wide brim and high top of a sombrero. The galaxy is massive—the size of 800 billion Suns—and lives within the southern part of the Virgo cluster of galaxies. Twenty-eight million light years from Earth, the galaxy is home to a surfeit of globular star clusters. M104 reveals a great deal of X-ray emissions, suggesting the outflow from a black hole a billion times bigger than our Sun. In 1912, the astronomer V. M. Slipher determined that the Sombrero Galaxy is moving away from us at 700 miles (1,126 kilometers) per second, one of the first discoveries that led scientists to conclude that the universe is expanding. Recent observations from the Spitzer Space Telescope reveal that Messier 104 is actually made up of two galaxies—a flat disc galaxy embedded within a large elliptical galaxy.

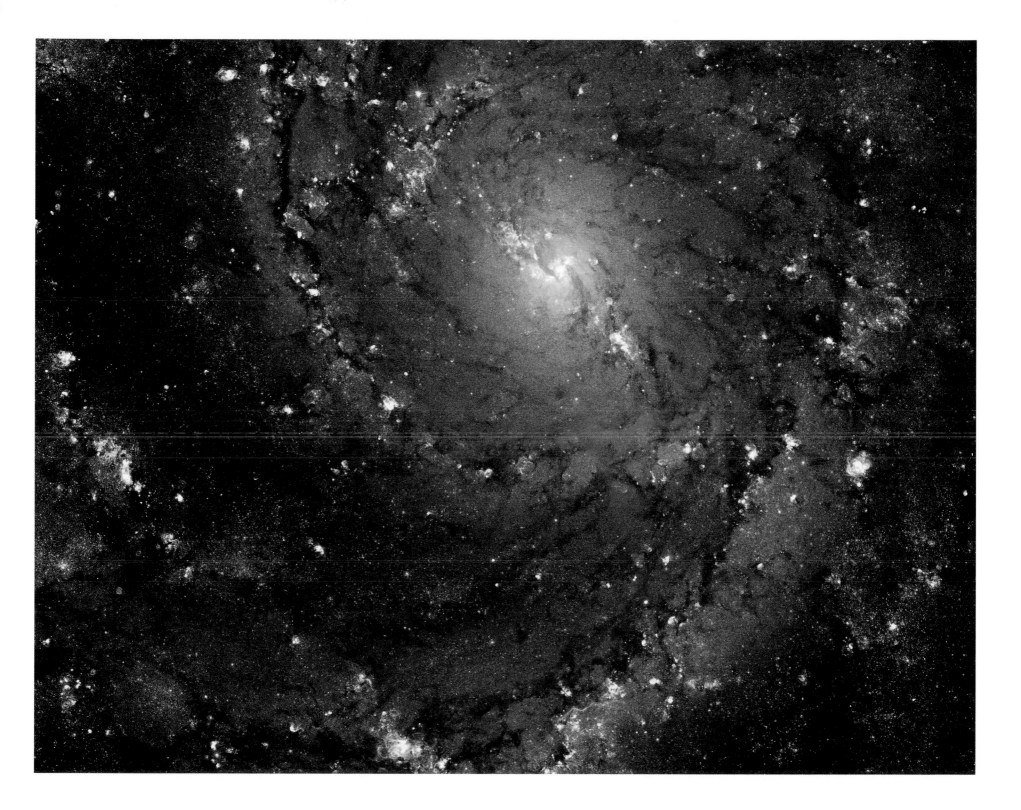

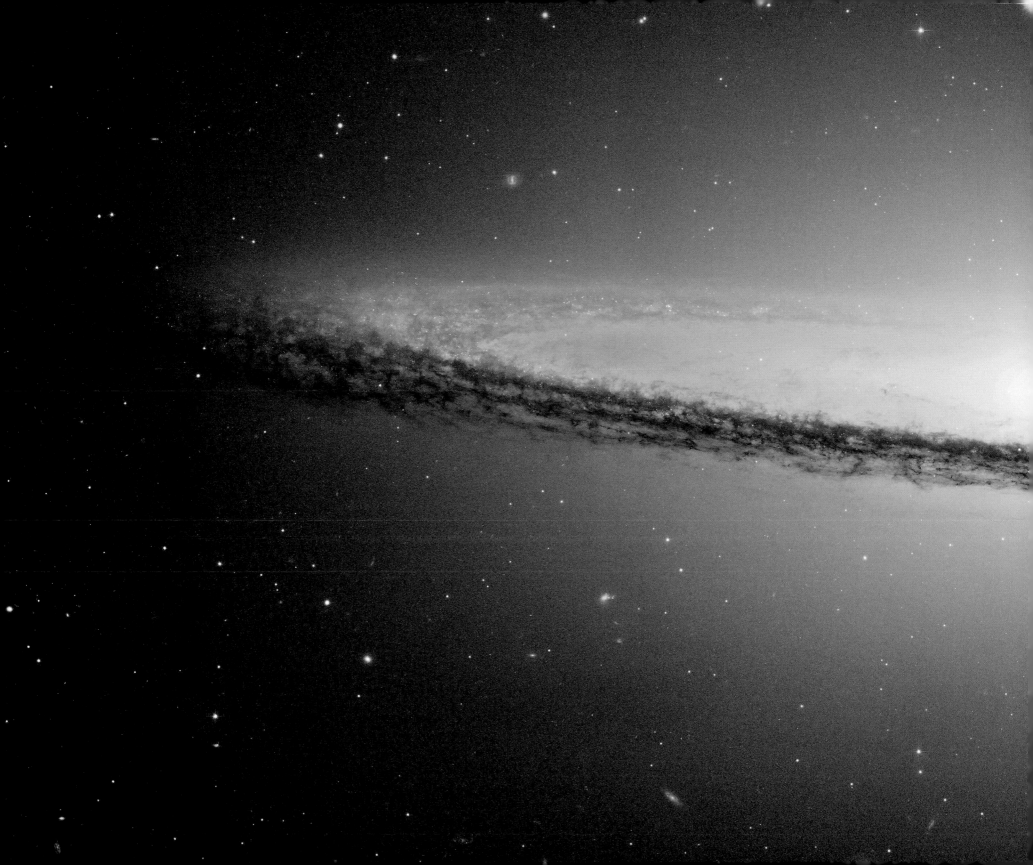

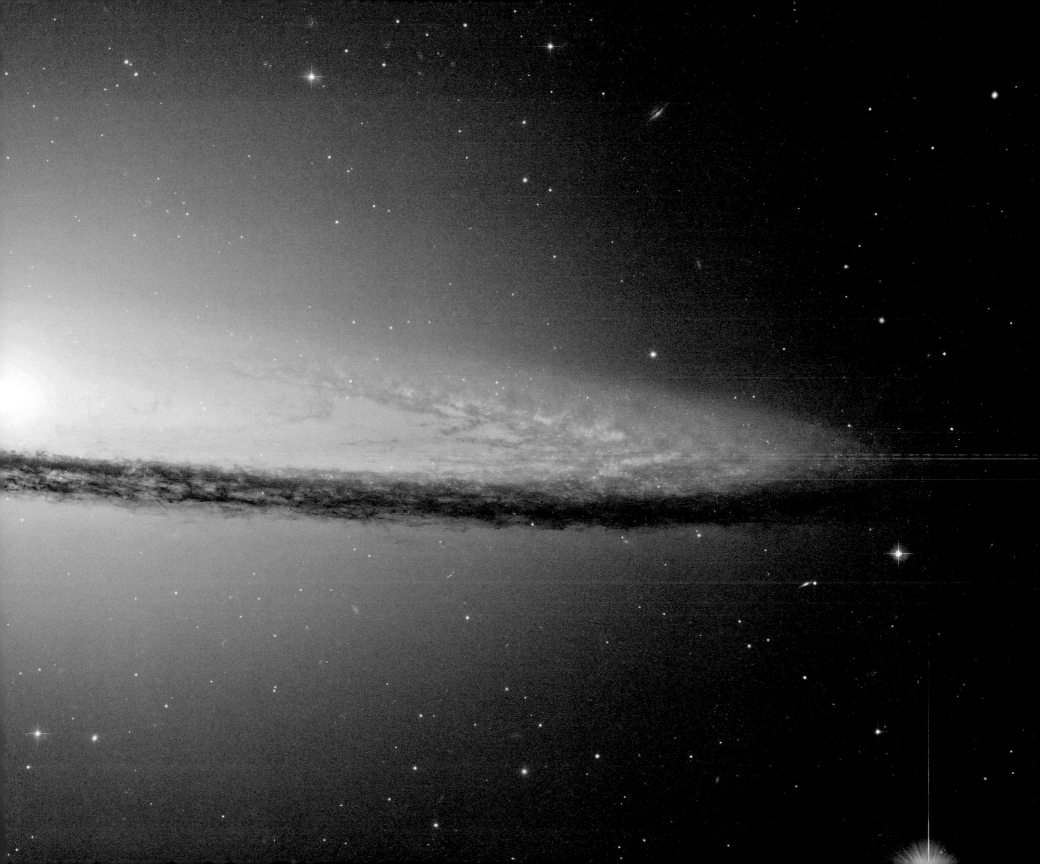

GALACTIC COLLISION

In 2013, the Chandra X-ray Observatory recorded this spectacular display of galactic movement—which features a dwarf galaxy (which cannot actually be seen) colliding with a large spiral galaxy known as NGC 1232. The galaxies are about 60 million light years from Earth, and the temperature of the enormous cloud of gas generated by the merger is millions of degrees. The impact of the collision produces a shock wave similar to a sonic boom. The gas from the shock wave appears as a comet-like orb, starting at the top left corner, and at the head of the "comet," at the bright pink-white spot to the right of the galaxy, is an area of luminous stars formed in the violent shock wave. These stars emit X-rays that are likely to last for hundreds of millions of years. This two-dimensional image doesn't provide us with information on the gas cloud's mass, but if the gas is spherical, the mass could be up to three million times greater than the Sun; if the gas is thin and flat, it could be the equivalent of forty thousand Suns. The collision is still happening and could go on for another forty million years. Amazingly, galaxies that are created through this kind of merger often leave many of their respective star systems intact.

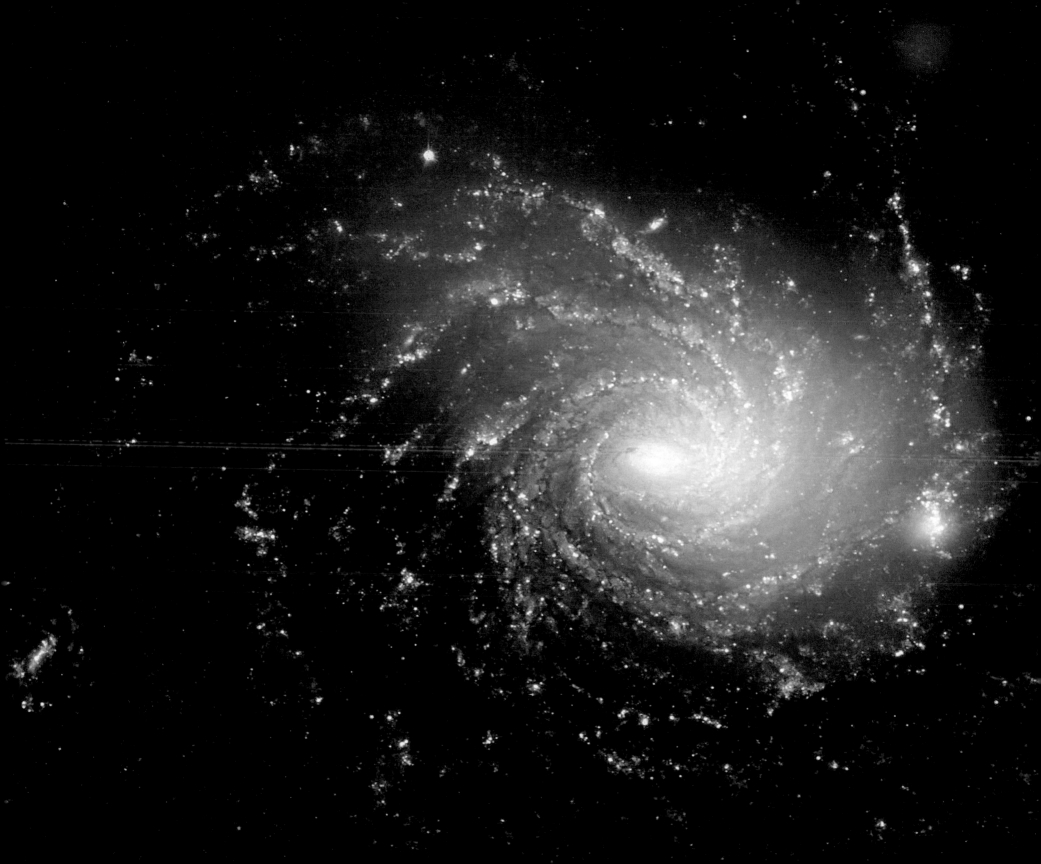

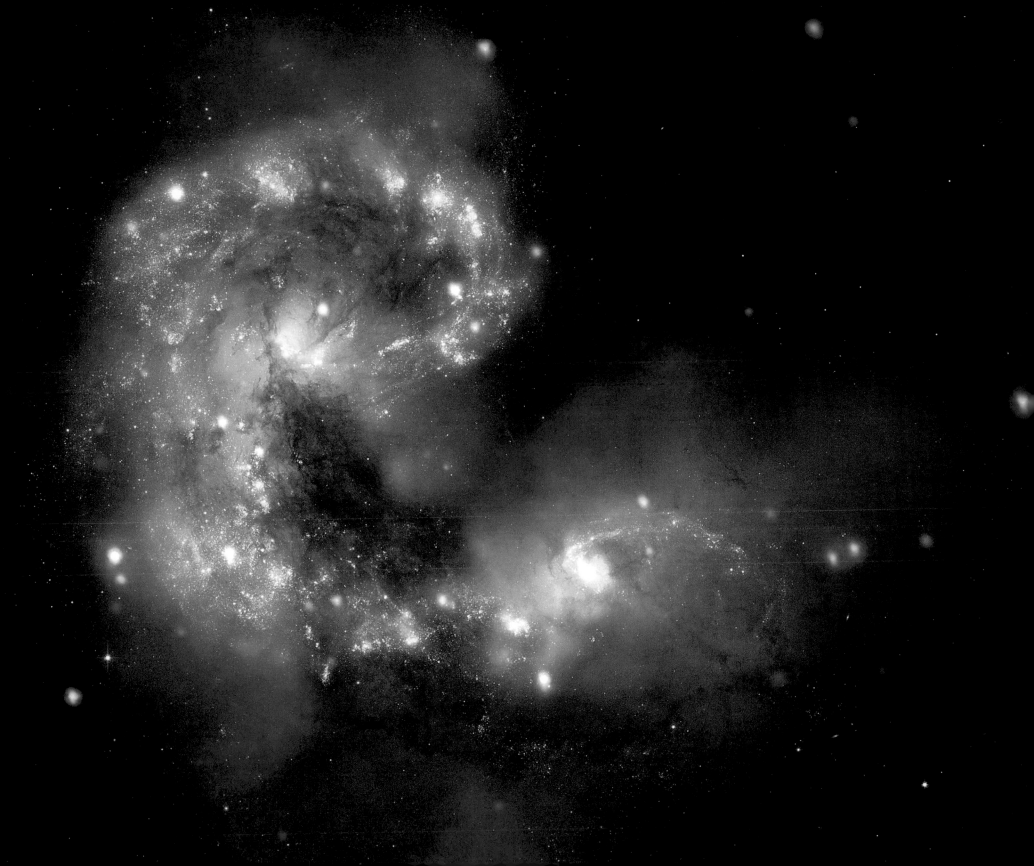

ANTENNAE GALAXIES

This spectacularly colorful image of the Antennae Galaxies is a composite created with data recorded by the Chandra X-ray Observatory in December 1999, the Hubble Space Telescope in July 2004 and February 2005, and the Spitzer Space Telescope in December 2003. Sixty-two million light years from Earth, the antenna-like arms (not pictured) of the two galaxies first arose from the energy released during their collision, which began a hundred million years ago and continues today. Many of the stars in the Antennae Galaxies went through relatively short life cycles before going supernova and ejecting gases, including oxygen, iron, magnesium, and silicon—rich detritus for forming new stars. The spots of luminosity in the image occur when these gases come into contact with black holes and neutron stars (the dense remnants of star explosions). The gases are compressed and the pressure results in the birth of billions of stars, many of which gather together in dense clumps of tens of thousands of stellar bodies. In studying these star clusters, scientists have found that only 10 percent of them will live past ten million years, at which point the stars will eventually disperse. The collision of the Antennae Galaxies gives us a vivid picture of what might happen when the Milky Way and Andromeda finally merge.

FACE-ON SPIRAL GALAXY

Sixty-eight million light years away in the constellation Ursa Major, the spiral galaxy NGC 3982 is 30,000 light years across, about one-third the size of the Milky Way. Like the Milky Way, NGC 3982 is composed of a flat disc of gas, dust, and stars, with a dense and bulging center and arms that dissipate in mass and spiral out. The various distinctive galactic shapes, ranging from "pinwheels" to "sombreros," are created by the rate of spinning of the arms. In the nucleus of spiral-arm galaxies, older stars tend to clump together, while the arms serve as star-birthing regions lit up by phosphorescent hydrogen. The bulging center of each galaxy is thought to contain a gigantic black hole, although the light from surrounding stars can often make this hard to verify. This image is a composite of data recorded between 2000 and 2009.

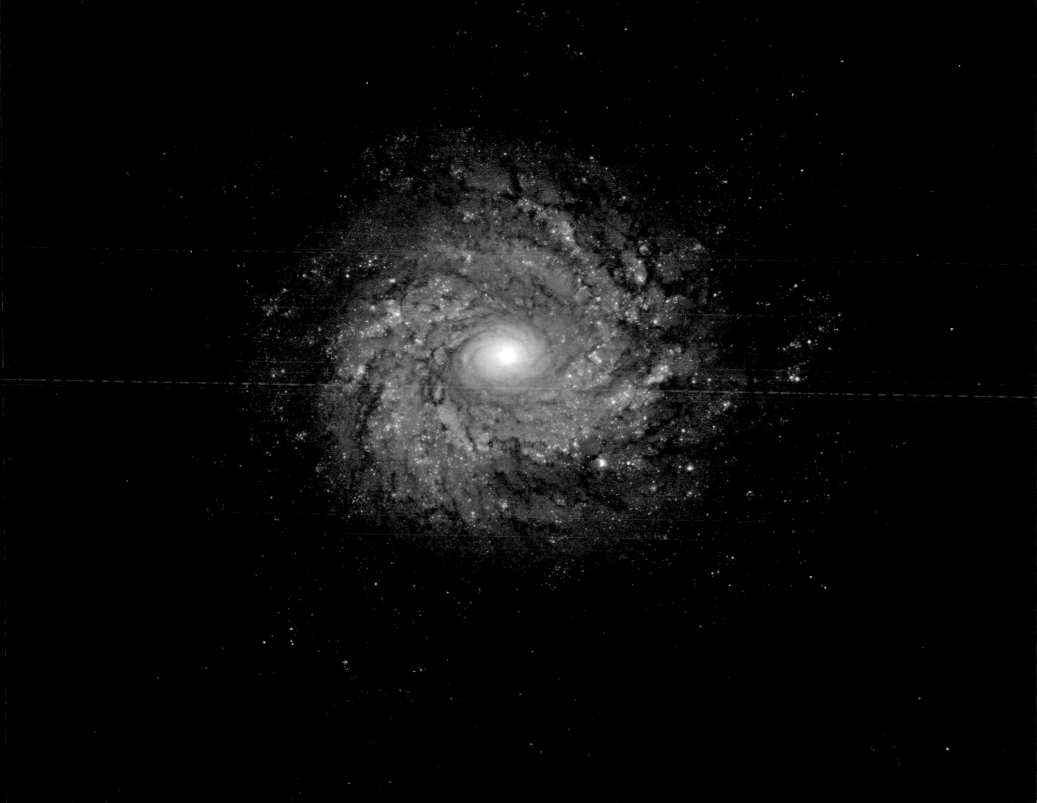

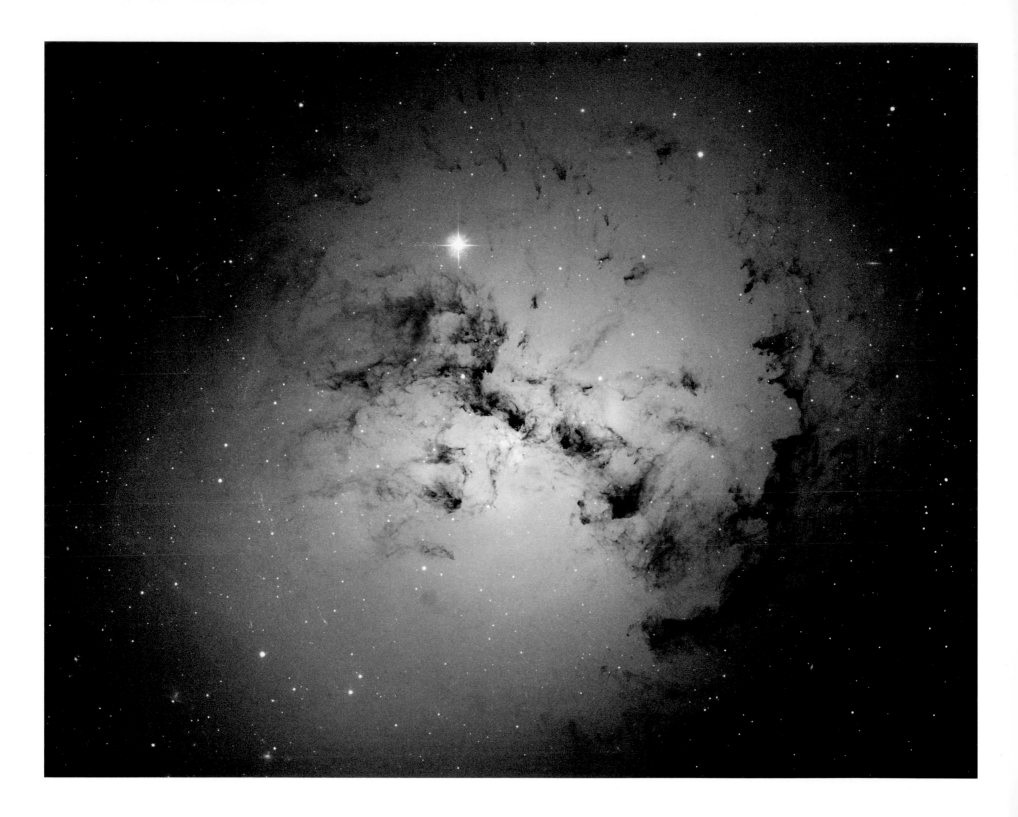

NGC 1316: A DUSTY GALAXY

Dust is the main source of stellar debris in galaxy NGC 1316. Located in the Fornax cluster of galaxies about 75 million light years from Earth, this elliptical galaxy was formed, scientists believe, after the collision of several spiral galaxies. NGC 1316 is one of the largest radio sources in the sky; its radio emission is most likely caused by material drifting into the black hole at the galaxy's center. NGC 1316 is pocked by visible battle scars—the tidal tails in the galaxy emerged from the shells of stars that were torn off and catapulted into space, most likely the result of gravitational forces from another nearby galaxy. This image was taken by the Hubble Space Telescope's Advanced Camera for Surveys in March 2003.

NGC 922

The spiral galaxy NGC 922 is 75,000 light years across and about 150 million light years from Earth. Roughly 330 million years ago, NGC 922 was distorted when a smaller galaxy collided with the spiral galaxy. As the smaller galaxy passed through the center of NGC 922, it disturbed clouds of gas, which led to the formation of new stars. The pink color in this 2012 Hubble Space Telescope image indicates nebulae that surround the galaxy and is evidence of excited hydrogen gas affected by the activity of new stars. Observations from the Chandra X-ray Observatory have revealed X-ray knots in NGC 922, which scientists believe to be large black holes—a startling discovery, since the gas composition of NGC 922 is rich in heavy elements, which usually prevents the creation of black holes.

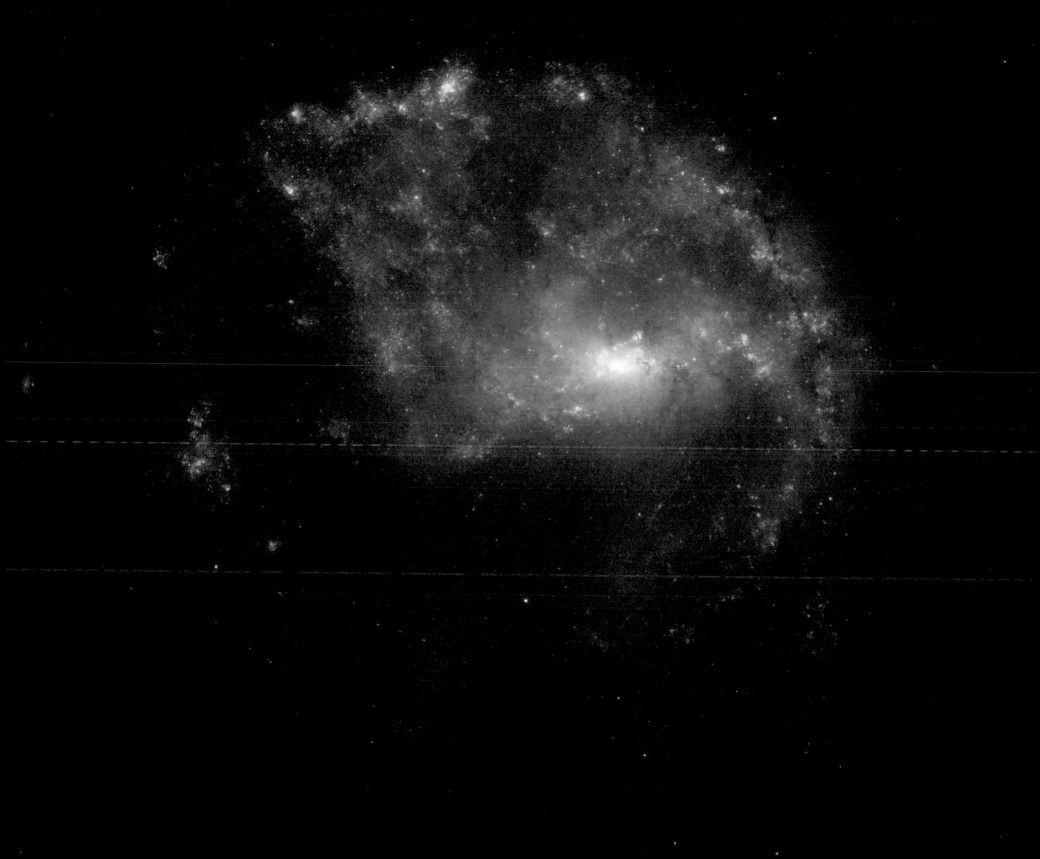

ARP 273 GALAXY DUO

About 300 million light years from the Earth, Arp 273 contains two galaxies that resemble a cosmic rose in the sky. UGC 1810, at right, is a large spiral galaxy with a disc bent out of shape by the gravitational pull of UGC 1813, which lies to the left of its mammoth partner. The bridge of gas between the galaxies separates them by tens of thousands of light years. In UGC 1813, stars are forming rapidly at the center due to the collision with the larger galaxy. The strange spiral patterns in UGC 1810 reveal that the smaller galaxy dove into it, warping the spiral arms of UGC 1810 in the process. When a smaller galaxy makes such a transit through a larger galaxy, it generally creates an asymmetrical pattern. Star formation tends to occur more rapidly in the smaller galaxy, as it usually has more available gas in its nucleus. This composite image was captured in December 2010 by the Hubble Space Telescope.

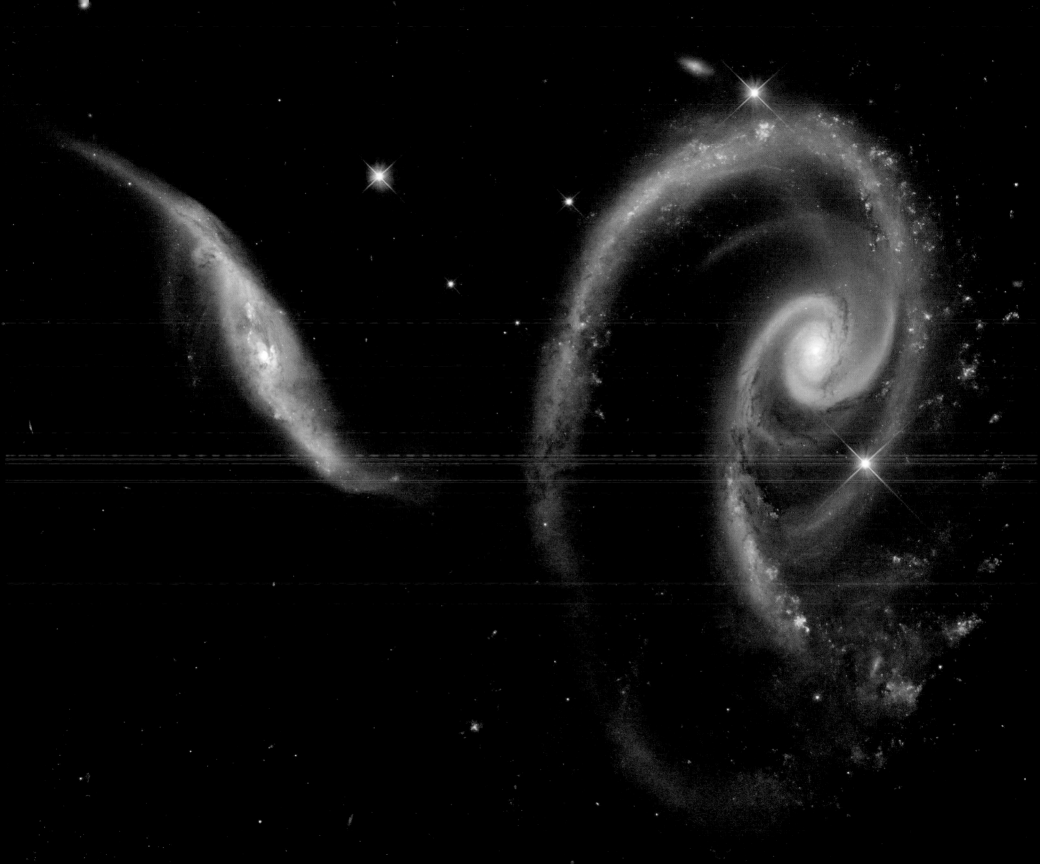

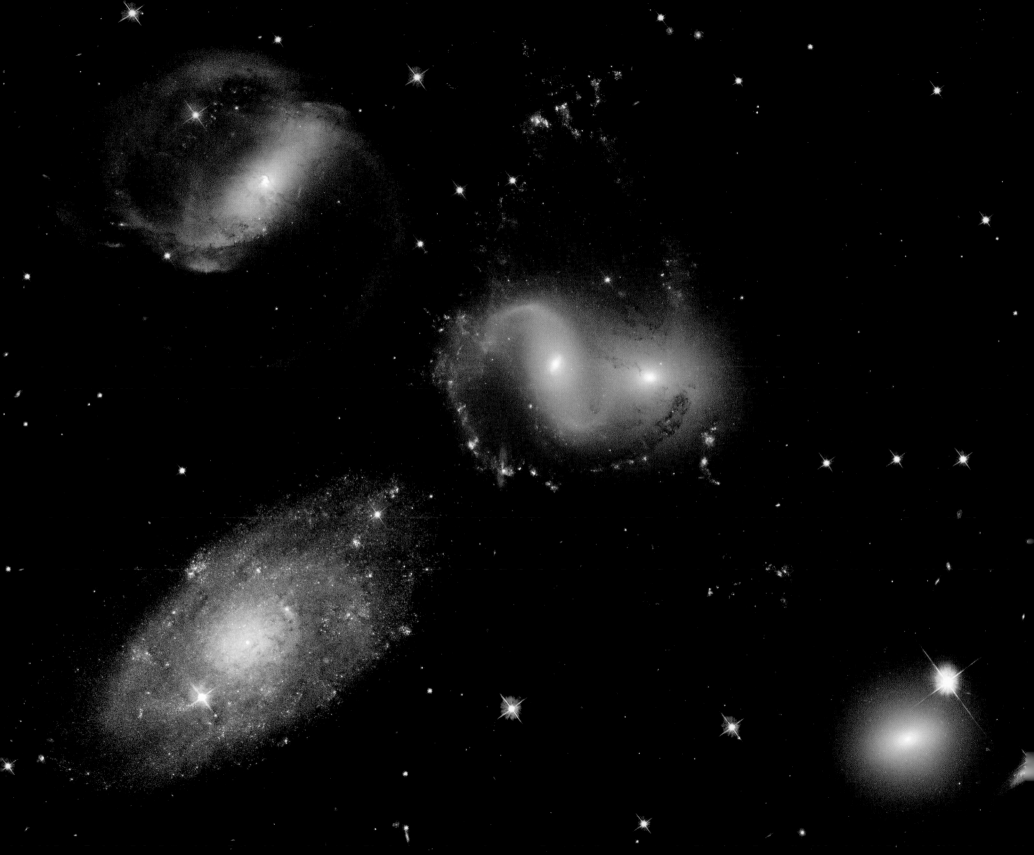

STEPHAN'S QUINTET

Stephan's Quintet is a cozy group of five galaxies 300 million light years away from us. Four of the galaxies are interconnected enough to affect each other in a demonstrable way—NGC 7319 (upper left), NGC 7318A and 7318B (together in the center), and NGC 7317 (lower right) all have a yellowish cast, and they sport loops and spirals that are the result of their collective gravitational pull on each other. These four galaxies are moving away from us at the same speed. NGC 7320, the bluish galaxy (lower left), is 40 million light years away from the rest of the group. The field of view in this image, captured by the Hubble Space Telescope's Wide Field Camera 3 in 2009, spans about 500,000 light years.

DARK MATTER MAP

In 2002, the Hubble Space Telescope took this mysterious image of Abell 1689, a cluster of galaxies located about 2.2 billion light years away. The foggy blue center of this photograph shows us the distribution of dark matter, which cannot actually be imaged but is represented in a colored overlay. The "dark matter map" is created by plotting the many arcs and rings from background galaxies whose light has been distorted by the gravitational field of dark matter. This phenomenon is known as gravitational lensing. Gravitational lensing occurs when light from an object is bent by a gravitational field that surrounds it. This can create distorted or multiple images of the object, and it enables us to detect the presence of dark matter. The universe is believed to be composed of 5 percent baryonic matter (the visible matter in the universe), 25 percent dark matter (a mysterious substance that is completely invisible and doesn't interact with baryonic matter at all, although it's perceived to have a gravitational effect on galactic clusters), and 70 percent dark energy (a force stronger than gravity that is believed to be responsible for the rapid expansion of the universe).

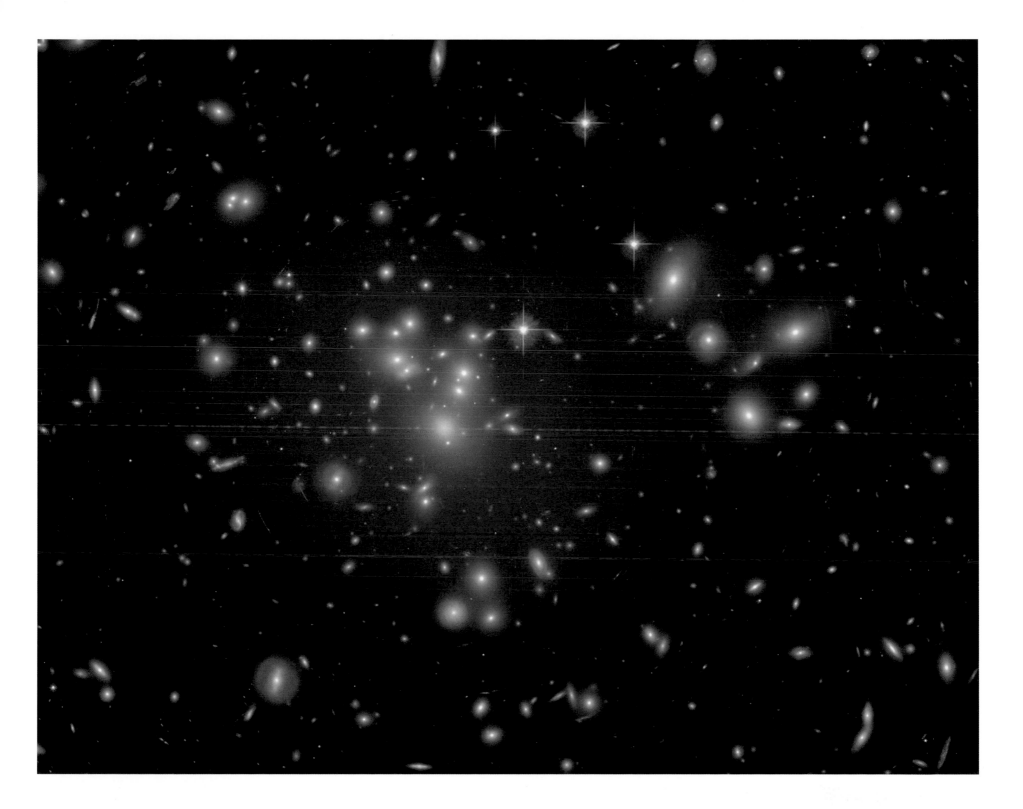

HYPERNOVA

This 2010 artist's concept image, based on Spitzer
Space Telescope observations, captures a hypernova (a
stellar explosion with more energy than a supernova)
3 billion light years from Earth that was almost
completely muffled by its own dust. Scientists believe
the source star was about fifty times more massive than
the Sun; as it died, it spewed out enormous clouds of
gas and dust, which glowed infrared and smothered
the luminosity of the starburst. The outer shell of the
hypernova first appeared in August 2007, then faded
from sight in 2008. The research team that studied
this phenomenon believes it may brighten again in a
decade, when light reaches us after the supernova's
shock wave pierces the outer shell of the dust cloud.

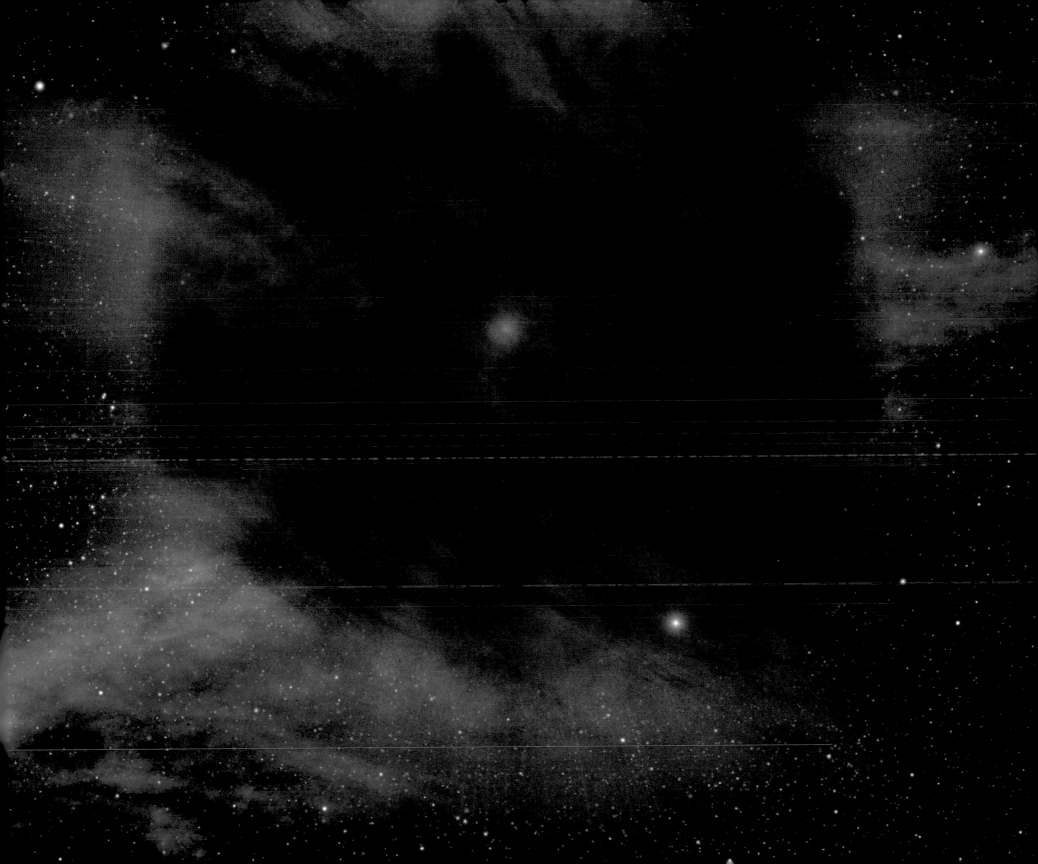

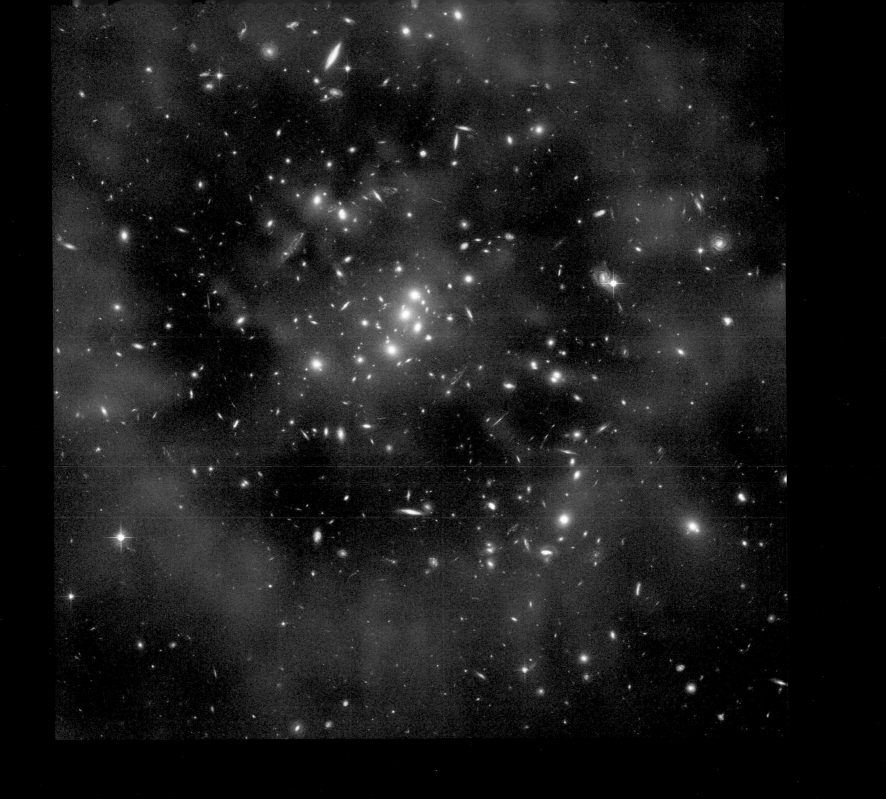

RING OF DARK MATTER

The galaxy cluster CL 0024+17 is 4 billion light years from Earth, and the gravity of the cluster bends the light of farther-away galaxies. In this image, taken in 2004 by the Hubble Space Telescope's Advanced Camera for Surveys, the ethereal foggy blue ring represents dark matter (which we can see thanks to the effect of gravitational lensing), which is made up of two giant galactic clusters melded together. Examining dark matter may help us to understand the even more elusive phenomenon known as dark energy. We don't know what dark matter is actually composed of, and some scientists believe our current understanding of physics will have to be dramatically expanded in order to explain the nature of these exotic particles.

PANDORA'S CLUSTER

This composite image of a clump of galaxies known as Pandora's Cluster was created with data collected by the Hubble Space Telescope, the European Southern Observatory's Very Large Telescope, the Japanese Subaru Telescope, and the Chandra X-ray Observatory in 2009. The image shows us the entirety of the enormous cluster in the colored foreground and offers detailed insight into Pandora's origins. Four smaller galaxy clusters collided to form this giant cluster, which is 4 billion light years away from us and took 350 million years to form. The mass of the galaxies makes up less than 5 percent of Pandora's overall mass—the majority of its mass is composed of dark matter (seen in blue) and hot gas (seen in red) that was stirred up when the galaxies collided. The dark matter was unaffected by the collision, but in some areas clouds of hot gas were completely stripped away in the impact.

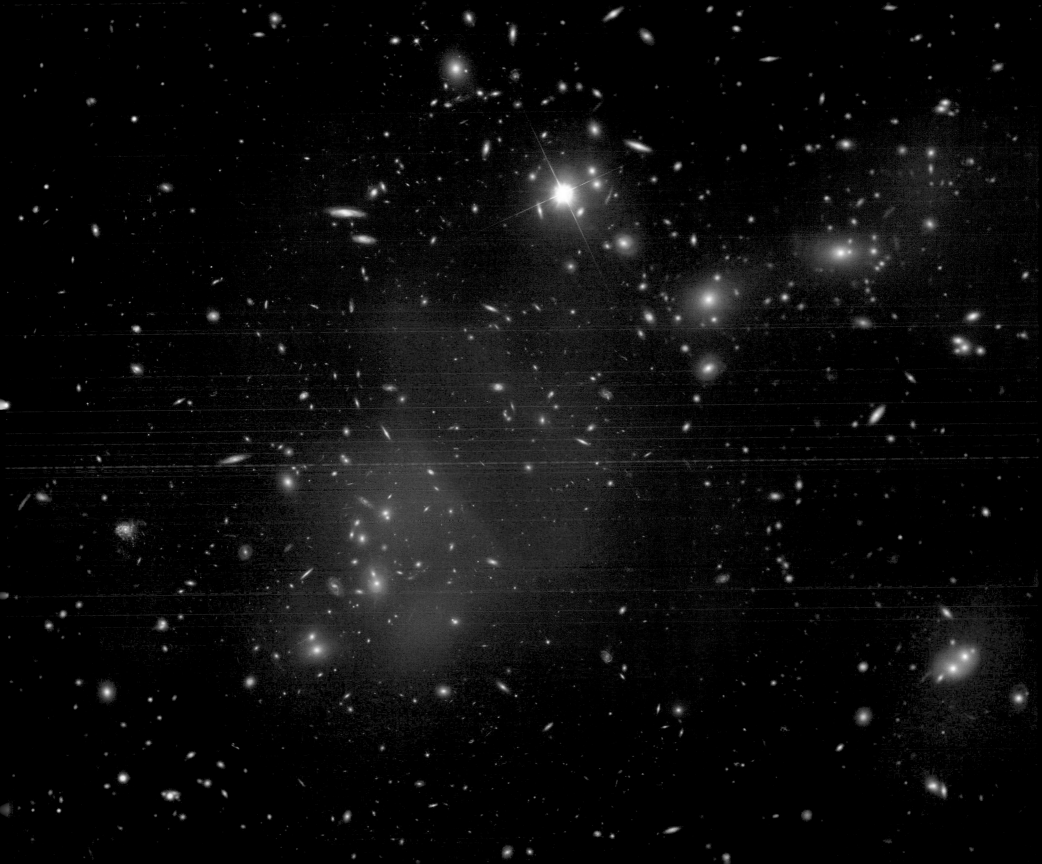

FOUR GALACTIC CLUSTERS

This composite 2005 image from the Hubble Space Telescope and the Chandra X-ray Observatory shows us the massive galaxy cluster known as MACS J0717. The image shows four separate galactic clusters in a head-on collision roughly 5.4 billion light years from Earth. This is one of the most geometrically complex collections of colliding galactic clusters known to us. A single galactic cluster is usually composed of fifty to a thousand galaxies. They are typically sculpted into long filaments—streams of galaxies, gas, and dark matter—some of which may flow into areas already clumped with matter. The powerful gravitational pull of dark matter often groups and keeps together fast-moving galaxies in these long filaments, almost like superhighways that create a path for the galaxies to travel down. Images of the galactic forms come from the Hubble, while the Chandra captured hot gas, which is color coded by temperature: reddish-purple for the coolest, blue for the hottest, and purple for mid-range temperatures.

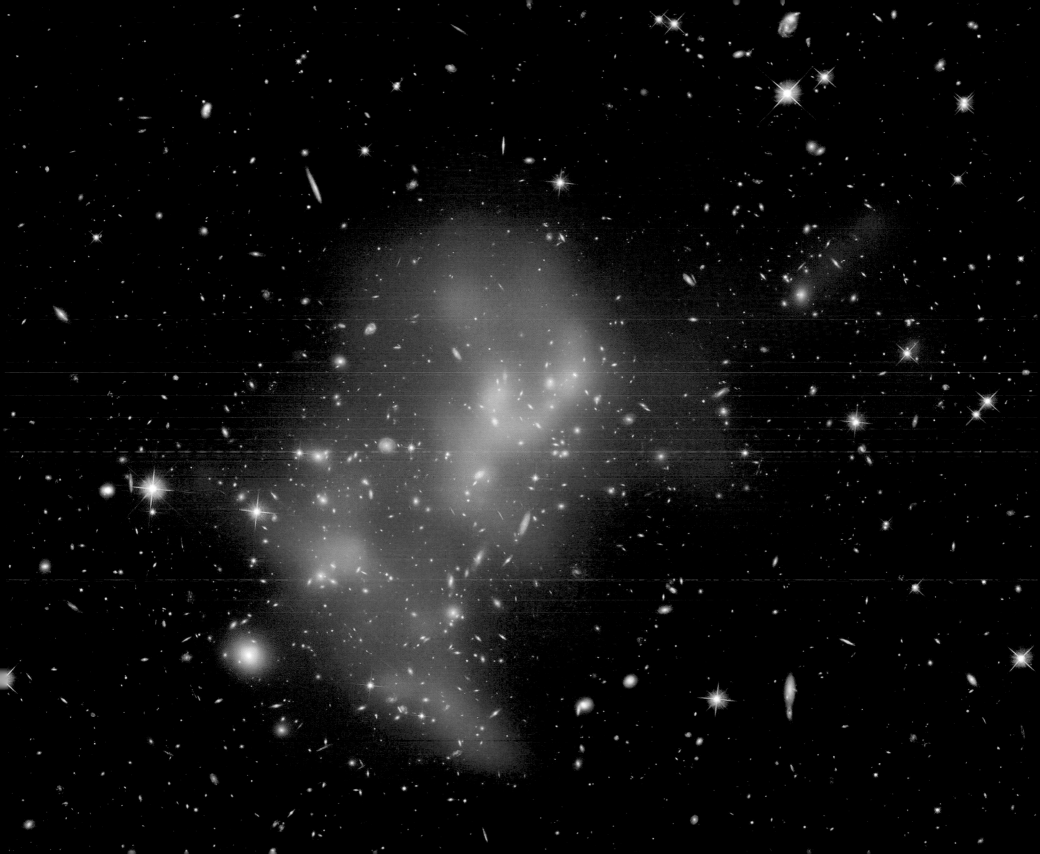

KEY FOR AGENCY ACRONYMS

ACS = Advanced Camera for Surveys

AURA = Association of Universities for Research in Astronomy

ASTER = Advanced Spaceborne Thermal Emission and Reflection
Radiometer

CfA (Harvard-Smithsonian Center for Astrophysics)

CNRS/INSU (French National Centre for Scientific Research/
Institute for Earth Sciences and Astronomy)

CXC = Chandra X-ray Center

DOD = Department of Defense

ERSDAC = Earth Remote Sensing Data Analysis Center

ESA = European Space Agency

ESO = European Southern Observatory

GRC = Glenn Research Center

GSFC = Goddard Space Flight Center

HEIC = Hubble European Space Agency Information Centre

INAF = National Institute for Astrophysics, Italy

IPHAS = INT Photometric H-Alpha Survey

JAROS = Japanese Resource Observation System Organization

JPL-Caltech = Jet Propulsion Laboratory/California Institute of
Technology

JSC = Johnson Space Center

METI = Ministry of Economy, Trade, and Industry, Japan

MSSL = Mullard Space Science Laboratory, UK

NASA = National Aeronautics and Space Administration

NOAA = National Oceanic and Atmospheric Administration

SDO = Solar Dynamics Observatory

STScI = Space Telescope Science Institute

UKATC/STFC = United Kingdom Astronomy Technology Centre/
Science and Technology Facilities Council

USGS = U.S. Geological Survey

VLT = Very Large Telescope (European Southern Observatory)

IMAGE CREDITS

Front jacket: NASA, Universities Space
 Research Association, Lunar and
 Planetary Institute
Back jacket: International Space
 Station Program, JSC Earth
 Science & Remote Sensing
 Unit, Astromaterials Research
 and Exploration Science Unit,
 Exploration Integration Science
 Directorate
Case: ESA/NASA - SOHO/LASCO
Frontispiece: NASA, JPL-Caltech, SSI
Title page: NASA's Earth Observatory,
 Jesse Allen and Norman Kuring
Page 9: NASA, ESA
Page 11: NASA, JPL-Caltech
Page 17: NASA, JSC
Page 18: NASA, JSC
Page 19: NASA, JSC
Page 20: NASA, JPL-Caltech
Page 21: NASA, GRC
Page 23: NASA, JSC
Page 24: NASA, GSFC, METI, ERSDAC,
 JAROS, US/Japan ASTER Science
 Team
Page 25: NASA's Earth Observatory,
 NOAA, DOD
Pages 26–27: NASA
Page 28: NASA, JSC
Page 29: NASA, JSC
Pages 30–31: NASA, JSC
Page 32: NASA

Page 33: NASA
Page 34: NASA, JPL-Caltech, USGS
Page 35: NASA, Johns Hopkins
 University Applied Physics
 Laboratory, Carnegie Institution
 of Washington
Page 36: NASA, JPL-Caltech, SETI
 Institute
Page 37: NASA, Johns Hopkins
 University Applied Physics
 Laboratory, Southwest Research
 Institute, GSFC
Page 39: NASA, JPL-Caltech, SSI
Page 40: JPL-Caltech
Page 41: NASA
Page 42: NASA, SDO
Page 43: NASA, SDO
Page 45: NASA, SDO
Page 46: NASA, JSC
Page 47: NASA, SDO
Pages 48–49: NASA, JPL-Caltech,
 UCLA
Page 50: NASA, JPL-Caltech
Page 51: NASA, JPL-Caltech, Harvard-
 Smithsonian CfA
Page 52: NASA, CXC, JPL-Caltech, CfA
Page 53: NASA, JPL-Caltech
Page 54: NASA, JPL-Caltech, UCLA
Page 55: NASA, JPL-Caltech, University
 of Arizona
Page 56: NASA, JPL-Caltech
Page 57: NASA, JPL-Caltech

Page 58: NASA, JPL-Caltech

Page 59: NASA, JPL-Caltech, STScI

Page 60: NASA, ESA, M. Robberto
(STScI/ESA), the Hubble Space
Telescope Orion Treasury Project
Team

Page 61: NASA, ESA, M. Robberto
(STScI/ESA), the Hubble Space
Telescope Orion Treasury Project
Team

Page 62: X-ray: NASA, Chandra X-ray
Observatory, Pennsylvania
State University, K. Getman,
E. Feigelson, M. Kuhn, and the
MYStIX team; Infrared: NASA,
JPL-Caltech

Page 63: NASA, ESA, the Hubble
Herritage Team (STScI/AURA)

Page 64: NASA, JPL-Caltech

Page 65: NASA, JPL-Caltech

Page 66: NASA, H. Ford (JHU),
G. Illingworth (UCSC/LO),
M. Clampin (STScI), G. Hartig
(STScI), the ACS Science Team,
ESA

Page 67: NASA, JPL-Caltech, CfA

Page 68: NASA, ESA, HEIC, and the
Hubble Heritage Team (STScI/
AURA)

Page 69: NASA, JPL-Caltech/UCLA

Page 70: NASA, JPL-Caltech, UCLA

Page 71: NASA, JPL-Caltech

Page 72: NASA, JPL-Caltech

Page 73: NASA, ESA, the Hubble
Heritage Team (STScI/AURA),
IPHAS

Pages 74–75: ESA, PACS, SPIRE,
Martin Hennemann and
Frederique Motte (Laboratoire
AIM Paris-Saclay, CEA/Irfu—
CNRS/INSU—University of Paris,
Diderot, France)

Page 76: NASA, H. Richer (University of
British Columbia)

Page 77: NASA, JPL-Caltech, UCLA

Pages 78–79: NASA, JPL-Caltech,
University of Wisconsin

Page 80: NASA, JPL-Caltech, Harvard-
Smithsonian

Page 81: NASA, ESA, JPL-Caltech,
Arizona State University

Page 82: ESA, Herschel, PACS, MESS
Key Programme Supernova
Remnant Team, NASA, ESA,
Allison Loll/Jeff Hester (Arizona
State University)

Page 83: NASA, ESA, CXC, JPL-Caltech,
J. Hester and A. Loll (Arizona
State University), R. Gehrz
(University of Minnesota), STScI

Page 84: NASA, ESA, the Hubble
Heritage Team (STScI/AURA)

Page 86: NASA, ESA, M. Livio and the
Hubble 20th Anniversary Team
(STScI)

Page 87: NASA, ESA, J. Maíz Apellániz
(Instituto de Astrofísica de
Andalucía, Spain)

Page 88: X-ray: NASA, CXC, CfA, S.
Wolk; Infrared: NASA, JPL, CfA,
S. Wolk

Page 89: NASA, the Hubble Heritage
Team (STScI/AURA)

Pages 90: NASA, JPL-Caltech, UCLA

Page 92: NASA, ESA, the Hubble
Heritage Team (STScI/AURA)

Page 93: NASA, JPL-Caltech, University
of Wisconsin

Page 94: NASA, Ron Gilliland (STScI)

Page 95: NASA, ESA, the Hubble
Heritage Team (STScI/AURA)

Pages 96: NASA, the Hubble Heritage
Team (STScI/AURA)

Page 97: NASA, ESA, and H. Bond
(STScI)

Page 99: NASA, JPL-Caltech, UCLA

Pages 100: NASA, ESA, the Hubble
Heritage Team (STScI/AURA)

Pages 102–103: NASA, JPL-Caltech,
UCLA

Page 105: NASA, JPL-Caltech

Page 106–107: NASA, ESA, SSC, CXC,
STScI

Page 108–109: NASA, JPL-Caltech,
University of Potsdam

Page 111: X-ray: NASA, CXC, PSU, L.
Townsley et al.; Optical: NASA,
STScI; Infrared: NASA, JPL, PSU,
L. Townsley et al.

Page 112: NASA, N. Walborn and J.
Maíz-Apellániz (STScI), R. Barbá
(La Plata Observatory, La Plata,
Argentina)

Page 113: NASA, ESA, F. Paresce
(INAF-IASF, Bologna, Italy), R.
O'Connell (University of Virginia,

Charlottesville), the Wide Field
Camera 3 Science Oversight
Committee

Pages 114–115: NASA, ESA, D. Lennon
and E. Sabbi (ESA/STScI), J.
Anderson, S. E. de Mink, R.
van der Marel, T. Sohn, and N.
Walborn (STScI), N. Bastian
(Excellence Cluster, Munich), L.
Bedin (INAF, Padua), E. Bressert
(ESO), P. Crowther (University of
Sheffield), A. de Koter (University
of Amsterdam), C. Evans
(UKATC/STFC, Edinburgh),
A. Herrero (IAC, Tenerife), N.
Langer (AifA, Bonn), I. Platais
(JHU), H. Sana (University of
Amsterdam)

Page 116: NASA, ESA, D. Lennon
and E. Sabbi (ESA/STScI), J.
Anderson, S. E. de Mink, R.
van der Marel, T. Sohn, and N.
Walborn (STScI), N. Bastian
(Excellence Cluster, Munich), L.
Bedin (INAF, Padua), E. Bressert
(ESO), P. Crowther (University of
Sheffield), A. de Koter (University
of Amsterdam), C. Evans
(UKATC/STFC, Edinburgh),
A. Herrero (IAC, Tenerife), N.
Langer (AifA, Bonn), I. Platais
(JHU), H. Sana (University of
Amsterdam)

Page 117: ESA, NASA, JPL-Caltech,
STScI

Page 118: NASA, ESA, CXC, the
University of Potsdam, JPL-
Caltech, STScI

Pages 120–121: NASA, ESA, A. Nota
(STScI/ESA)

Page 123: NASA, ESA, the Hubble
Heritage Team (STScI/AURA)

Page 124: ESA, Herschel, PACS &
SPIRE Consortium, O. Krause,
HSC, H. Linz

Pages 126–127: NASA, JPL-Caltech

Pages 128–129: NASA, JPL-Caltech,
UCLA

Pages 130–131: NASA, ESA, the Hubble
Heritage Team (STScI/AURA)

Pages 132–133: NASA, JPL-Caltech

Pages 134–135: NASA, ESA, the Hubble
Heritage Team (STScI/AURA)

Page 136–137: NASA, JPL-Caltech,
UCLA

Page 139: NASA, ESA, the Hubble
Heritage Team (STScI/AURA)

Page 140: NASA, The Hubble Heritage
Team (AURA/STScI)

Page 141: X-ray: NASA, CXC, MSSL,
R. Soria et al; Optical: AURA,
Gemini OBs

Page 143: NASA, ESA, the Hubble
Heritage Team (STScI/AURA)

Pages 144–145: NASA, the Hubble
Heritage Team (STScI/AURA)

Page 147: X-ray: NASA, CXC,
Huntingdon Institute for X-ray
Astronomy, G. Garmire; Optical:
ESO, VLT

Page 148: NASA, JPL-Caltech, Harvard-
Smithsonian CfA

Page 151: NASA, ESA, the Hubble
Heritage Team (STScI/AURA)

Page 152: NASA, ESA, the Hubble
Heritage Team (STScI/AURA)

Page 155: NASA, ESA

Page 157: NASA, ESA, the Hubble
Heritage Team (STScI/AURA)

Page 158: NASA, ESA, the Hubble SM4
ERO Team

Page 161: NASA, ESA, E. Julio (JPL-
Caltech), P. Natarajan (Yale
University)

Pages 162–163: NASA, JPL-Caltech

Page 164: NASA, ESA, M. J. Jee and H.
Ford (Johns Hopkins University)

Pages 166–167: NASA, ESA, J. Merten
(Institute for Theoretical
Astrophysics, Heidelberg/
Astronomical Observatory of
Bologna), D. Coe (STScI)

Page 169: NASA, ESA, CXC; C. Ma,
H. Ebeling, and E. Barrett et al
(University of Hawaii/IfA); STScI

Endsheets: Image 1: ESA/ROSETTA/
NAVCAM. Image 2: © ESA/
ROSETTA/MPS/UPD/LAM/
IAA/SSO/INTA/UPM/DASP/
IDA. Image 3: © ESA/ROSETTA/
MPS FOR OSIRIS TEAM MPS/
UPD/LAM/IAA/SSO/INTA/
UPM/DASP/IDA. Image 4: ESA/
ROSETTA/NAVCAM.

BIBLIOGRAPHY

Burrows, William E. *The Infinite Journey: Eyewitness Accounts of NASA and the Age of Space.*
New York: Discovery Books, 2000.

Gribbin, John, and Mary Gribbin. *Stardust: Supernovae and Life—The Cosmic Connection.*
New Haven: Yale University Press, 2000.

Hubble Space Telescope. "About Hubble." http://www.spacetelescope.org/about.

Jet Propulsion Laboratory, California Institute of Technology. "Basics of Space Flight."
http://www2.jpl.nasa.gov/basics/index.php.

Kaku, Michio, and Jennifer Trainer Thompson. *Beyond Einstein: The Cosmic Quest for the
Theory of the Universe.* New York: Anchor Books, 1995.

MYStIX: Massive Young-Star Forming Complex Study in Infrared and X-ray NASA History
Office. http://history.nasa.gov.

National Air and Space Museum. Space History Division. "Top NASA Photos of All Time."
Air & Space Magazine, November 2008.
http://www.airspacemag.com/photos/top-nasa-photos-of-all-time-9777715/?no-ist

Sagan, Carl. *Cosmos.* New York: Ballantine Books, 2013.

WEB RESOURCES

Chandra X-Ray Observatory, http://www.chandra.harvard.edu.

European Space Agency, http://www.esa.int.

Herschel Space Observatory, http://www.herschel.caltech.edu.

Hubble Space Telescope, http://www.hubblesite.org.

Jet Propulsion Laboratory, http://www.jpl.nasa.gov.

Milky Way Project, http://www.milkywayproject.org.

Spitzer Space Telescope, http://www.spitzer.caltech.edu.

Zooniverse, http://www.zooniverse.org.

COMET 67P/CHURYUMOV-GERASIMENKO

These images of the Comet 67P/Churyumov-Gerasimenko were captured by the *Rosetta* spacecraft. Designed by the European Space Agency and equipped with NASA instruments, *Rosetta* is the first spacecraft to orbit a comet and land on its surface. *Rosetta* launched in 2004 and reached the comet in 2014 after a ten-year journey through the solar system. During its two-year rendezvous with Comet 67P/Churyumov-Gerasimenko, the spacecraft will explore the comet's nucleus and study how the comet is transformed by the sun.

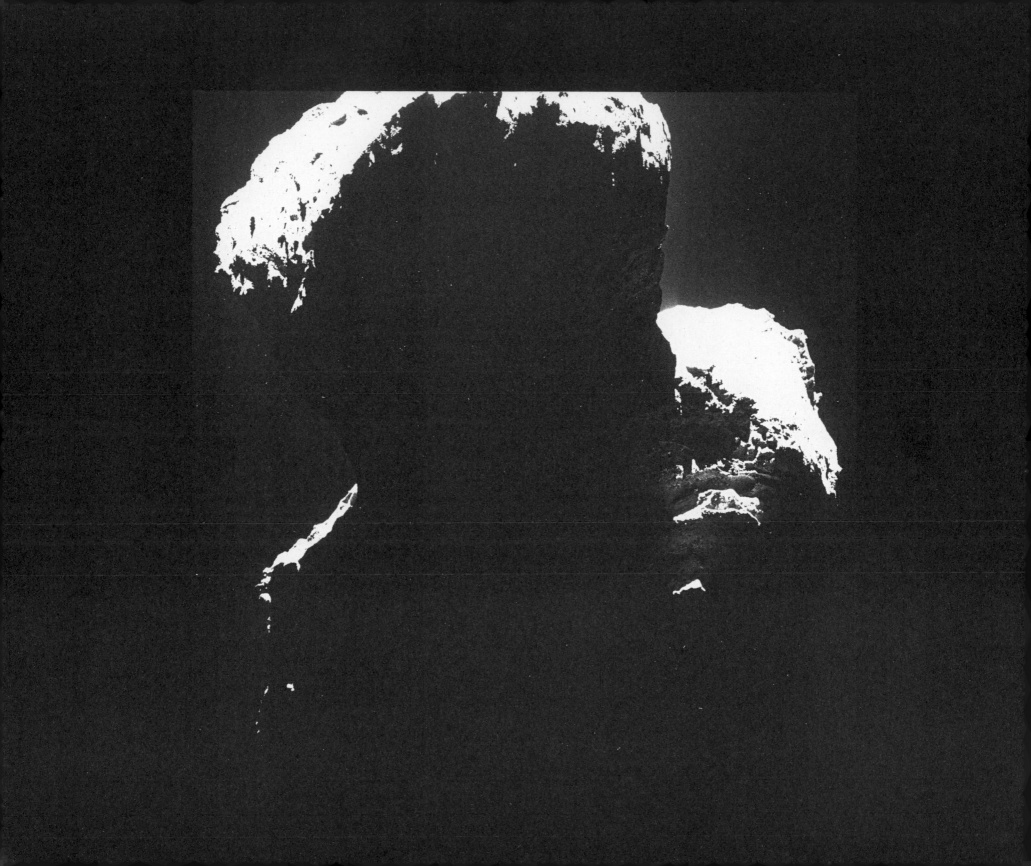